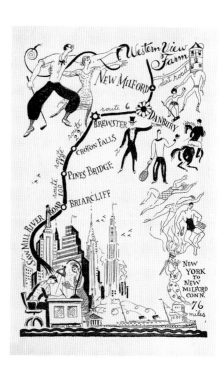

Art Deco Postcards

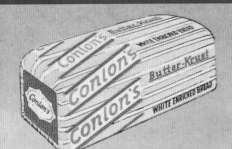

Conlon BAKING COMPANY

West Virginia's FINEST BAKERY

CHARLESTON, West Virginia

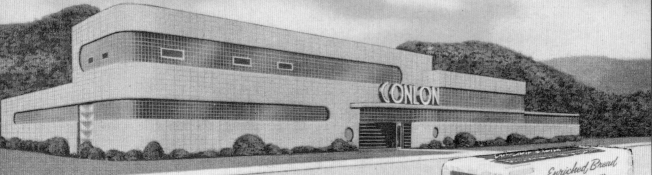

BAKERS OF *Conlon* AND
Butter-Krust PRODUCTS

PATRICIA BAYER

Art Deco
Postcards

with 264 illustrations

Thames & Hudson

PUBLISHER'S NOTE: Many of the postcards in this book are reproduced larger than actual size; in a few instances inscriptions on the original postcards have been deleted for technical reasons. In the captions, dates of a building or event, and of postcards, are given where known.

Front cover New Union Pacific Station, Las Vegas, Nevada, USA, 1940 (postcard: 1940; see also page 241)
Back cover, left Woolworth Store, Seattle, Washington, USA, 1940 (see also page 205)
Back cover, middle Frecker's Malted Milk Shop, Columbus, Ohio, USA (postcard: 1937; see also page 108)
Back cover, right The Giant Underwood Master, New York World's Fair, USA, 1940 (see also page 36)

Half-title page A card for Western View Farm, New Milford, Connecticut, USA, c. 1932
Frontispiece Conlon Baking Company, Charleston, West Virginia, USA, 1938 (postcard: 1938)
Title page Electrical Products Building, New York World's Fair, USA, 1939 (postcard: 1939)
Opposite Villa Isola, Bandoeng (Bandung), Java, Indonesia, 1933
Below First Class Observation Deck of the ocean liner *Kogane Maru*, 1936

First published in the United Kingdom in 2011 by Thames & Hudson Ltd, 181A High Holborn, London WC1V 7QX

British Library Cataloguing-in-Publication Data
A catalogue record for this book is available from the British Library

ISBN 978-0-500-23888-2

Printed and bound in China through Asia Pacific Offset Ltd

To find out about all our publications, please visit **www.thamesandhudson.com**. There you can subscribe to our e-newsletter, browse or download our current catalogue, and buy any titles that are in print.

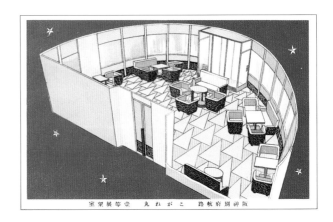

室望展等壱 丸ねがこ 路帆府別神版

CONTENTS

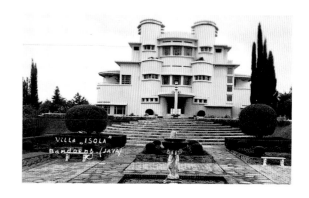

INTRODUCTION

Art Deco as a style is an eclectic hybrid, a glorious and contradictory magpie. It had its roots in France before the First World War, reached a peak at the 1925 Paris Exposition, and for some fifteen years influenced architecture and design in many places around the world, perhaps nowhere more so than on the streets of Manhattan, where iconic structures such as the Empire State and Chrysler buildings rose around 1930. These 'cathedrals of commerce', built so soon after the stock market crash of 1929, still stand, soaring testaments to a great style that can even now appear to our eyes as modern, even futuristic.

The term 'Art Deco' (or 'Art Moderne', hence *moderne*) can be applied to architecture, decorative arts, interior design – even paintings, graphic arts, sculpture and costumes – of roughly the years between the end of World War I in 1918 and the beginning of World War II in 1939. The style was informed by sources from many eras, cultures and places, from ancient Egypt to Mesoamerica to tribal Africa, but it also borrowed from various contemporary developments such as the Bauhaus, Cubism and the Ballets Russes. And in the 1930s many designers looked to aerodynamic and Machine Age forms for inspiration, often using new products such as aluminium, stainless steel, chrome, Bakelite, and an opaque pigmented glass marketed as Vitrolite, Carrara Glass and Sani Onyx.

Above all, buildings, interiors and furniture referred to as being in the Art Deco style are characterized by distinctive, though disparate, decorative elements and forms. The types of decoration run the gamut from traditional to innovative: characteristic modes include stylized floral, strictly rectilinear, opulently exotic, boldly geometric and sleekly streamlined. Sunbursts, chevrons, stepped forms – these are just some of the common motifs in the Art Deco repertory seen on objects as well as buildings. Later variants of – some would say successors to – Art Deco include the less busy, more straightforward and geometric Streamline Moderne, Nautical Moderne and Zigzag Moderne,

which are generally 1930s manifestations with more simplicity and curvilinearity.

The 1925 Paris Exposition des Arts Décoratifs et Industriels Modernes gave Art Deco its name – though the abbreviated term was not used until the second half of the 20th century – and is considered the apex of the style. The greatest French artists, designers and architects contributed to the fair, which was intended to show the world the predominance of France in those realms, and its influence spread far and wide over the next decade and a half. But artists, designers and architects in other countries added their own local touches or sought inspiration from even more varied sources, with the result that the style has come to be defined by elements that at times can seem contradictory yet are still somehow recognizable as Art Deco, be it the symmetrical conventionalized blossoms painted on a ceramic vase or the stepped massing of a downtown storefront or the sleek androgynous figure silhouetted on a book's cover.

Postcards of buildings, skylines, and street scenes produced in the 1920s to 1940s offer a fascinating overview of the global appeal of Art Deco in its various manifestations; in addition, in some we see that a few pre-1920s structures have elements presaging Art Deco, while in others that it is still alive in some buildings of the early 1950s.

I began to collect Art Deco-era postcards in the 1980s, when I could not resist owning some of the 'linens' (cards printed on a textured linen-like paper stock, their vivid hues sometimes far from 'true' and their subject buildings sometimes 'touched up' to remove unwanted, unsightly elements or even add an extra storey!) that depict pastel-hued confections in Miami Beach, hotels such as the Albion, Breakwater, Colony and Delano, which beckoned cold, weary Northerners and foreigners to America's newest oceanside playland. Then I began to search out cards from the great international expositions of the 1920s and 1930s, most of whose pavilions and monuments were temporary structures – unlike the Eiffel Tower of the 1889 Paris Exposition, which is considered by most experts to have launched the mailing of postcards as a worldwide phenomenon. I started with Paris's 1925 Exposition and roughly ended with the New York World's Fair of 1939-40. In between there were international as well as large regional and national fairs, and millions of postcards were printed, written and sent showing the wonderful buildings. Some were black-and-white images touched up with colour highlights; others were almost entirely coloured by artists and printers, with colours often not at all those of the actual site or structure, colours that could be simplified, cleaned up, enhanced and even 'idealized'. Finally, having

written books on Art Deco interiors and buildings, I found myself concentrating on postcards depicting those subjects.

The postcards shown are all on paper. The American ones mostly measure 3½ × 5½ inches / 8 × 14 cm, while European cards of the time were generally bigger, 4 × 6 inches / 10 × 15 cm (the standard US size today). A few are actual black-and-white photographs (known as real photographic cards or RPPCs, printed on Kodak or other special paper and sometimes hand-coloured or airbrushed with transparent hues); a few are reproductions of artists' designs; but the vast majority are mass-produced colour images that may have originated as photographs but were touched up or modified before the lithographic printing process in order to produce a somewhat romanticized, simplified image. Taken together, they form a delightful record of a period gone by, and in all too many instances of a building or an interior that no longer survives, a street now unrecognizable, or, in the case of exposition pavilions, a fabulous creation that was always meant to be ephemeral.

I have attempted to make the collection as international as possible, but the huge number of American linens that were produced, compared with the very few such colourful cards from other countries, means that most of the postcards illustrated are American in origin. (Some hand-drawn cards and even a handful of real photo cards from elsewhere have surfaced, however.) These non-US postcards are telling Art Deco images that show the extent of the style's influence, be it to hotels in Britain, cinemas in India or skyscrapers in South America. Some countries with great Deco architecture are sadly underrepresented, notably Australia, India, New Zealand and South Africa, and the cards found from those places may not show outstanding examples of the style. I hope, however, that this collection will give an idea of the many types of places created in the first half of the 20th century – from the more obvious hotels, theatres, skyscrapers, memorials, amusement parks and city skylines to the less common government buildings, schools, libraries, museums, and even sanatoriums – that people visited in the Jazz Age and chose to remember in the form of picture postcards, or, more frequently, to write home about on the back of the card.

The cards illustrated here come from my collection and those of Jeremy Storey of Perth, Australia, and Randy Juster of Sacramento, California.

ACKNOWLEDGMENTS

My deepest thanks go to Jeremy Storey and Randy Juster, whose postcards and expertise helped make this book so rich. My own collection would not have been enough to

8

show the variety and huge international appeal of Art Deco architecture and interior design.

I am grateful, too, to a wide spectrum of architecture and Art Deco enthusiasts, marketing and public relations people, company archivists, academics and others who helped me in seeking out historical details, and present-day information, on the cards illustrated. I would like to single out the following: Joseph R. Allen, University of Minnesota, Twin Cities; Lisa Calhoun, Mansfield Freeman Center for East Asian Studies, Wesleyan University, Middletown, Connecticut; Bethany D. Canfield, National Register/State Historian, West Virginia State Historic Preservation; Sandra Cohen-Rose and Colin Rose, Art Deco Society of Montreal, Montreal, Canada; Connecticut Postcard Club members, including Pam Hutchinson, Art Johnson, José Rodriguez, and Joseph Taylor; William Copeley, New Hampshire Historical Society, Concord; David E. Crawford, University Archivist, Reinert-Alumni Library, Creighton University, Omaha, Nebraska; Robin Grow and Robyn Saalfield, Victorian Art Deco and Moderne Society, Melbourne, Australia; Sue Kramer, Camden-Clark Foundation, Parkersburg, West Virginia; Tracey Leitch, Sydney, Australia; Karen Neuforth, Barton County Historical Society, Great Bend, Kansas; Paul Perdue, Pine Bluff, Arkansas; Dr Billy Joe Peyton, West Virginia State University Department of History, Charleston; Yoshiko Samuel, Professor of Asian Languages and Literatures, Wesleyan University, Middletown, Connecticut; Rebecca Binno Savage, Detroit Art Deco Society, Detroit, Michigan; Richard Shurley, City of Griffin, Georgia; Marco Steenbergen, Zitron Nederland BV, Hengelo, The Netherlands; Graeme Tonks, University of Tasmania, Launceston, Tasmania, Australia; and Jane Zande, Congregation Beth Israel, West Hartford, Connecticut. A general thank you to all who helped me but whose names I never got, or forgot (or whose cards ended up being cut owing to reasons of space alone, and not quality).

Among family members, personal friends and close colleagues (past and present), thanks go to: Helen Bayer, James Bayer, Judith C. Brown and Shannon Brown, Dan Campbell, Pamela Cavallaro, Donald Clem, Terri Craig, Michael Goldman and Sjoerd Doting, Joanne Manter, Kathleen and David Mayhew, Susan Randel, Anne Ranson and Abby Ripley, Pamela Ross, Bonnie Slotnick, Janine Stanley-Dunham, Veronica F. Towers, Hilary Whitney, Barbara Winard and, out of alphabetical order but only because I saved the most valuable for last, Frank Murphy, without whose encouragement, support, patience and haranguing I would not have finished this book during a period that at times proved very trying. Thanks, all, for helping me bring this long-gestating project to fruition.

9

AUTHOR'S NOTE

The Art Deco postcards you will
see here show buildings, interiors
and occasional others such as vessels
and vehicles of the period – subjects
roughly corresponding to those of my
earlier books, *Decoration and Design
Classics of the 1920s and 1930s* and *Art
Deco Architecture: Design, Decoration
and Detail from the Twenties and
Thirties*. My apologies to anyone who
purchased this book sight unseen and
was disappointed not to find cards
showing masked Pierrots and Pierrettes,
cloche-wearing flappers, and borzois
posing with stylishly dressed mistresses.

MAJOR NAMES IN THE CREATION OF POSTCARDS

The photographers, printers, publishers
and distributors of postcards make up
an endless list, but the major names
found on cards of the Art Deco era
are relatively few, especially in the
United States, where most of the linen
cards of the time were printed by
three companies:

Curt Teich Co., Chicago, Ill., USA
(1893–1974). Perhaps the most
important and successful printer and
publisher was German-born Curt Teich
(1877–1974). He pioneered methods of
offset lithography, including the five-
colour printing process, and produced the
largest number of white-bordered cards
in the world. The production of linen
cards began in 1931, and with his expert
colour printers Teich was dominant in
that area for many years. The cards may
be signed with names including
'Curteich', 'C.T. American Art', 'C.T.
Art-Colortone', and 'C.T. Photo-Colorit'.

The Curt Teich Postcard Archives,
compilers of an invaluable online dating
guide to the cards, is in the Lake County
Discovery Museum, Wauconda, Ill.
Tichnor Brothers, Inc., Boston and
Cambridge, Mass., USA (1907–87).
Brothers Harry Nathan Tichnor and
Louis Tichnor founded a printing and
souvenir sales company, the Market
Press, which soon became known as
Tichnor Brothers. In the mid-1930s
it enticed several talented colour
printers away from Curt Teich, and
soon it was producing linens using
the five-colour process.
Colourpicture, Boston and Cambridge,
Mass., USA (1938–69). A rival firm
set up by Harry Tichnor, a nephew
of the brothers, after he lost his
position in a company shakeup.
After founding it he lured away two
Tichnor colour printers.

Other American firms and
photographers represented in this book

are given below, with the approximate years when they operated, if known:

The Albertype Co., Brooklyn, N.Y. (1887–1952)

American Colortype Co., New York, N.Y., and Chicago, Ill. (1904–56)

American News Co., New York, N.Y. (1864–1969)

Asheville Postcard Co., Asheville, N.C. (1921–82)

Beals, Des Moines, Iowa (1930s–50s); issued cards under the trade name 'Art Tone Glo-Var Finished'

Reuben H. Donnelley Corporation, Chicago, Ill. (1916–)

Grinnell Litho Co., New York City (dates unknown)

Kraemer Art Co., Cincinnati, O., and Berlin, Germany (1908–53)

E. C. Kropp Co., Milwaukee, Wis. (1907–56)

Longshaw Card Co., Pasadena and Los Angeles, Calif. (1930s–57)

Lumitone Press, New York, N.Y. (1928–58)

Manhattan Post Card Publishing Co., New York, N.Y. (1928–65)

Metrocraft / Metropolitan, Everett, Mass. (1940s–84)

Mid-West Map Co. / MWM, Aurora, Mo. (1930–80)

Miller Art Co., Brooklyn, N.Y. (1922–41); produced many New York World's Fair cards

Irving Underhill (1903–60), New York, N.Y.; photographer, specialized in New York City; his name accompanied by a copyright symbol appears on cards from various publishers

Some well-known, long-established European postcard makers, such as Raphael Tuck and Valentine's of Great Britain, produced Art Deco cards, and in France the studio of Alfred Noyer, a Parisian photographer, produced numerous cards, notably of the 1925 Exposition.

Alfred Noyer / Noyer Studio, Paris, France (1910–40s), studio overseen by

photographer Alfred Noyer; cards often marked with 'AN' logo

Michael Patras, Paris, France (1932–40); photographer, published many of his Paris scenes as postcards

Photogelatine Engraving Co., Ltd, Toronto, Ont., Canada (1910–53)

Raphael Tuck & Sons, London, England, and New York, N.Y. (1896–1960s); chiefly known for cards pre-dating the Art Deco period, but produced some interesting lithographic view cards

Valentine & Sons / Valentine's Co. Ltd, Dundee, Scotland, and London, England (1825–1963); major publisher known for series including cards from the 1938 Empire Exhibition, Glasgow; had branches abroad, including Canada and Australia.

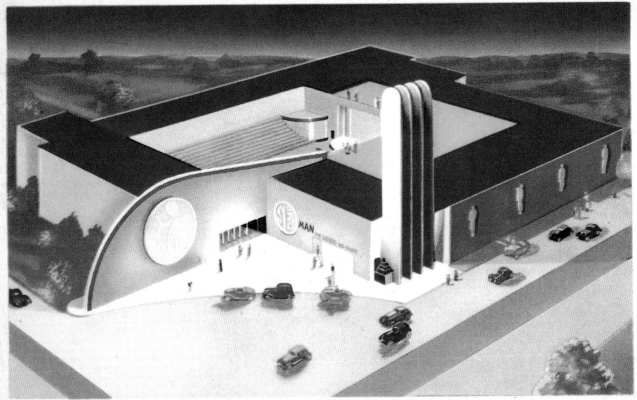

New York World's Fair 1939

A-9

WORLD FAIRS AND EXPOSITIONS

The often extraordinary but, sadly, largely ephemeral pavilions, restaurants and other attractions of the expositions that took place between 1925 and 1940, starting with the 1925 Paris Exposition Internationale des Arts Décoratifs et Modernes Industriels and culminating in the 1939–40 World's Fair in New York City, were depicted on millions of postcards that are today among the most ubiquitous, and desirable, of all such cards. They attracted vast numbers of fairgoers – over 16 million to Paris in 1925, and over 40 million to New York in 1939–40 – so one can only imagine how many cards were printed and purchased from these expositions and all those that occurred in between.

The cards featuring the structures of the 1925 Paris Exposition are among the most exquisite depictions of Art Deco architecture to be found. Interestingly, Le Corbusier's Pavillon de L'Esprit Nouveau was antithetical to the exposition's luxuriant, extensively decorated pavilions, but it is the one whose design was the most influential in terms of later architecture.

Fairs outside Europe, from Rio de Janeiro to Taipeh, and especially in North America, tended to be large-scale platforms for industry, commerce, technology and transportation rather than showcases of art and design. Their pavilions were some of the most inventive, exuberant and inviting structures ever built, and it's not unusual to find over a dozen different cards depicting a single building.

Postcards of many fairs were available in series, sets or packets – bound with heavier front and back covers in France; in wrapped sets that could be put in the mail in America; and as multiview sets folded concertina-like, with an attachment at one end on which a recipient's address and sometimes a brief message could be written.

13

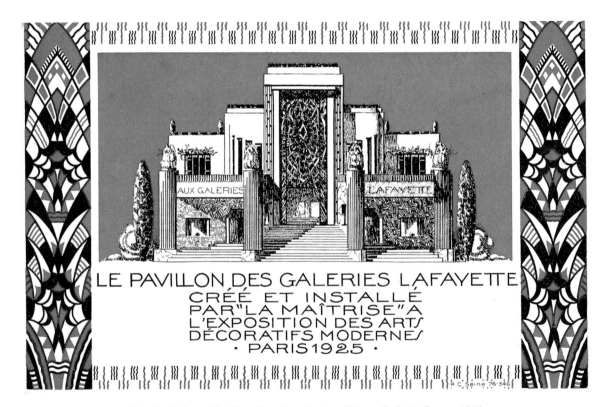

Galeries Lafayette Pavilion, Exposition des Arts Décoratifs, Paris, France, 1925

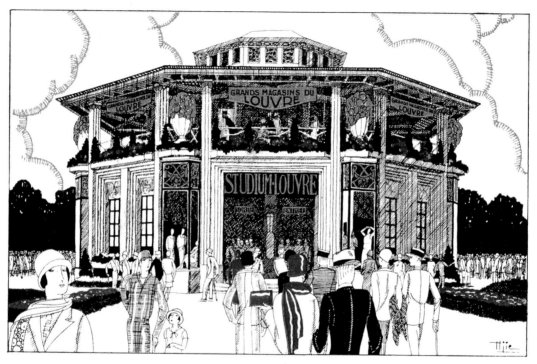

EXPOSITION DES ARTS DÉCORATIFS. PARIS 1925
LE PAVILLON DES GRANDS MAGASINS DU LOUVRE

Grands Magasins du Louvre Pavilion, Exposition des Arts Décoratifs, Paris, France, 1925

16

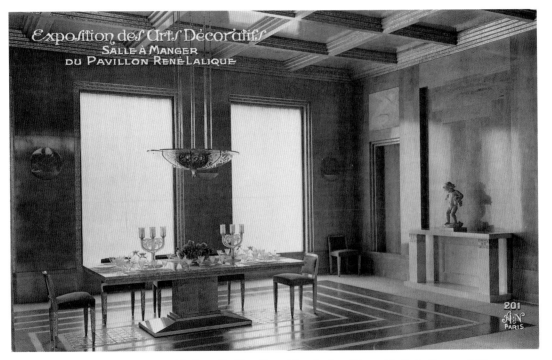

Dining Room of the René Lalique Pavilion, Exposition des Arts Décoratifs, Paris, France, 1925

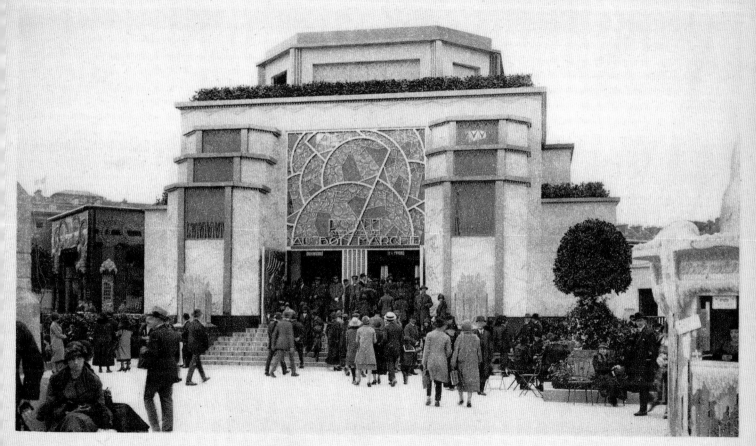

AU BON MARCHÉ - PARIS

Le Pavillon "**POMONE**" à l'Exposition des Arts Décoratifs 1925

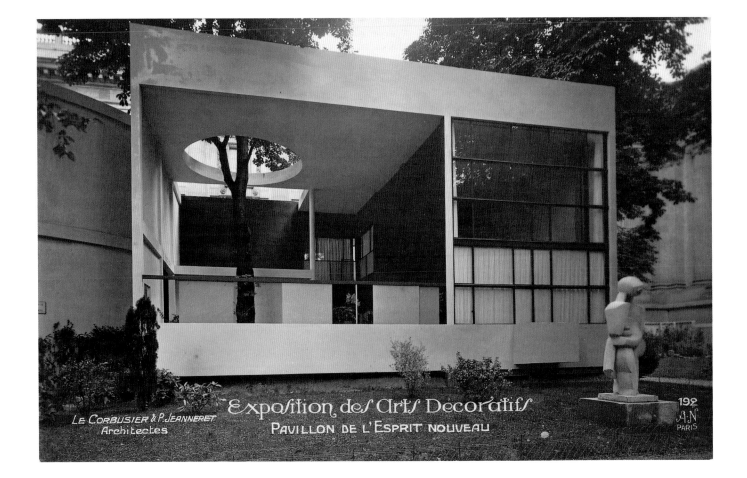

Exposition des Arts Décoratifs
PAVILLON DE L'ESPRIT NOUVEAU

Le Corbusier & P. Jeanneret
Architectes

192
A.N
PARIS

< 'Pavillon de l'Esprit Nouveau', Exposition des Arts Décoratifs, Paris, France, 1925

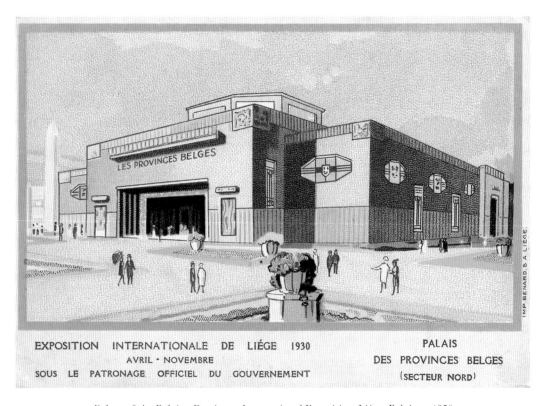

EXPOSITION INTERNATIONALE DE LIÉGE 1930
AVRIL - NOVEMBRE
SOUS LE PATRONAGE OFFICIEL DU GOUVERNEMENT

PALAIS
DES PROVINCES BELGES
(SECTEUR NORD)

19

Palace of the Belgian Provinces, International Exposition, Liège, Belgium, 1930

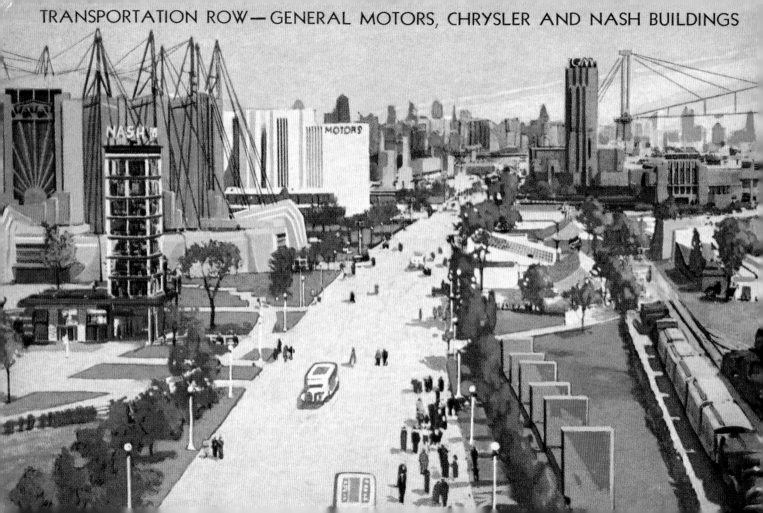

TRANSPORTATION ROW—GENERAL MOTORS, CHRYSLER AND NASH BUILDINGS

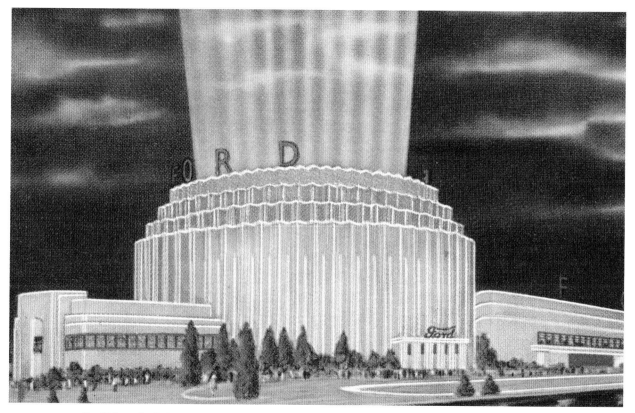

Ford Motor Co. Exhibit, A Century of Progress Exposition, Chicago, Illinois, USA, 1934 (postcard: 1934)

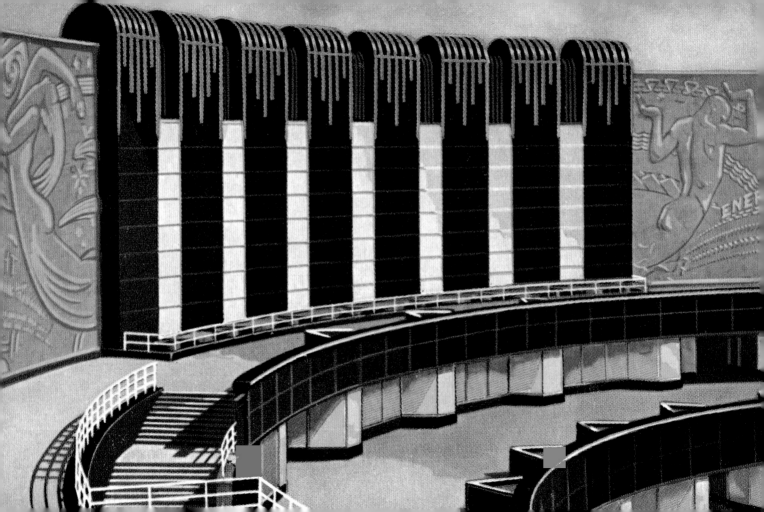

North Midway Luncheonette, A Century of Progress Exposition, Chicago, Illinois, USA, 1933

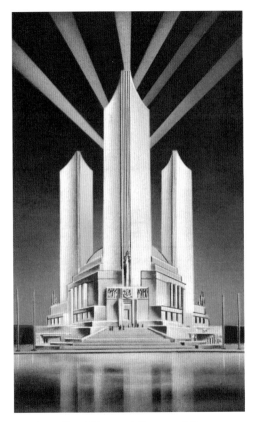

Three Fluted Towers, A Century of Progress
Exposition, Chicago, Illinois, USA, 1933–34

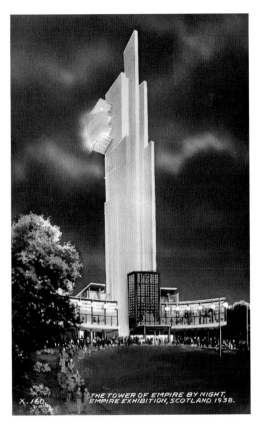

THE TOWER OF EMPIRE BY NIGHT,
EMPIRE EXHIBITION, SCOTLAND 1938.

X. 160.

The Tower of Empire, Empire Exhibition,
Glasgow, Scotland, 1938

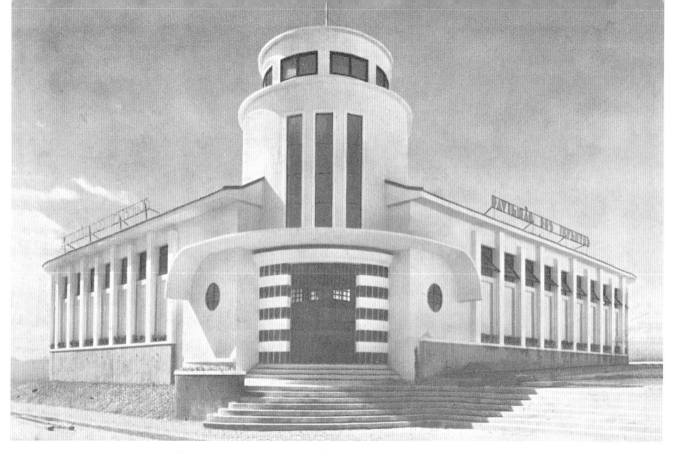

Pavilion of Inventions, International Fair of Samples, Rio de Janeiro, Brazil, 1934

26

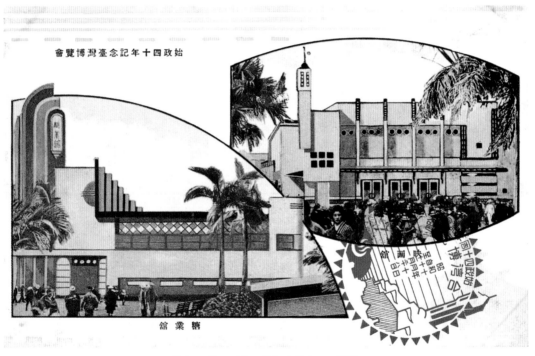

始政四十年記念臺灣博覽會

糖業舘

Taiwan Exposition, Taipei, Taiwan, 1935

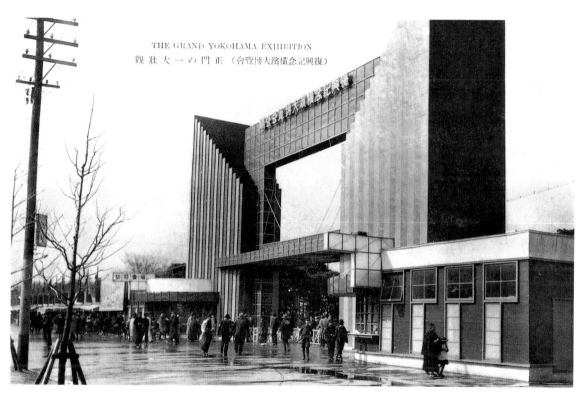

THE GRAND YOKOHAMA EXHIBITION

（復興記念横濱大博覽會）正門の一大壯觀

Grand Yokohama Exhibition to Commemorate Reconstruction, Japan, 1935

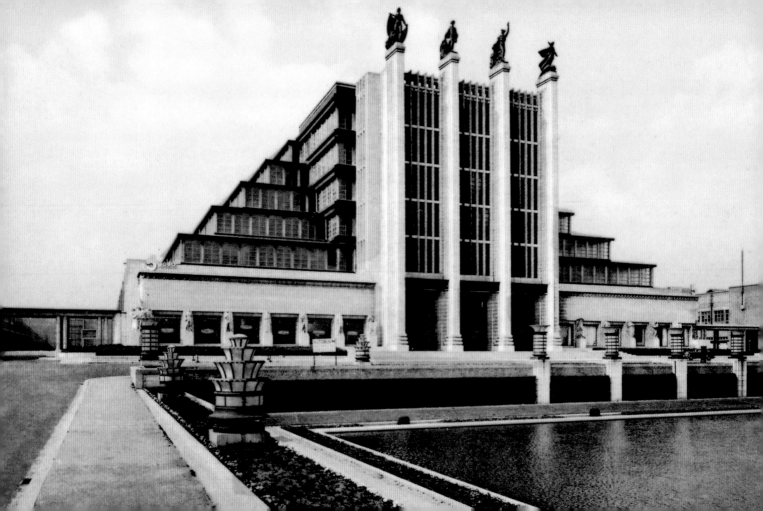

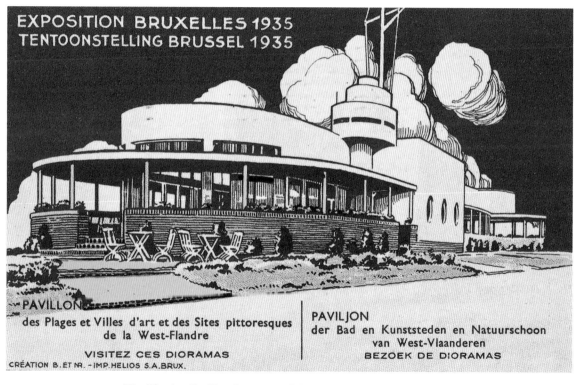

West Flanders Pavilion, International Exposition, Brussels, Belgium, 1935

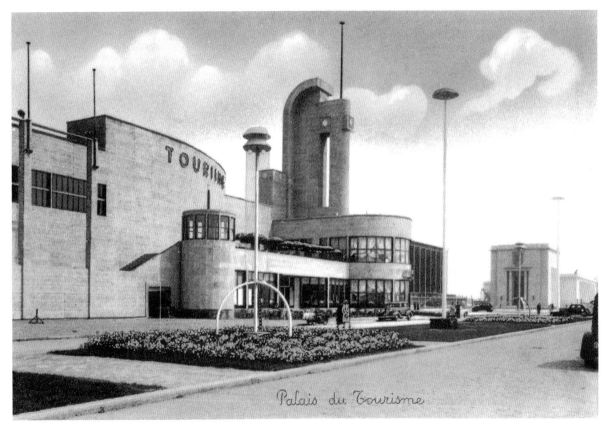

Palace of Tourism, International Exposition, Liège, Belgium, 1939

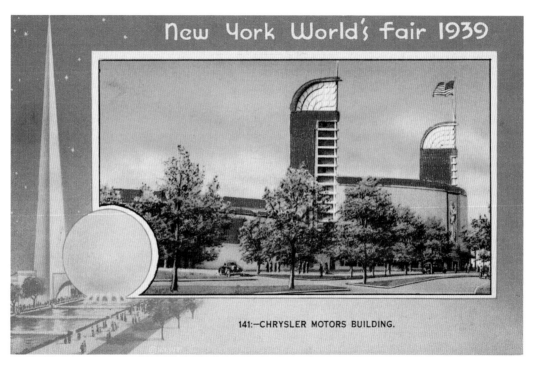

New York World's Fair 1939

141:—CHRYSLER MOTORS BUILDING.

Chrysler Motors Building, New York World's Fair, USA, 1939

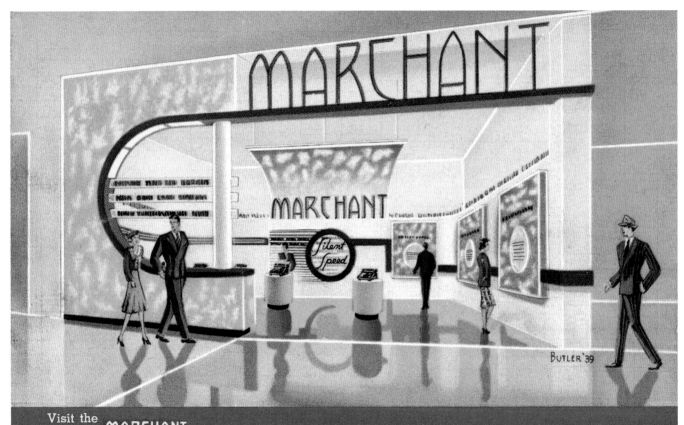

BUTLER '39

Visit the **MARCHANT** Calculating Machine Company Exhibit at the New York World's Fair

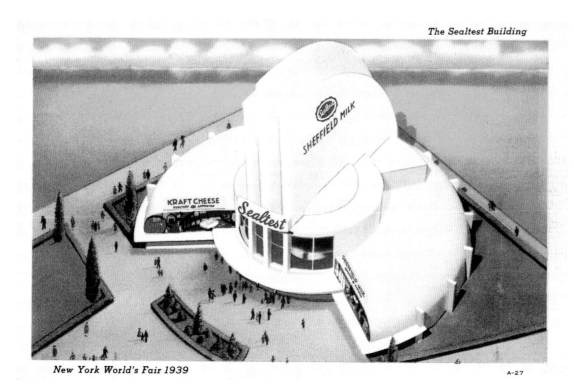

33

Sealtest Building, New York World's Fair, USA, 1939

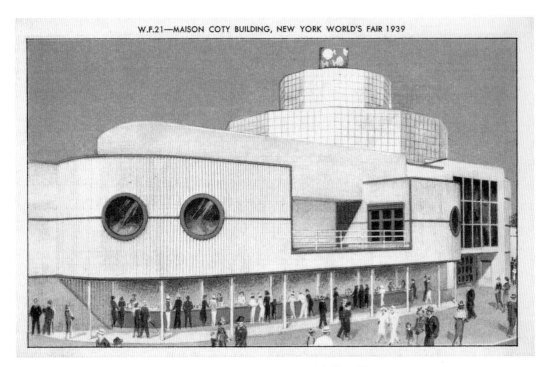

W.F.21—MAISON COTY BUILDING, NEW YORK WORLD'S FAIR 1939

Maison Coty Building, New York World's Fair, USA, 1939

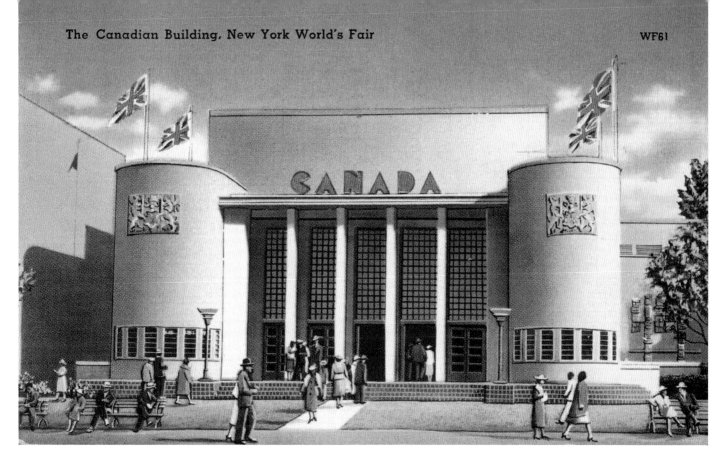

Canadian Building, New York World's Fair, USA, 1939

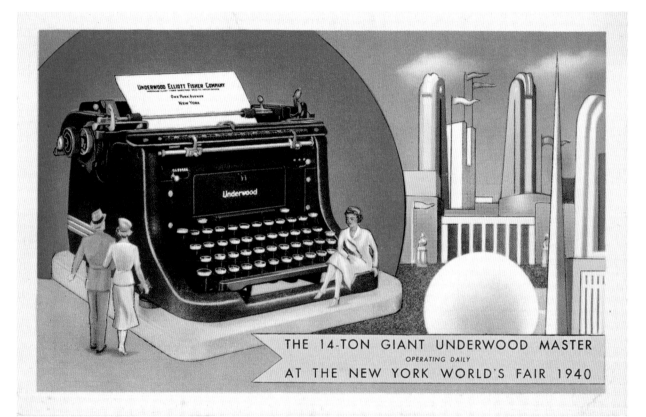

The Giant Underwood Master, New York World's Fair, USA, 1940

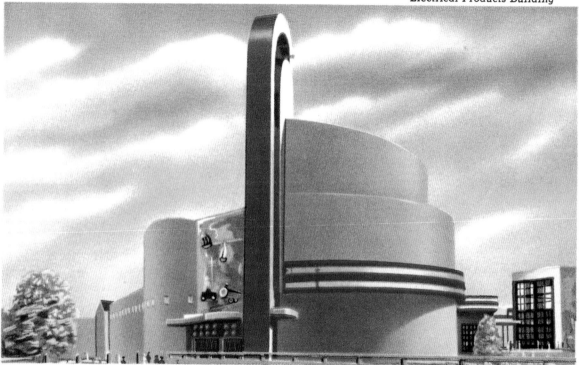

Electrical Products Building, New York World's Fair, USA, 1939

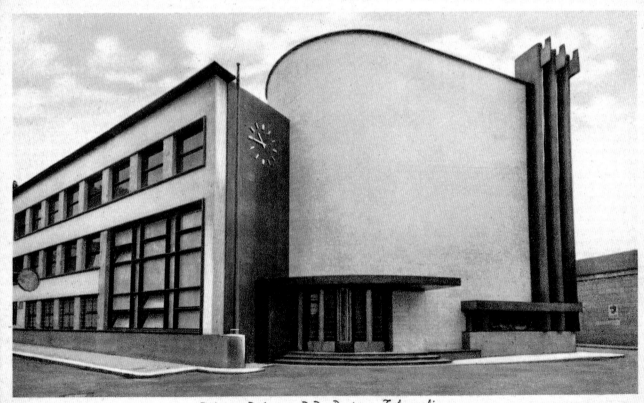

Pola - Palazzo R.R. Poste e Telegrafi.

PUBLIC STRUCTURES

In this section we will be concerned with structures for government, justice, learning, worship and commemoration. Of all Art Deco architecture, these seem to have managed best to escape the wrecker's ball or renovation and change of purpose beyond recognition. Buildings of this type in the United States were often designed by well-known architects, decorated by illustrious artists and sculptors, and built with the finest materials: many were funded by government agencies in the wake of the Great Depression, when men and women were put back to work to help erect and enhance these often symbolic structures.

Libraries ranged from small to monumental projects such as the Los Angeles Public Library. Museums, conservatories, planetariums and other exhibition spaces devoted to culture and science include several noteworthy Art Deco buildings. Some elementary and secondary schools and universities, especially in North America,

featured stepped forms and incorporated *moderne* lettering, glass bricks, stylized façade sculptures and terrazzo flooring in geometric patterns.

Places of healing – whether physical or mental – form a small group of structures with Art Deco exteriors or interiors. One doesn't often think of sending a postcard to someone of a place where one is recuperating, but there were some striking hospitals and related structures built in the 1920s–40s that were well worthy of depiction.

Houses of worship, shrines and other structures related to organized religion and religious rites, ceremonies and education are more rarely seen. Nonetheless, Catholic, Protestant and Mormon faiths are shown here.

Finally, some remarkable monuments and memorials were erected in this period, commemorating a wide range of events from war heroism to the settling of the national debt.

39

State Capitol, Salem, Oregon, USA, 1936–39 (postcard: 1939)

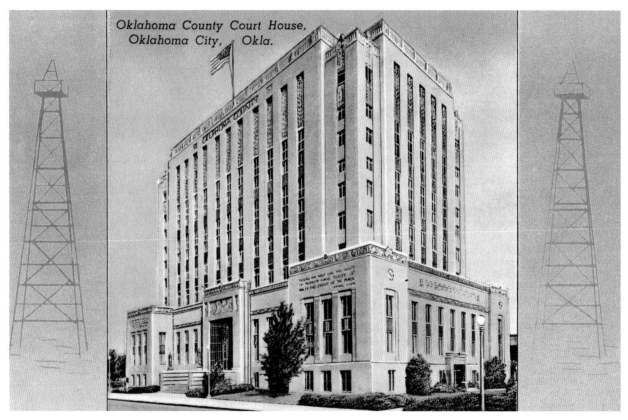

Oklahoma County Court House, Oklahoma City, Oklahoma, USA, 1937

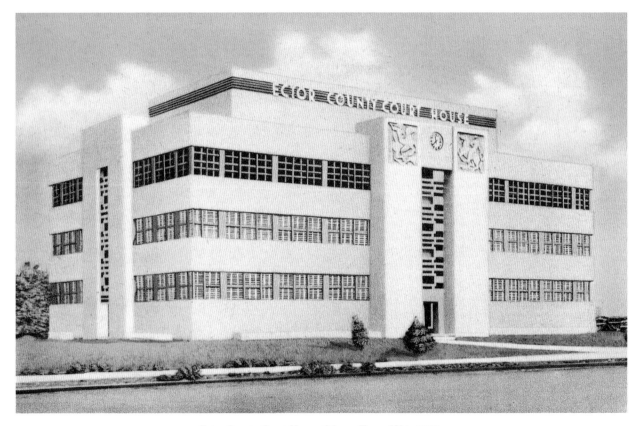

Ector County Court House, Odessa, Texas, USA, 1938

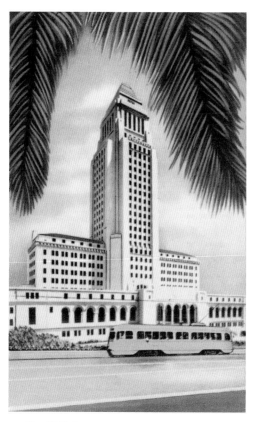

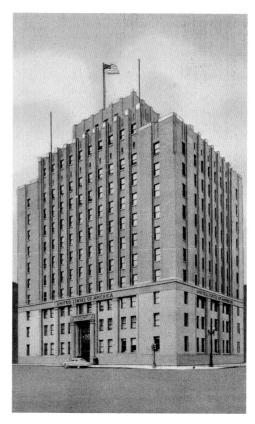

City Hall, Los Angeles, California, USA, 1928

Federal Building, Omaha, Nebraska, USA, 1933–34
(postcard: 1950)

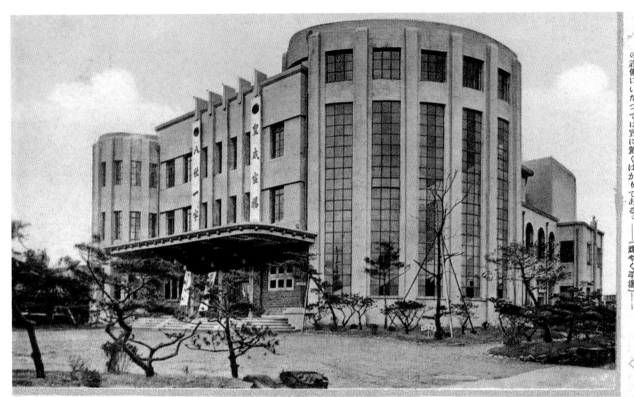

建築美冴え

IMRORTANT BUILDINGS AND NOTED
PLACES AT HEIZYO, TYOSEN.

< An 'important building', Heizyo, Tyosen (now Pyongyang, North Korea), 1935–37

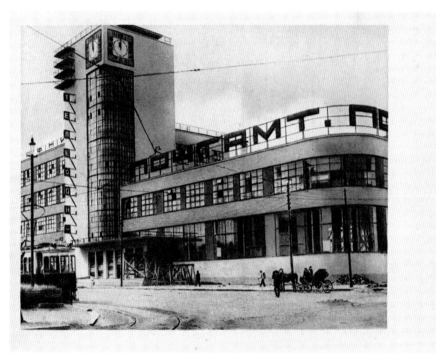

Post Office, Kharkov, Ukraine, 1928–29

45

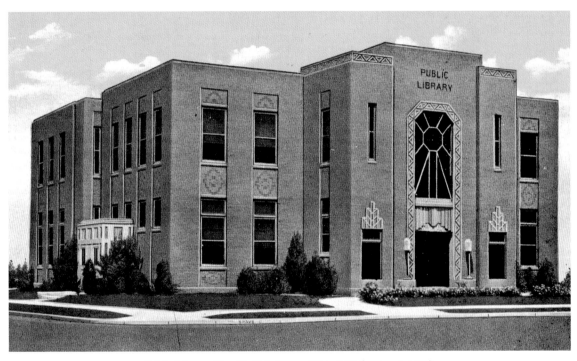

Public Library, Pine Bluff, Arkansas, USA, 1931 (postcard: 1935)

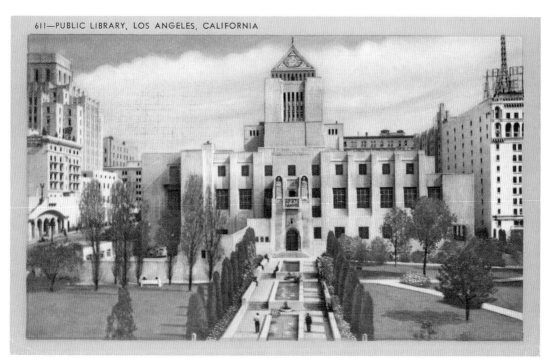

611—PUBLIC LIBRARY, LOS ANGELES, CALIFORNIA

Public Library, Los Angeles, California, USA, 1926

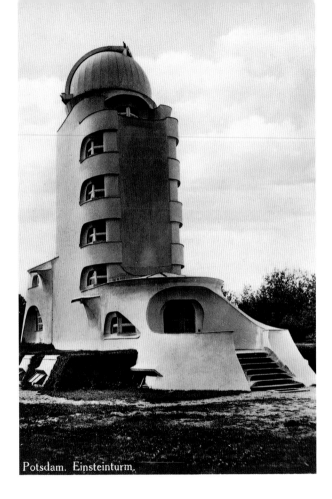

Potsdam. Einsteinturm.

< Einsteinturm, Potsdam, Germany, 1919–21

De La Warr Pavilion, Bexhill-on-Sea, England, 1935 >

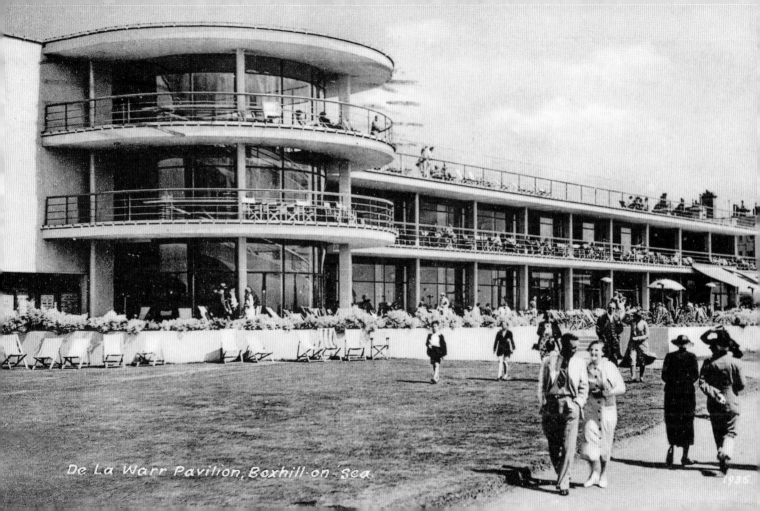

De La Warr Pavilion, Bexhill-on-Sea.

1935

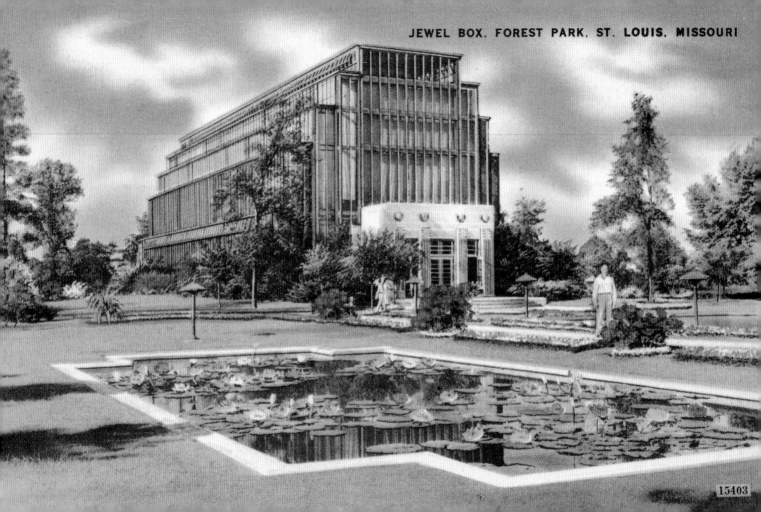

JEWEL BOX, FOREST PARK, ST. LOUIS, MISSOURI

15403

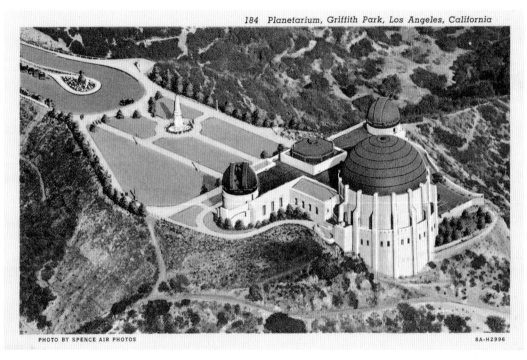

184 Planetarium, Griffith Park, Los Angeles, California

PHOTO BY SPENCE AIR PHOTOS 8A-H2996

Planetarium, Griffith Park, Los Angeles, California, USA, 1935 (postcard: 1938)

"BRICK GLASS" SCHOOL BUILDING, HIBBING, MINN.—26

PARK SCHOOL

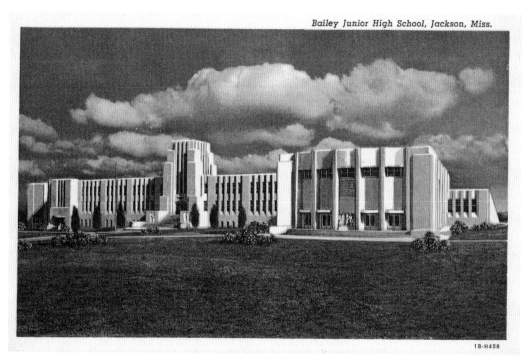

Bailey Junior High School, Jackson, Mississippi, USA, 1938 (postcard: 1941)

54

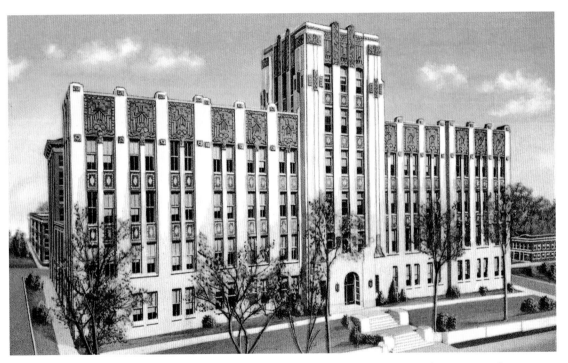

Administration Building, Creighton University, Omaha, Nebraska, USA, 1929–30 (postcard: 1937)

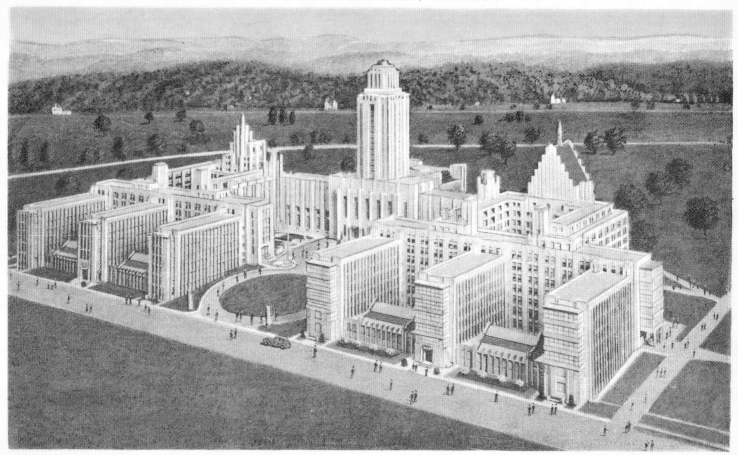

56

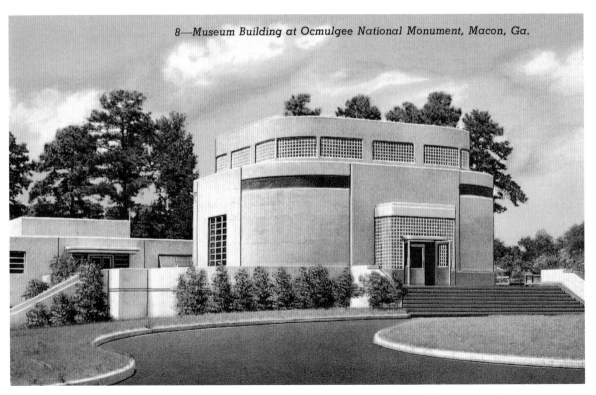

8—Museum Building at Ocmulgee National Monument, Macon, Ga.

Museum Building at Ocmulgee National Monument, Macon, Georgia, USA (postcard: 1943)

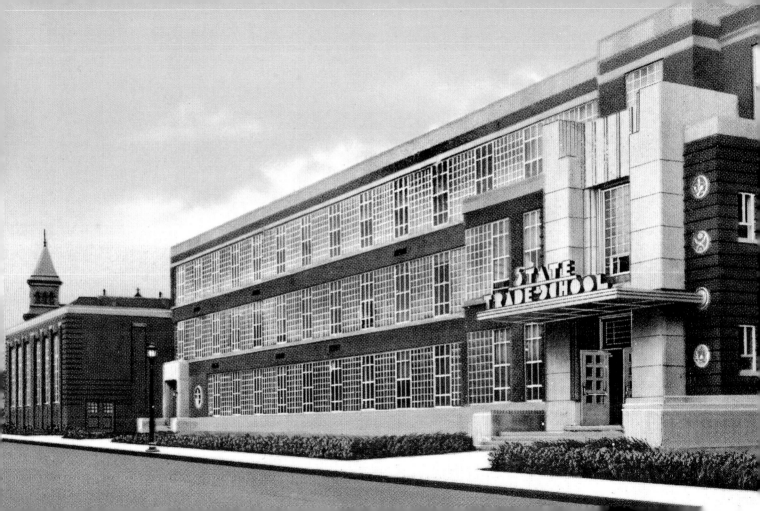

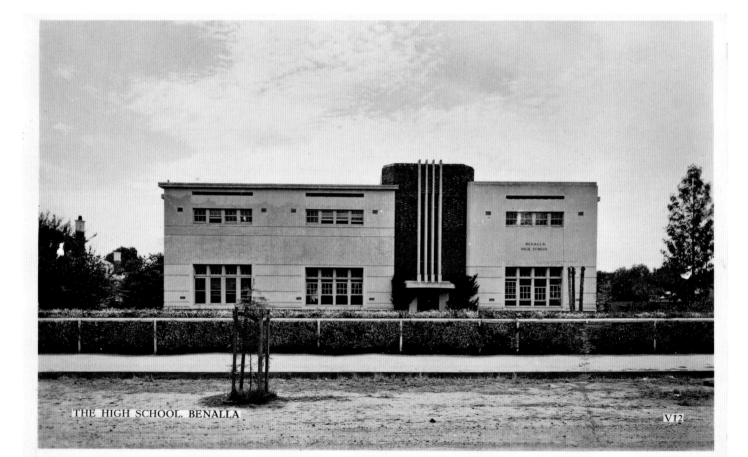

THE HIGH SCHOOL, BENALLA

V12

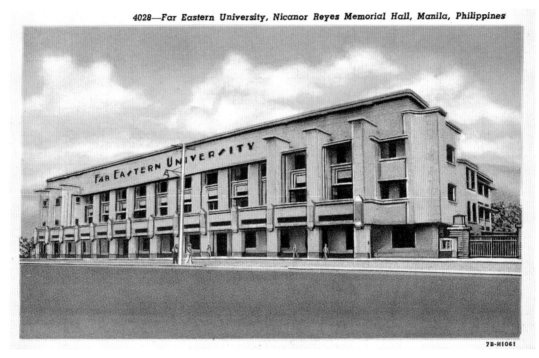

4028—Far Eastern University, Nicanor Reyes Memorial Hall, Manila, Philippines

7B-H1061

Nicanor Reyes Memorial Hall, Far Eastern University, Manila, Philippines (postcard: 1947)

60

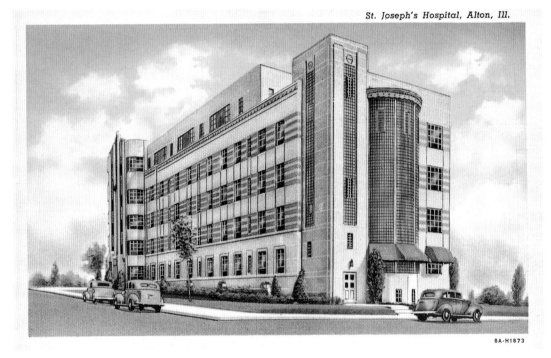

St Joseph's Hospital, Alton, Ill.

8A-H1873

St Joseph's Hospital, Alton, Illinois, USA, 1937 (postcard: 1938)

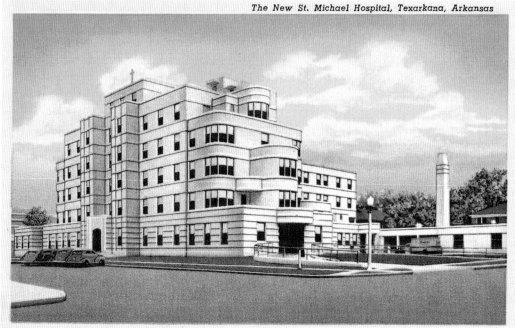

The New St. Michael Hospital, Texarkana, Arkansas

BB-H1206

New St Michael Hospital, Texarkana, Arkansas, USA (postcard: 1947)

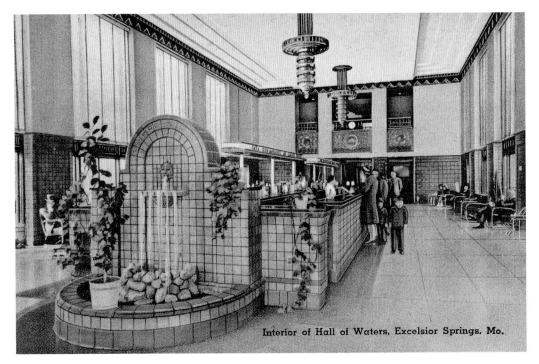

Interior of Hall of Waters, Excelsior Springs, Mo.

Hall of Waters, Excelsior Springs, Missouri, USA

Indian Sanatorium, Albuquerque, New Mexico, USA, 1934 (postcard: 1938)

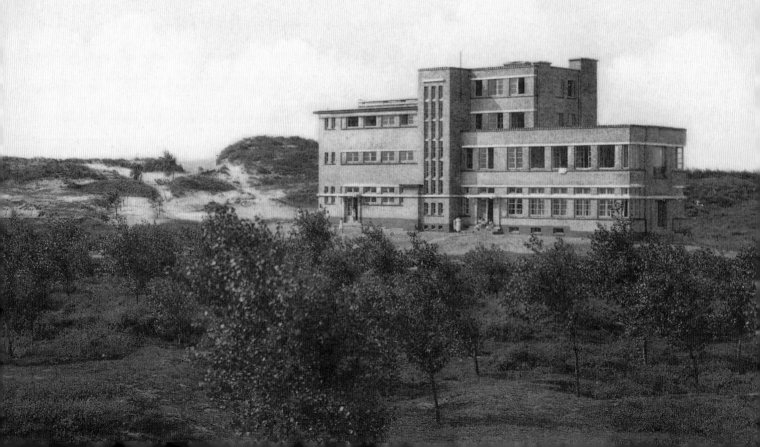

Oostduinkerke-Duinpark Home « Joie et Santé ».

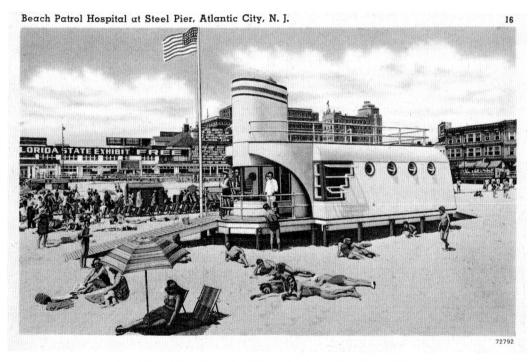

Beach Patrol Hospital at Steel Pier, Atlantic City, N. J. 16

72792

Beach Patrol Hospital at Steel Pier, Atlantic City, New Jersey, USA

< 'Joie et Santé', Oostduinkerke, Belgium, 1934

65

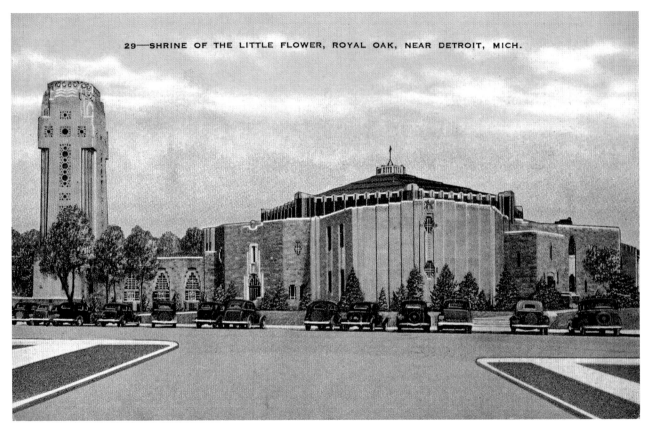

29—SHRINE OF THE LITTLE FLOWER, ROYAL OAK, NEAR DETROIT, MICH.

Shrine of the Little Flower, Royal Oak, Michigan, USA, 1931–36

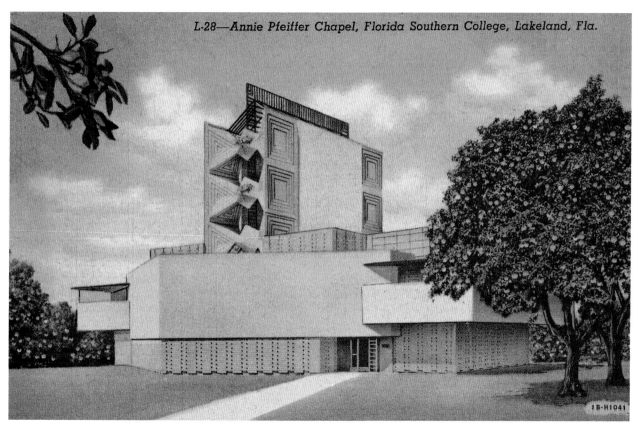

Annie Pfeiffer Chapel, Florida Southern College, Lakeland, Florida, USA, 1938–41 (postcard: 1941)

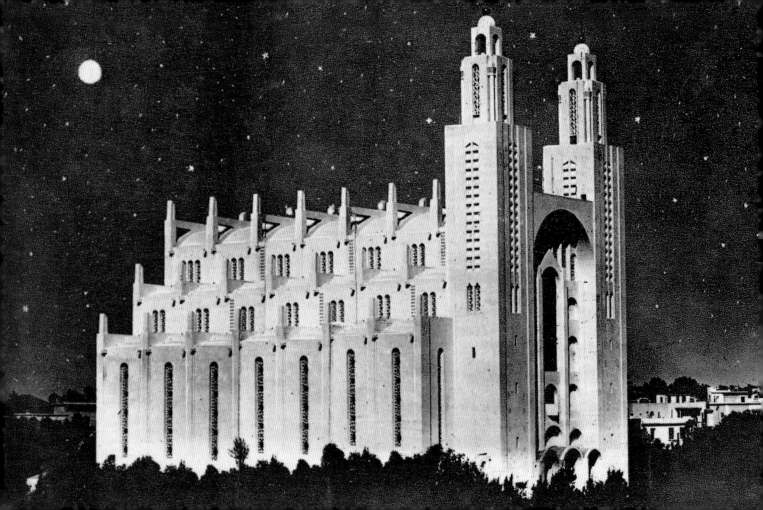

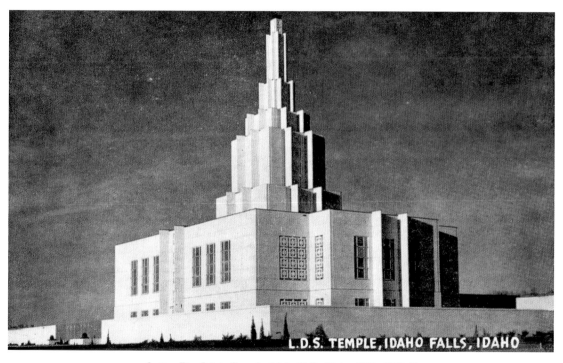

Latter-Day Saints Temple, Idaho Falls, Idaho, USA, 1940-45

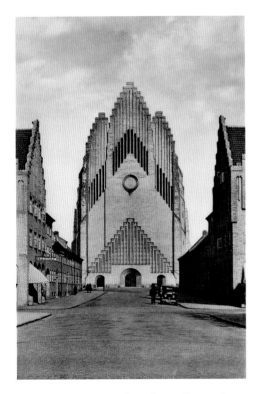

Grundtvig Church, Copenhagen, Denmark, 1920–38

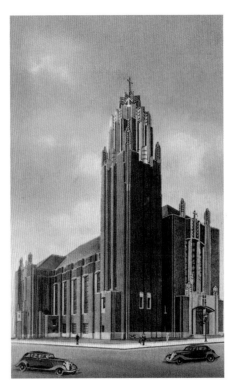

Holy Trinity Church, Bloomington, Illinois, USA, 1934 (postcard: 1934)

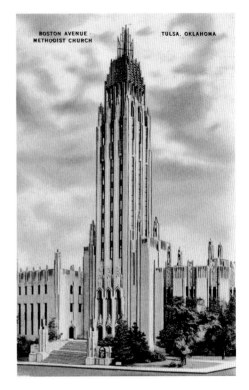

Boston Avenue Methodist Church, Tulsa, Oklahoma, USA, 1929

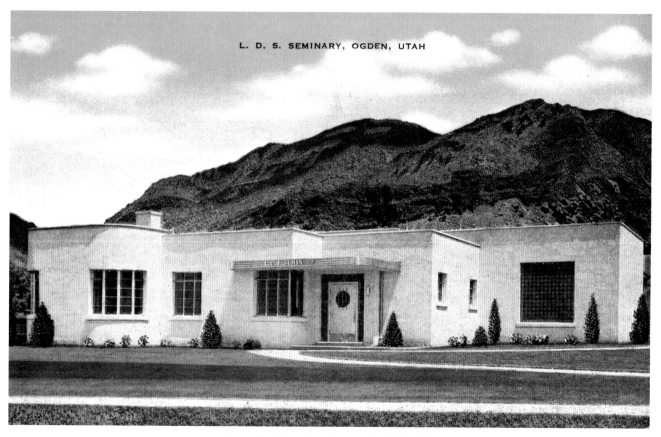

Latter-Day Saints Seminary, Ogden, Utah, USA

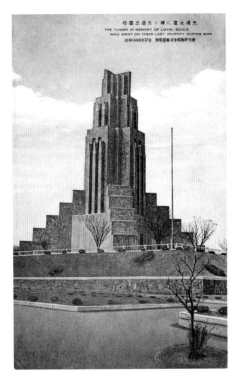

'Tower in Memory of Loyal Souls Who Went
on Their Last Journey during War',
Dairen (now Dalian), China

Monument to the Financial Independence
of the Republic, Ciudad Trujillo (now Santo
Domingo), Dominican Republic, 1930s
(postcard: 1948)

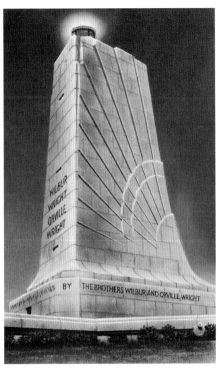

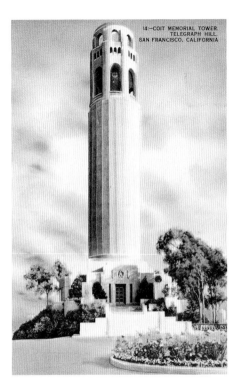

Wright Memorial, Kill Devil Hills,
North Carolina, USA, 1932

Coit Memorial Tower, Telegraph Hill,
San Francisco, California, USA, 1931

74

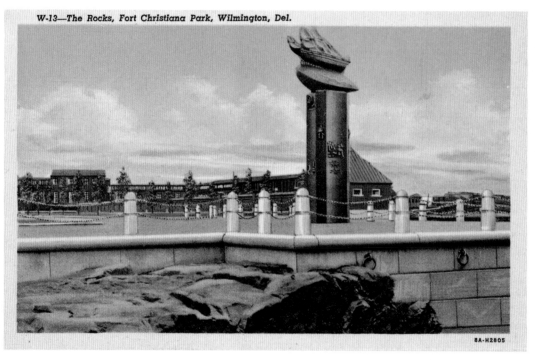

W-13—The Rocks, Fort Christiana Park, Wilmington, Del.

8A-H2805

The Rocks, Fort Christiana (Christina) Park, Wilmington, Delaware, USA, 1938 (postcard: 1943)

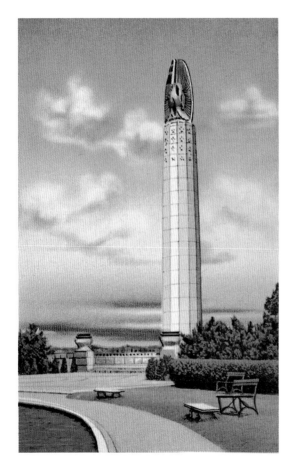

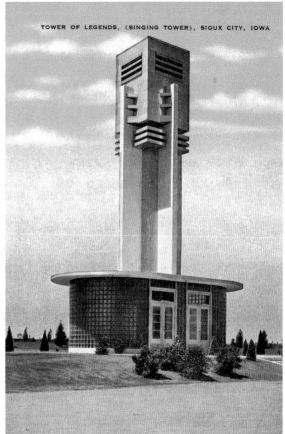

TOWER OF LEGENDS, (SINGING TOWER), SIOUX CITY, IOWA

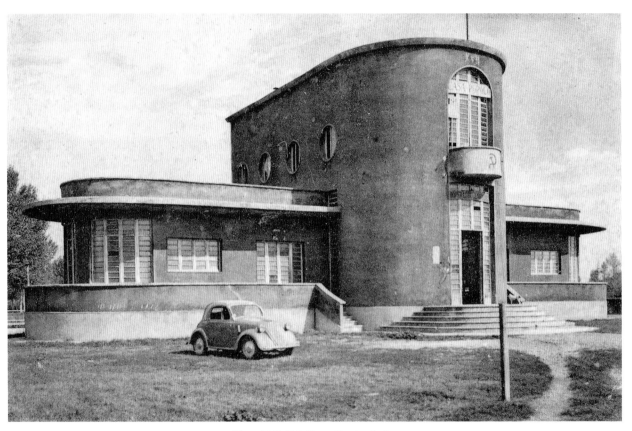

Town Hall, Zelo Buon Persico, Italy

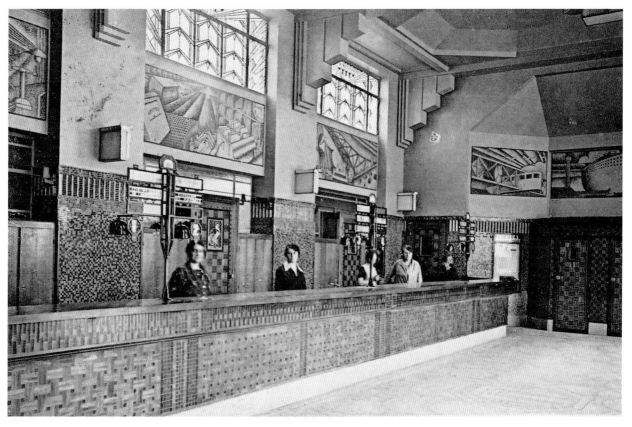

Post Office, Bar-le-Duc, France, 1925

HOTEL
ST. GEORGE
CLARK STREET
BROOKLYN, N.Y.

PLACES TO STAY OR LIVE

Hotels, motels, resorts, apartment buildings and private houses are among the settings depicted on these cards, ranging from some of the world's grandest hotels to a humble little 'tourist court' in the American South, and from an elegant 30-storey high-rise apartment building in Buenos Aires to a single-storey 'Beautiful Residence' in Dyersburg, Tennessee.

Hotels dominate this category. Miami confections occupy the largest subset within this group, but there are also astonishing Streamline Moderne hotels in the American Midwest, Canada and South America, as well as large-scale urban hotels such as the Park in Shanghai and the Beresford in Glasgow with superb Art Deco detailing. Some of the hotels in smaller towns are long gone or renovated beyond recognition, but others – the Midland in Morecambe, England, for instance – still stand and have retained or regained their character.

No-nonsense cheap-and-cheerful tourist courts, auto courts and motels sprouted up in the US in the 1930s and '40s along the country's ever-growing highway system. These humble overnight stops, great (and mostly long gone) examples of American roadside architecture, are among the most delightful places to stay that are depicted on linens.

Unfortunately, very few Art Deco residences seem to have been reproduced on postcards, though there are occasional unidentified generic 'modernistic dwellings', as well as some grand homes, including one at Bandung on the island of Java (p. 5). High-rise, or skyscraping, apartment buildings are also rarely seen on cards, although Manhattan has some remarkable Art Deco multistorey residences, notably three twin-towered apartment complexes on Central Park West of 1929–31, of which I haven't given up hope of finding cards some day!

79

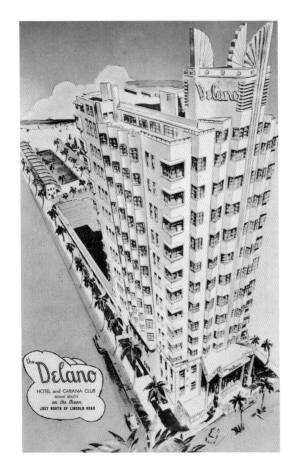

the **Delano**
HOTEL and CABANA CLUB
MIAMI BEACH
on the Ocean
JUST NORTH OF LINCOLN ROAD

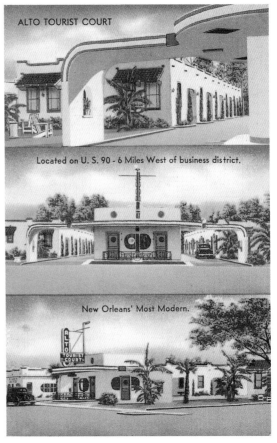

ALTO TOURIST COURT

Located on U. S. 90 - 6 Miles West of business district.

New Orleans' Most Modern.

<< Delano Hotel, Miami Beach, Florida, USA, 1947

< Alto Tourist Court, New Orleans, Louisiana, USA

CORAL COURT
Ultra-Modern
One of the finest
in the Mid-West
on U. S. Highway 66
City Route, one mile
west of City Limits,
three miles east of
intersection of By Pass,
Highways #61, 66, 67
and 77

70 rooms, tile cottages
with private tile bath
in each room.
Hot and cold water
porter and maid service
—Beauty Rest Spring
and mattresses—
Hot Water Radiant
Heat—24 Hour Service
7755 Watson Road
(Highway 66)
St. Louis 19, Mo.

WOODLAND 2-5786

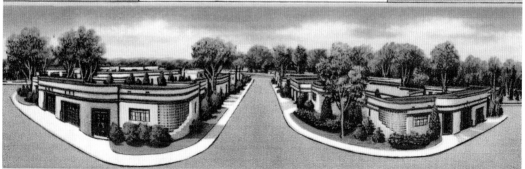

Coral Court, St Louis, Missouri, USA, 1941–48

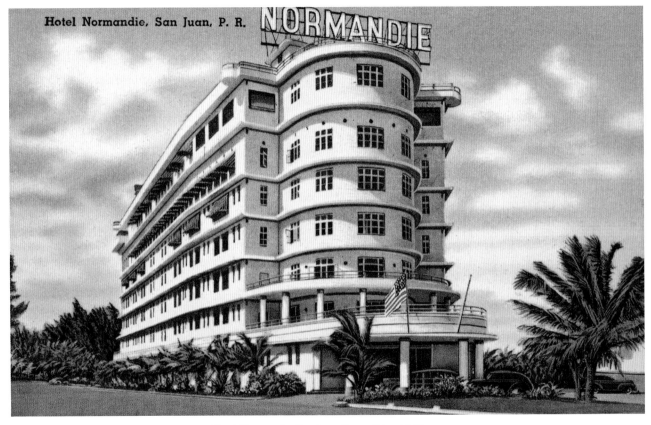

82

Hotel Normandie, San Juan, Puerto Rico, 1942

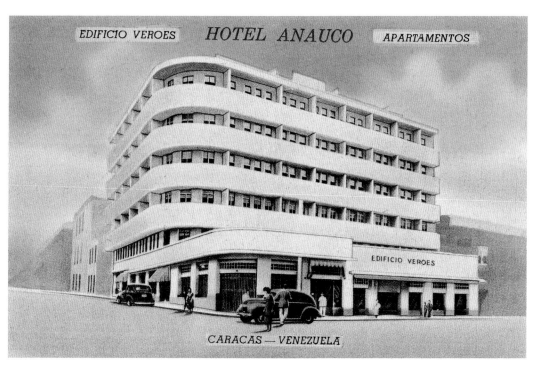

EDIFICIO VEROES HOTEL ANAUCO APARTAMENTOS

EDIFICIO VEROES

CARACAS — VENEZUELA

Veroes Building Apartments, Hotel Anauco, Caracas, Venezuela

83

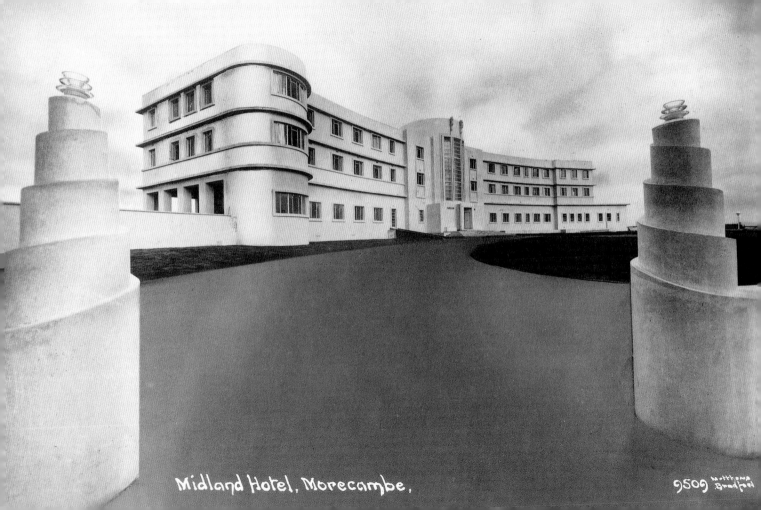

Midland Hotel, Morecambe,

9509

WREST POINT HOTEL, HOBART, TAS Terry Turle Photo No. 23

Wrest Point Hotel, Hobart, Tasmania, Australia

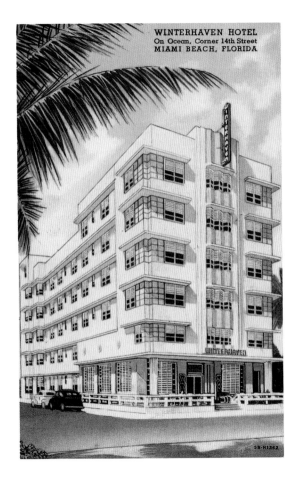

WINTERHAVEN HOTEL
On Ocean, Corner 14th Street
MIAMI BEACH, FLORIDA

SB-H1262

< Winterhaven Hotel, Miami Beach, Florida, USA, 1939
(postcard: 1945)

Hotel New Yorker, Miami Beach, Florida, USA, 1939 >
The Raleigh, Miami Beach, Florida, USA, 1940 >>

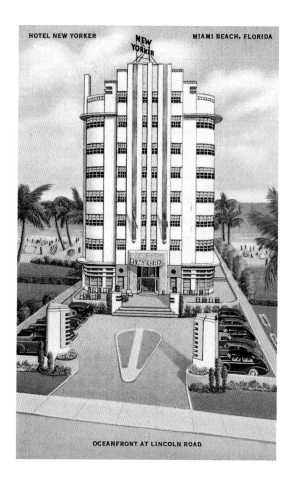

HOTEL NEW YORKER

NEW YORKER

MIAMI BEACH, FLORIDA

OCEANFRONT AT LINCOLN ROAD

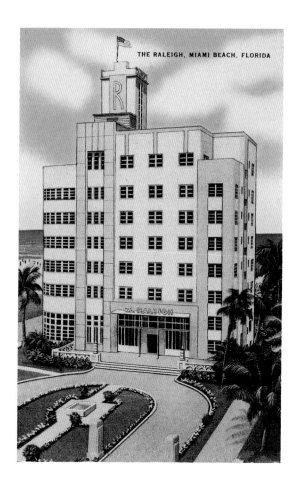

THE RALEIGH, MIAMI BEACH, FLORIDA

The RALEIGH

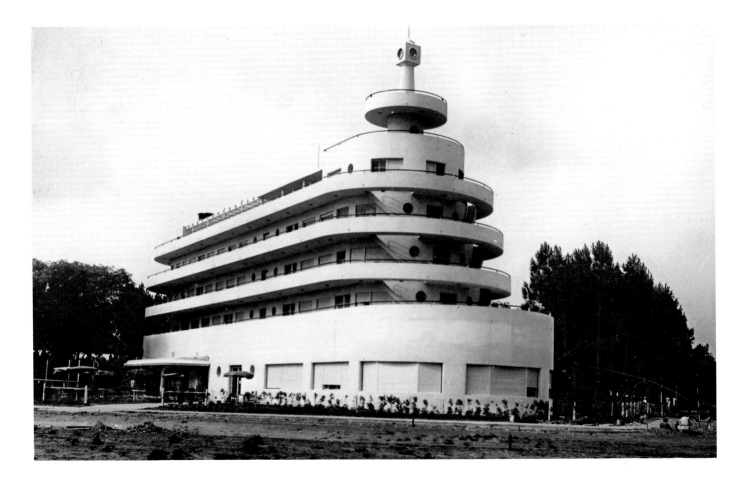

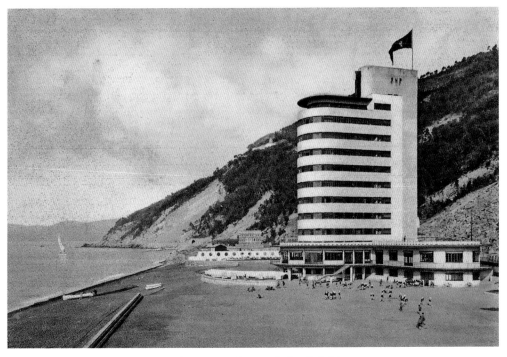

Colonia Fara, Chiavari, Italy, 1935–36

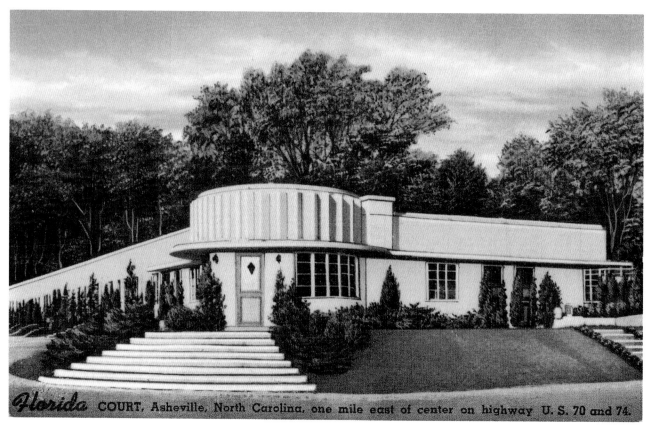

Florida Court, Asheville, North Carolina, USA

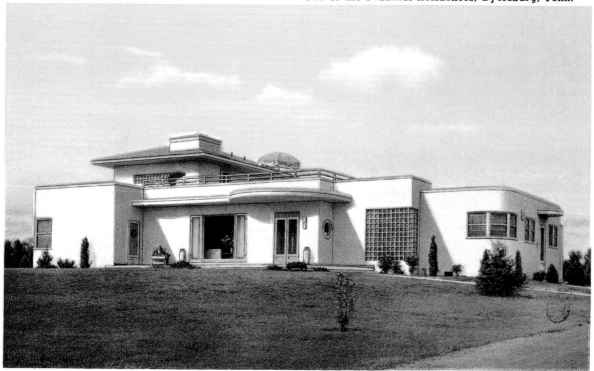

2B208-N

'One of the Beautiful Residences', Dyersburg, Tennessee, USA (postcard: 1942)

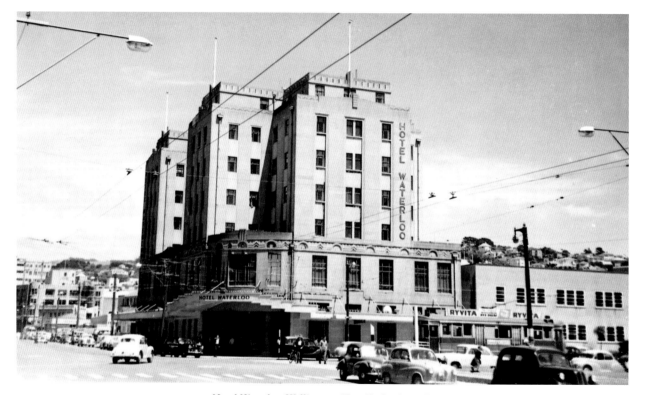

Hotel Waterloo, Wellington, New Zealand, 1937

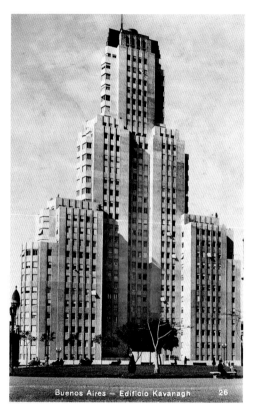

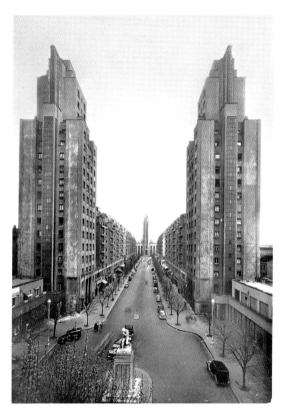

Kavanagh Building, Buenos Aires, Argentina, 1934–36

Apartment Buildings, Villeurbanne, France, 1927–34

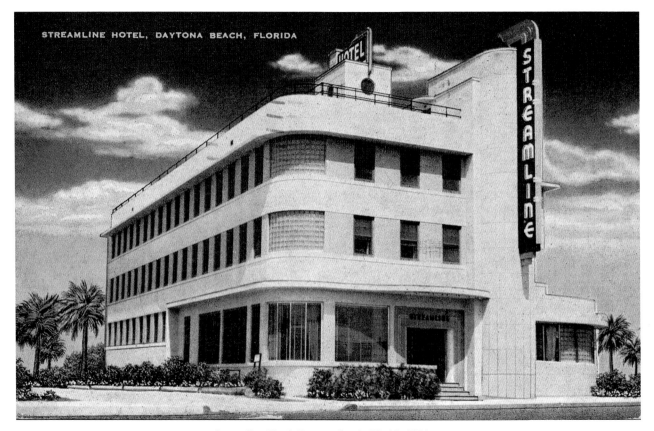

Streamline Hotel, Daytona Beach, Florida, USA

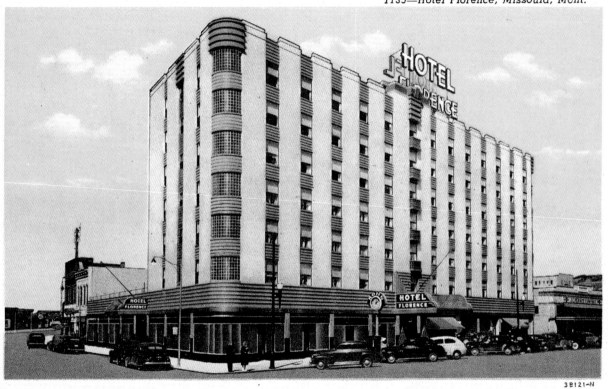

3B121-N

Hotel Florence, Missoula, Montana, USA, 1941

96

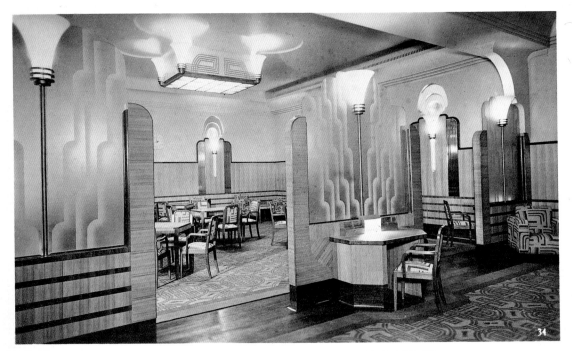

S.19787. THE PARLOUR, CUMBERLAND HOTEL, MARBLE ARCH, LONDON, W.1.

The Parlour, Cumberland Hotel, London, England, 1933

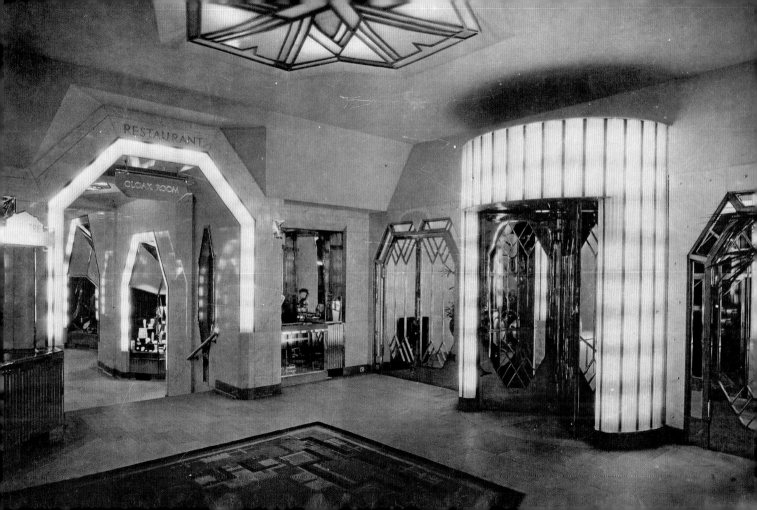

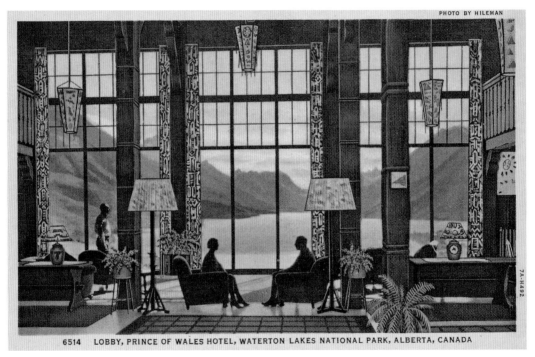

Lobby, Prince of Wales Hotel, Waterton Lakes National Park, Alberta, Canada, 1926–27 (postcard: 1937)

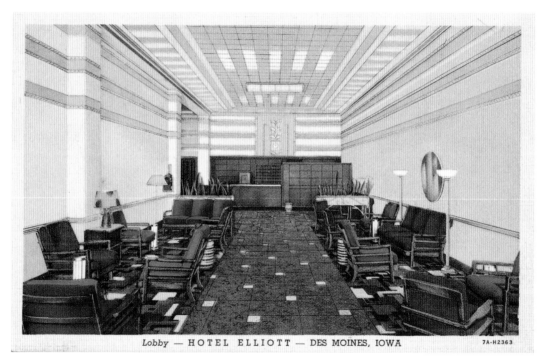

Lobby — HOTEL ELLIOTT — DES MOINES, IOWA

7A-H2363

Lobby, Hotel Elliott, Des Moines, Iowa, USA (postcard: 1937)

100

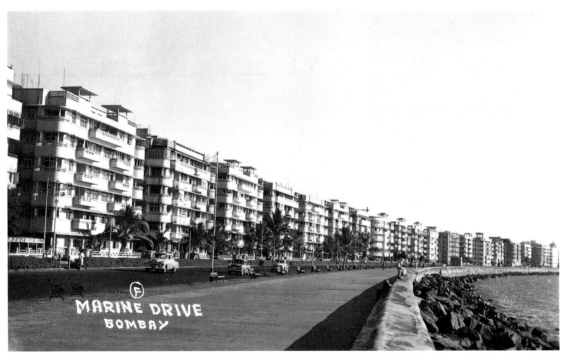

Marine Drive, Bombay (now Mumbai), India

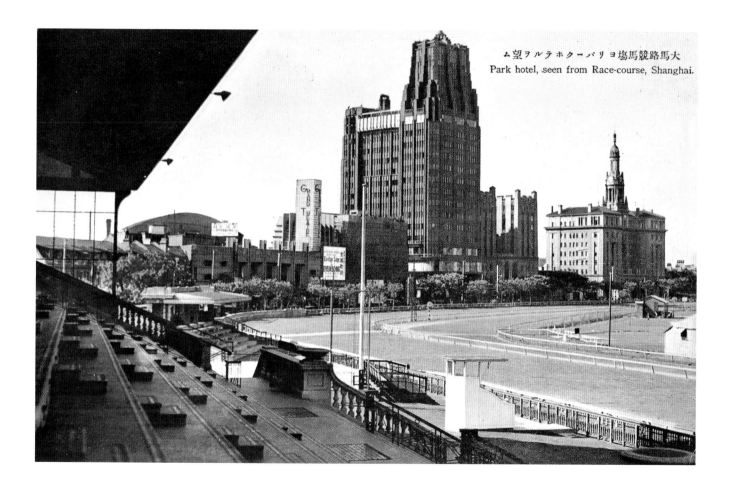

大馬路競馬場ヨリパークーホテルヲ望ム

Park hotel, seen from Race-course, Shanghai.

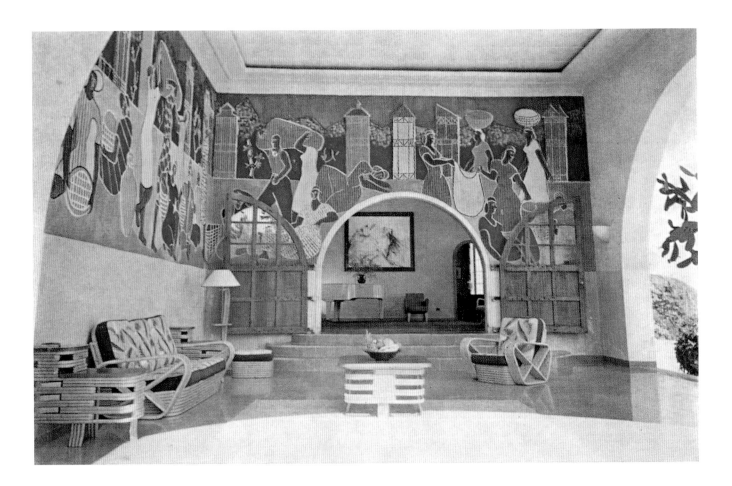

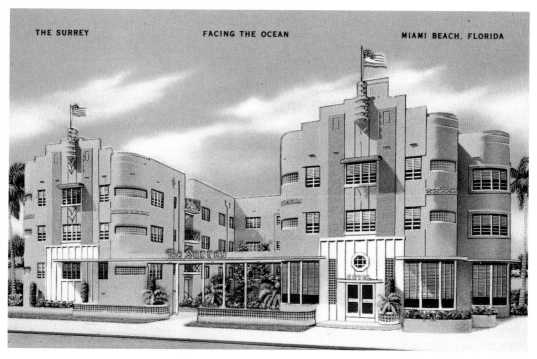

The Surrey, Miami Beach, Florida, USA

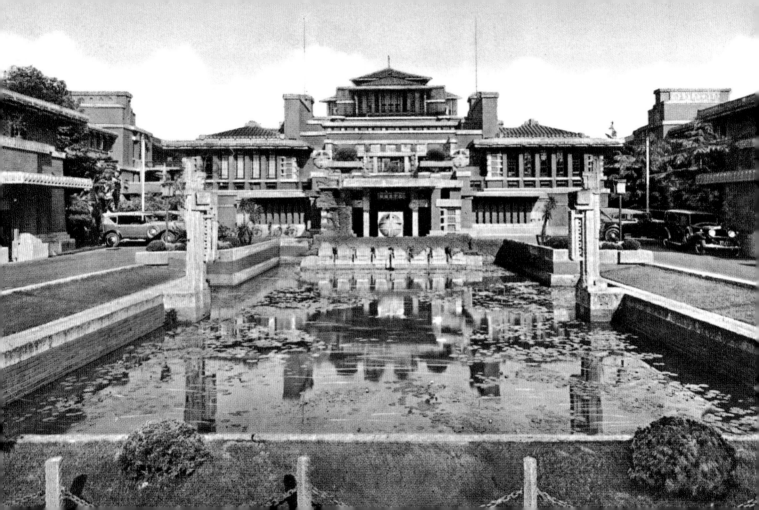

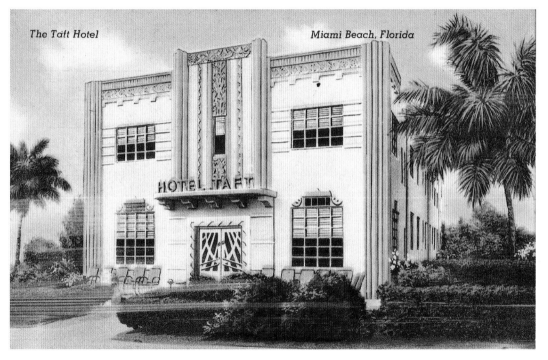

Taft Hotel, Miami Beach, Florida, USA, 1936

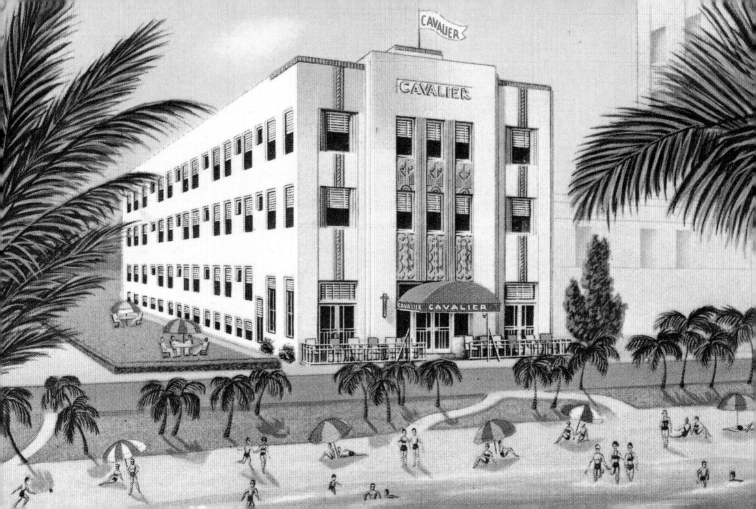

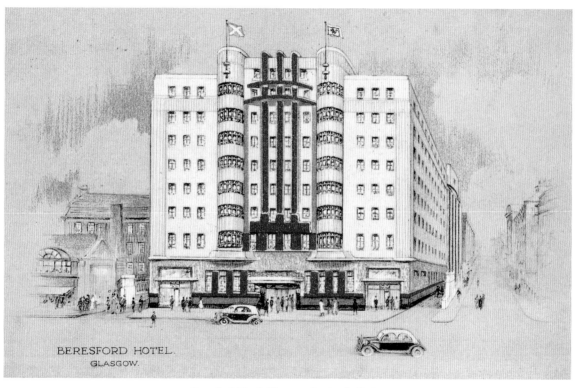

BERESFORD HOTEL.
GLASGOW.

Beresford Hotel, Glasgow, Scotland, 1938

Smart Places to Meet and Eat

67 EAST STATE ST. — 38 WEST BROAD ST. — 8 SIXTEENTH AVE.

7A-H3029

PLACES TO EAT AND DRINK

Roadside cafés, diners, restaurants, cocktail bars and big-city nightclubs alike were depicted on Art Deco postcards – especially on American linens. These were sold largely at the venues, and patrons were often encouraged to write out their cards on the spot (some establishments even offered to stamp and post the cards for the customer). The most striking and varied of these cards are those showing the glamorous and glitzy, or sleek and sophisticated, interiors of cocktails bars and lounges, be they in Midwestern locales – the state of Wisconsin seems to have had a remarkable concentration of great Deco drinks spots (at least, they produced lots of postcards of them) – or big-city hotels such as the Strand Palace in London. But just such as Tops in Taps in Rockford, Illinois, and the White Drum along western Massachusetts's Mohawk Trail.

Many Art Deco bars and eateries displayed features that are touchstones of the style: nautical porthole windows; walls or partitions of glass bricks or blocks; façades gleaming with panels of black or coloured Vitro-lite; wood or metal-sheathed bars with curving corners; neon and other signs with distinctive sans-serif Deco lettering; and ultra-modern lighting fixtures. Decorative elements include zigzag and other geometric patterns; stylish bob-cut flappers or sleek greyhounds or graceful gazelles etched in glass or painted on walls; and stylized blossoms edging mirrors or adorning carpets.

The golden age of US diners, the distinctive eatery that took its inspiration from train cars, was in the 1930s and post-war 1940s, and arguably the most collectable type of Art Deco-era postcard is the one showing these streamlined structures that often gleamed inside and out with stainless steel and chrome, and at night beckoned with signs and decorations illuminated in neon.

Sadly, so many of the establishments seen on the following pages are long gone, but the splendid advertising postcards give places such as the Bon Ton in Keene, New Hampshire, a life beyond their days of existence.

109

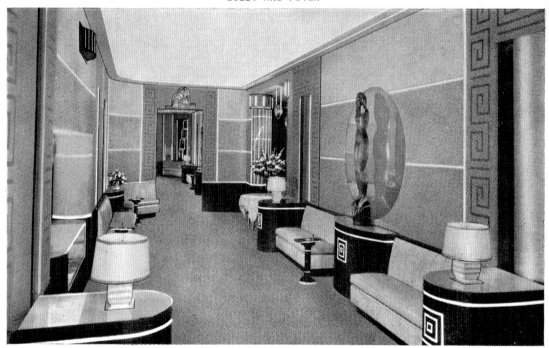

CHEZ PAREE, 610 FAIRBANKS COURT, CHICAGO, ILL.

Lobby and Foyer, Chez Paree Theater Restaurant, Chicago, Illinois, USA, probably 1930s

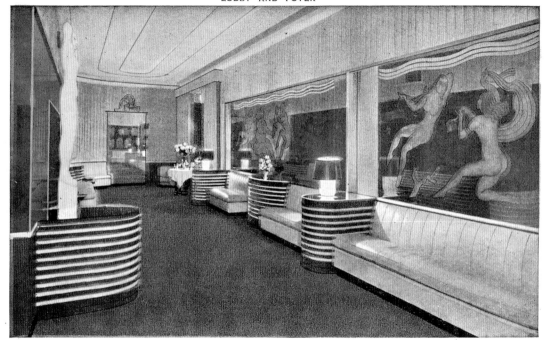

CHEZ PAREE, 610 FAIRBANKS COURT, CHICAGO, ILL.

Lobby and Foyer, Chez Paree Theater Restaurant, Chicago, Illinois, USA, probably 1940s

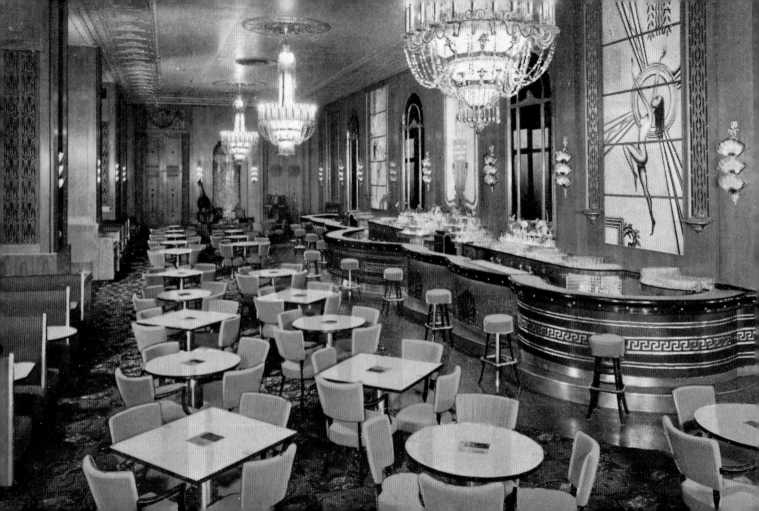

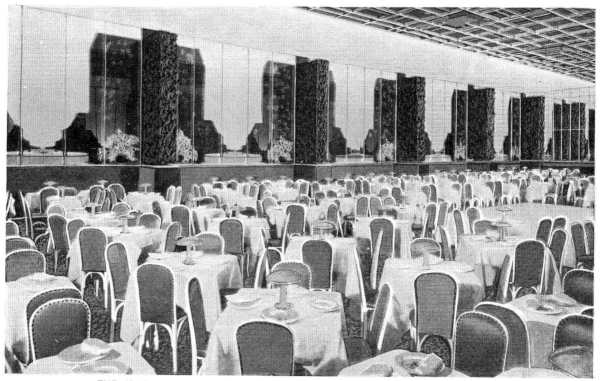

THE JOSEPH URBAN ROOM, CONGRESS HOTEL AND ANNEX, CHICAGO, ILL.

Joseph Urban Room, Congress Hotel and Annex, Chicago, Illinois, USA

< Cocktail Lounge, Hotel Schroeder, Milwaukee, Wisconsin, USA, 1928

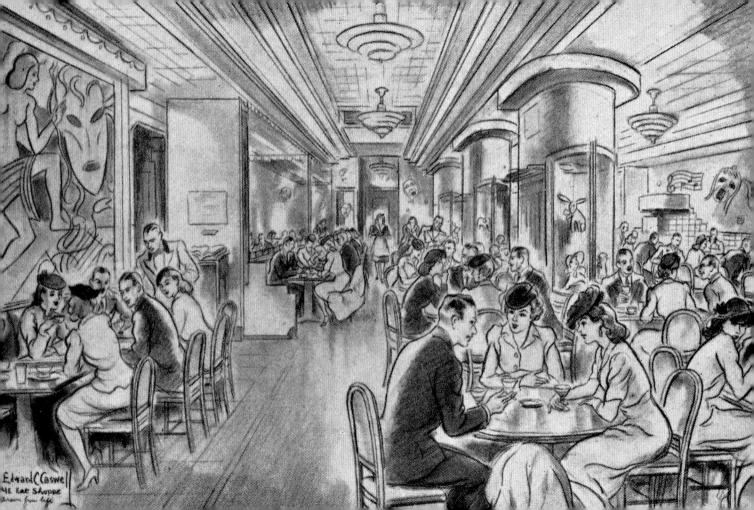

Edward C Caswell
4E Eat Shoppe
drawn from life

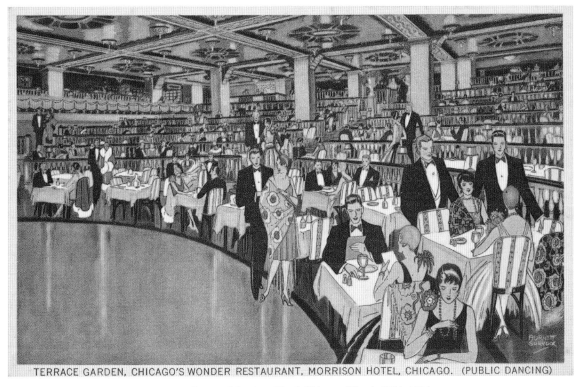

TERRACE GARDEN, CHICAGO'S WONDER RESTAURANT, MORRISON HOTEL, CHICAGO. (PUBLIC DANCING)

Terrace Garden, Morrison Hotel, Chicago, Illinois, USA, 1925

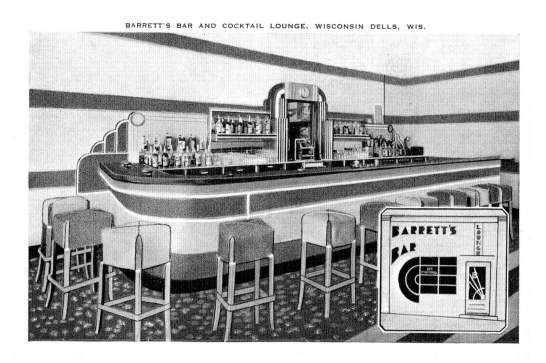

BARRETT'S BAR AND COCKTAIL LOUNGE, WISCONSIN DELLS, WIS.

Barrett's Bar and Cocktail Lounge, Wisconsin Dells, Wisconsin, USA

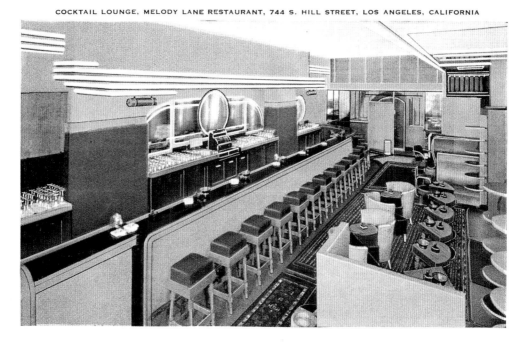

COCKTAIL LOUNGE, MELODY LANE RESTAURANT, 744 S. HILL STREET, LOS ANGELES, CALIFORNIA

Cocktail Lounge, Melody Lane Restaurant, Los Angeles, California, USA

117

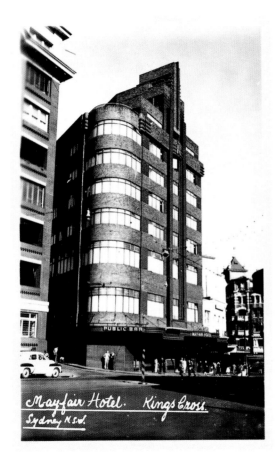

< Mayfair Hotel, Kings Cross, Sydney, Australia, 1937

Court Café, Albuquerque, New Mexico, USA >
Kents Restaurant, Atlantic City, New Jersey, USA, 1927 > >

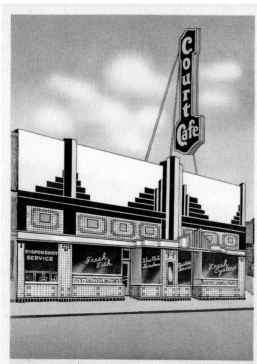

COURT CAFE

On Highways 66 and 85 in the heart of
ALBUQUERQUE, NEW MEXICO

Known from Coast to Coast -- 24 Hour Service

"TOURISTS COME AS YOU ARE"

SA-H610

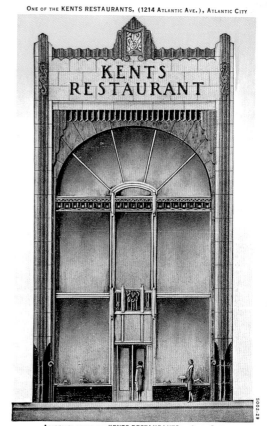

ADDRESSES OF ALL THE KENTS RESTAURANTS ON OTHER SIDE

5002-29

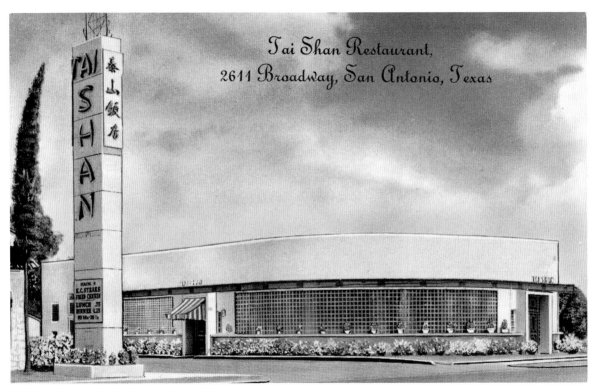

Tai Shan Restaurant, San Antonio, Texas, USA

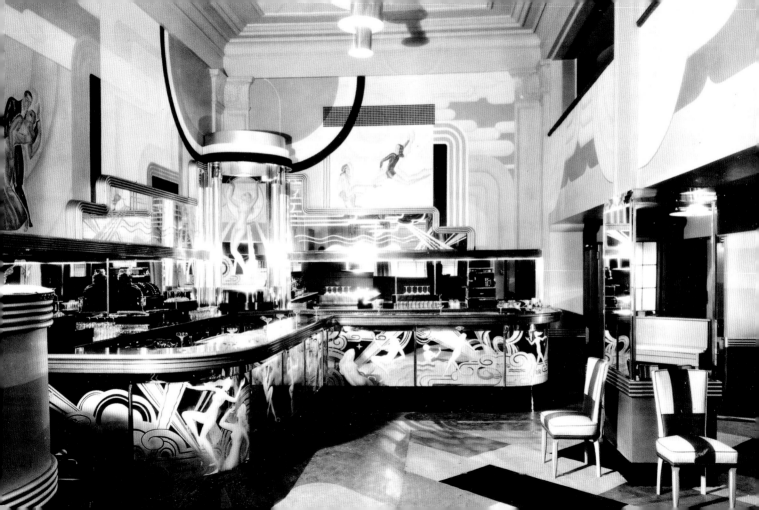

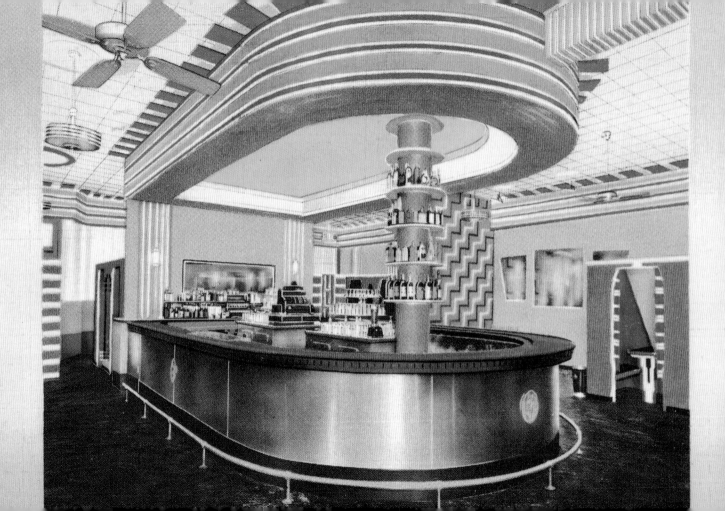

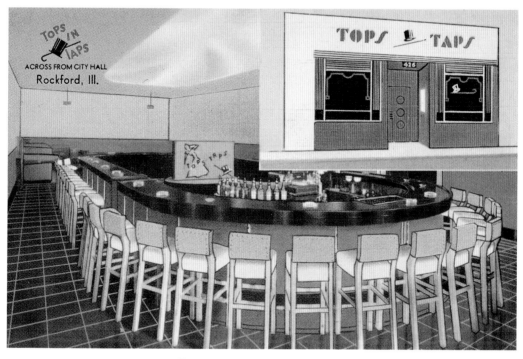

Tops in Taps, Rockford, Illinois, USA

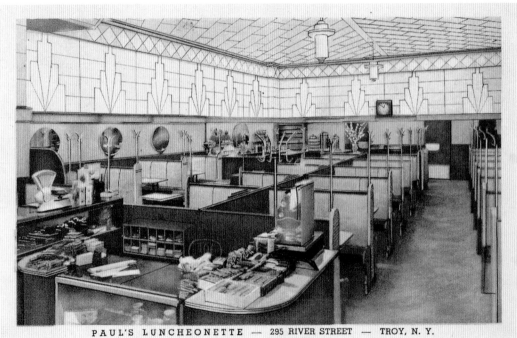

PAUL'S LUNCHEONETTE — 295 RIVER STREET — TROY, N. Y.

Paul's Luncheonette, Troy, New York, USA (postcard: 1944)

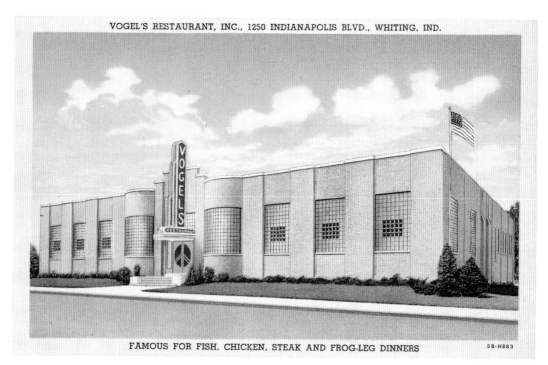

VOGEL'S RESTAURANT, INC., 1250 INDIANAPOLIS BLVD., WHITING, IND.

FAMOUS FOR FISH, CHICKEN, STEAK AND FROG-LEG DINNERS

5B-H883

Vogel's Restaurant, Whiting, Indiana, USA (postcard: 1945)

126

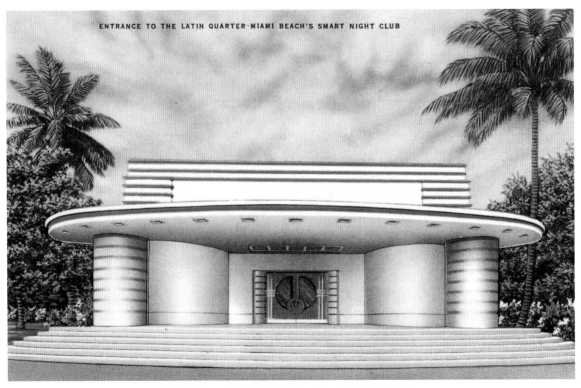

ENTRANCE TO THE LATIN QUARTER–MIAMI BEACH'S SMART NIGHT CLUB

Latin Quarter Night Club, Miami Beach, Florida, USA

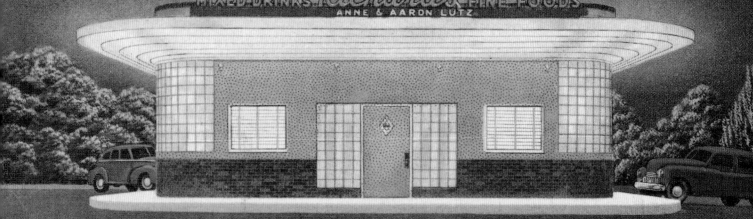

MIXED DRINKS *Richard's* FINE FOODS
ANNE & AARON LUTZ

Richard's
DRIVE IN
FINE FOOD AND
MIXED DRINKS

Anne & Aaron Lutz

2615 SO. BROADWAY — DENVER, COLO.

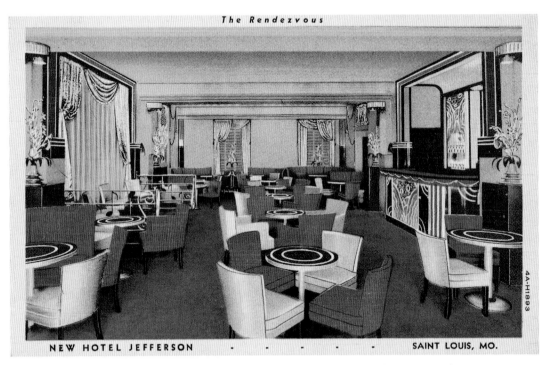

The Rendezvous

NEW HOTEL JEFFERSON · · · · · SAINT LOUIS, MO.

The Rendezvous, New Hotel Jefferson, St Louis, Missouri, USA (postcard: 1934)

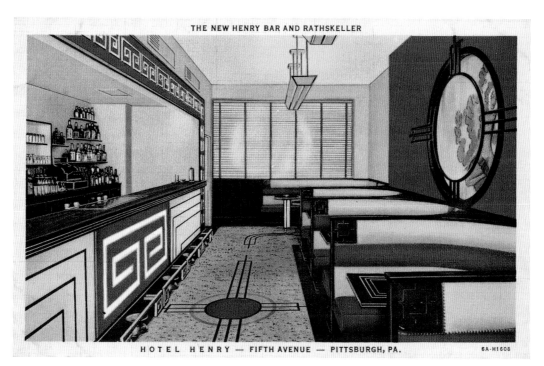

THE NEW HENRY BAR AND RATHSKELLER

HOTEL HENRY — FIFTH AVENUE — PITTSBURGH, PA.

6A-H1608

New Henry Bar and Rathskeller, Hotel Henry, Pittsburgh, Pennsylvania, USA (postcard: 1936)

130

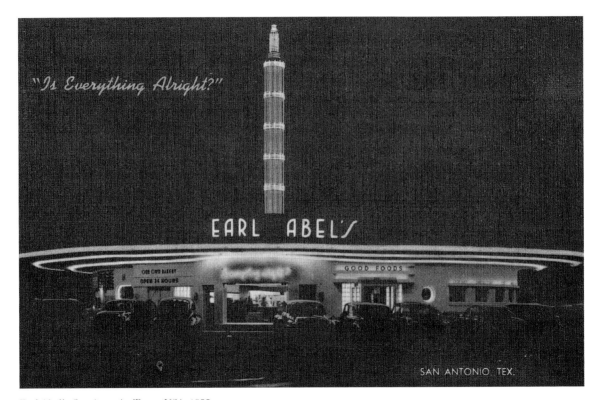

Earl Abel's, San Antonio, Texas, USA, 1933

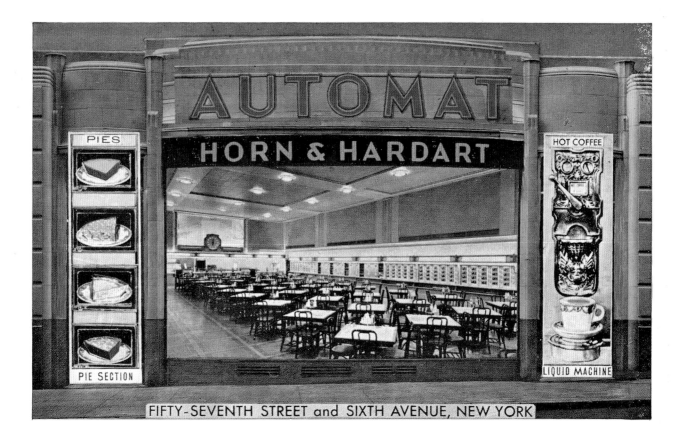

PIES

PIE SECTION

AUTOMAT
HORN & HARDART

HOT COFFEE

LIQUID MACHINE

FIFTY-SEVENTH STREET and SIXTH AVENUE, NEW YORK

132

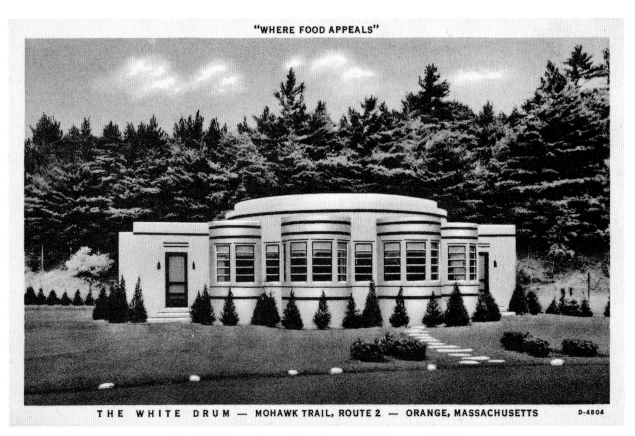

The White Drum, Orange, Massachusetts, USA (postcard: 1937)

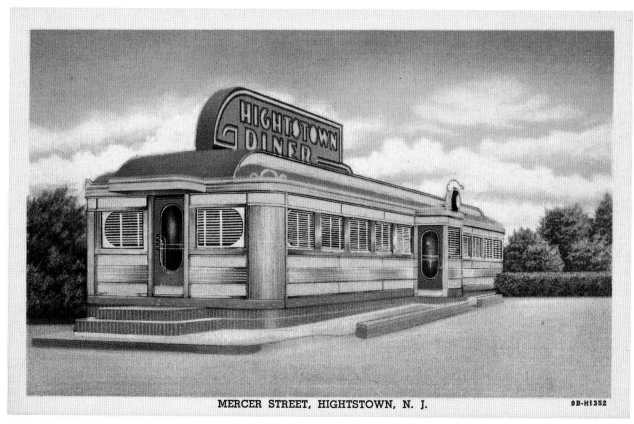

MERCER STREET, HIGHTSTOWN, N. J.

9B-H1352

Hightstown Diner, Hightstown, New Jersey, USA (postcard: 1949)

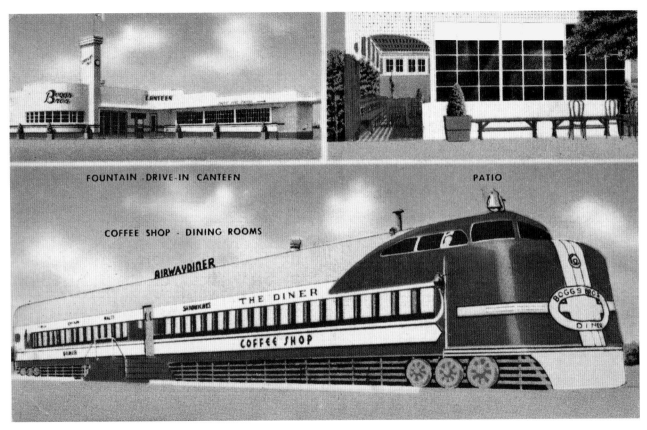

Airway Diner, San Diego, California, USA, 1935 and 1942

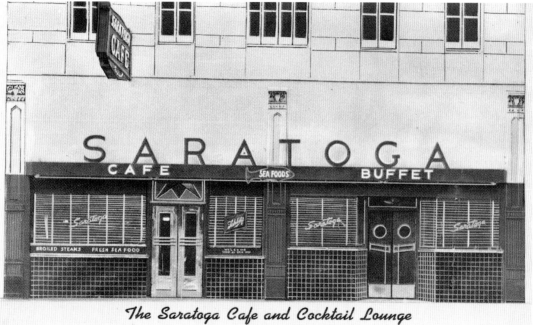

Saratoga Café and Cocktail Lounge, Phoenix, Arizona, USA, 1925

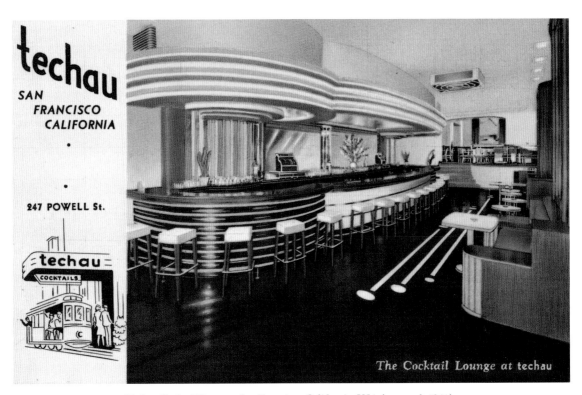

Techau Cocktail Lounge, San Francisco, California, USA (postcard: 1941)

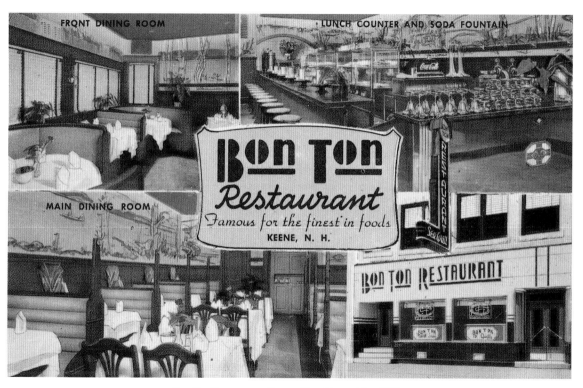

FRONT DINING ROOM

LUNCH COUNTER AND SODA FOUNTAIN

Bon Ton
Restaurant
Famous for the finest in foods
KEENE, N. H.

MAIN DINING ROOM

BON TON RESTAURANT

Bon Ton Restaurant, Keene, New Hampshire, USA

Lauer Sisters' Restaurant, Chicago, Illinois, USA (postcard: 1934)

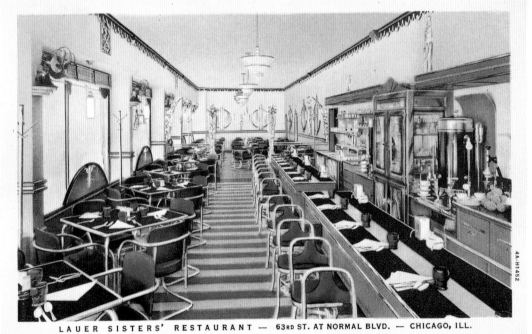

LAUER SISTERS' RESTAURANT — 63RD ST. AT NORMAL BLVD. — CHICAGO, ILL.

Cocktail Lounge, Grand Hotel, Mackinac Island, Michigan, USA (postcard: 1935) >

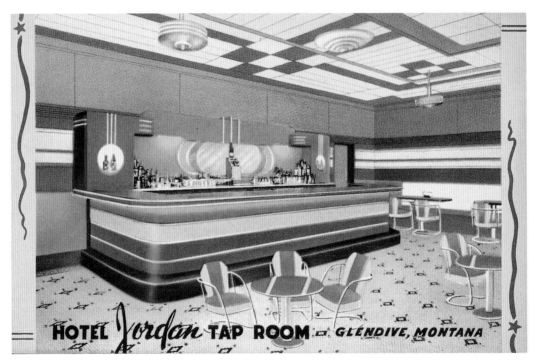

Hotel Jordan Tap Room, Glendive, Montana, USA (postcard: 1940)

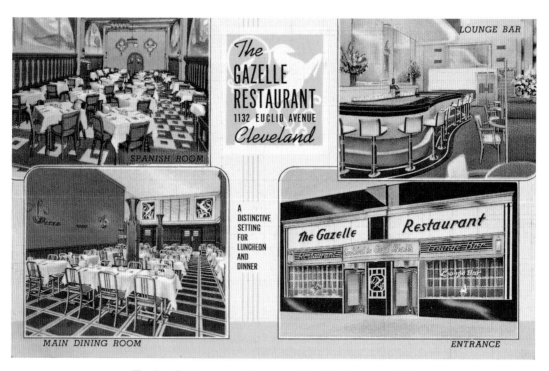

The Gazelle Restaurant, Cleveland, Ohio, USA (postcard: 1940)

Cocktail Lounge and Bar, Hotel Jermyn, Scranton, Pennsylvania, USA (postcard: 1935)

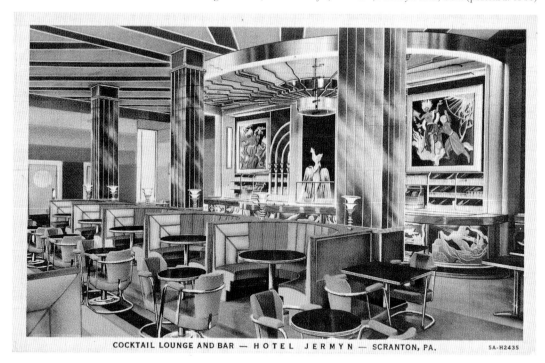

COCKTAIL LOUNGE AND BAR — H O T E L J E R M Y N — SCRANTON, PA.

5A-H2435

143

< Hoe Sai Gai Modern Room, Chicago, Illinois, USA, 1937 (postcard: 1939)

PLACES OF ENTERTAINMENT

Going to the pictures was one of the most popular and affordable pastimes in the period, and the cinema was a structure much given to styling and decoration in the latest mode the world over. The shapes and façades of concert halls, auditoriums and other live-performance venues were usually less decorative than those of cinemas, but their interiors could be just as grand. At many of these venues murals stretched over huge sections of walls or ceilings; elaborate modernistic lighting – wall sconces, chandeliers, even floor lights along seat bottoms – was much in use; and fabrics of all kinds, on floors, upholstery, curtains or scrims, featured boldly hued and conventionalized floral, geometric, animal or classical designs. Silver- and gold-leaf designs, as well as Monel metal, chrome and stainless-steel elements gleamed both inside and out.

Dancing was a popular activity in the Art Deco era. Competitive ballroom dancing started in the 1920s, soon after social dances such as the foxtrot and tango were introduced, and there was a proliferation of dance halls and ballrooms featuring live music for partner dancing or the less formal, more exuberant Charleston and types of swing.

Other leisure activities and sports took place in buildings decorated in the Art Deco style, including bowling alleys, kennel clubs, dog-racing stadiums, poolside and waterfront changing facilities, and country clubs and rural resorts.

In a more serious vein were social clubs where civic-minded individuals, war veterans and members of societies such as the Moose, Eagles and Masons, political associations, and unions and other workers' groups could get together, united in their beliefs, causes or backgrounds. These might include restaurants and bars, and could be for at least part of the time open-to-the-public venues offering live theatre, films and other entertainment.

145

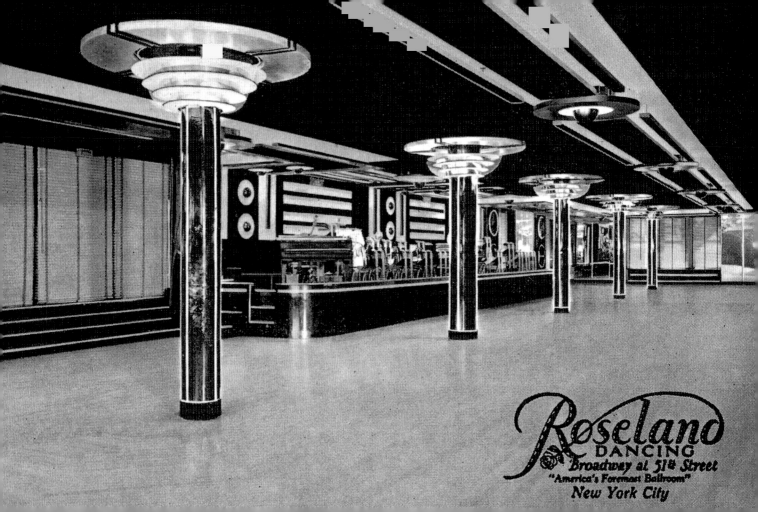

Roseland DANCING
Broadway at 51st Street
"America's Foremost Ballroom"
New York City

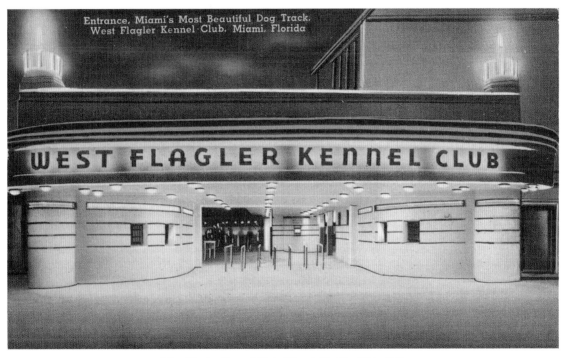

West Flagler Kennel Club, Miami, Florida, USA, 1930

148

City Auditorium, Superior, Nebr.

7B303-N

City Auditorium, Superior, Nebraska, USA, 1936 (postcard: 1947)

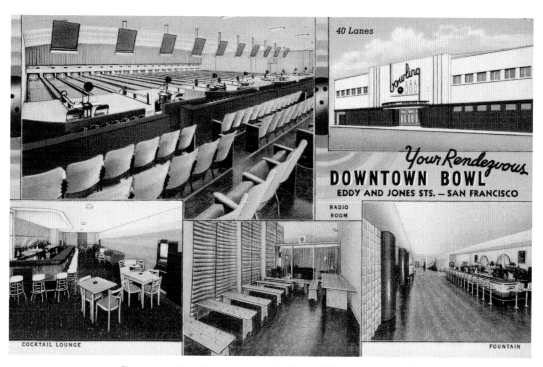

Downtown Bowl, San Francisco, California, USA (postcard: 1942)

150

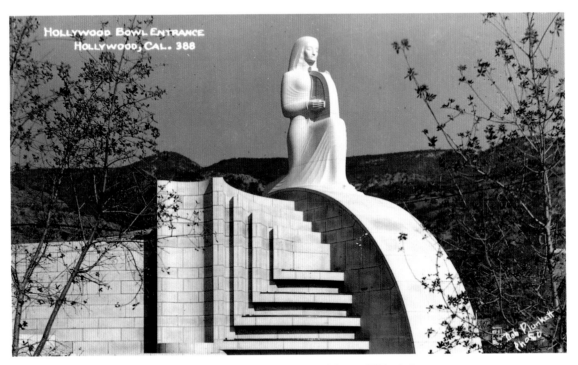

Hollywood Bowl Entrance, Hollywood, California, USA, 1940

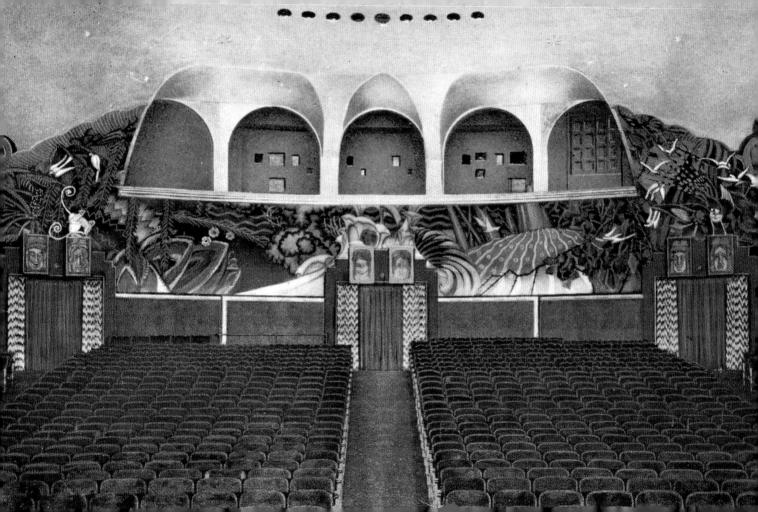

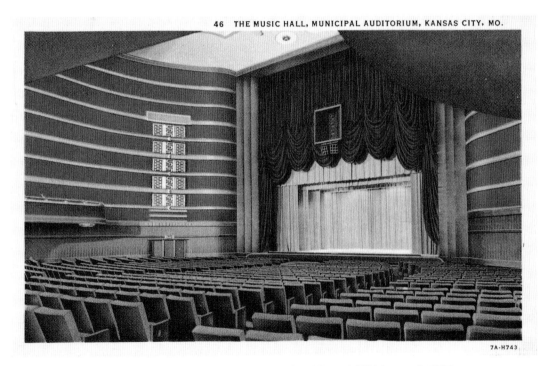

Music Hall, Municipal Auditorium, Kansas City, Missouri, USA (postcard: 1937)

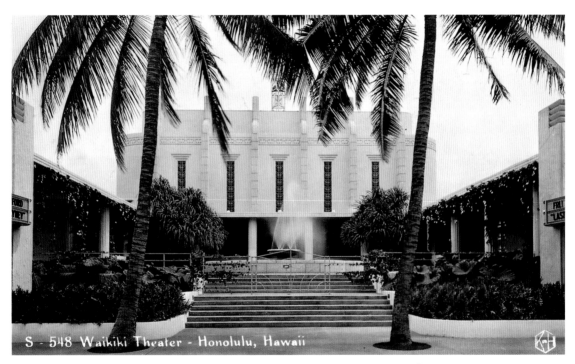

S - 548 Waikiki Theater - Honolulu, Hawaii

Waikiki Theater, Honolulu, Hawaii, 1936 (postcard: 1941)

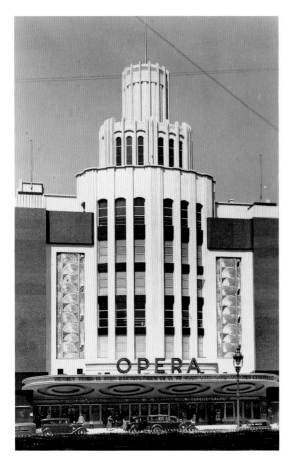

154

< Teatro Opera, Buenos Aires, Argentina, 1936

Liberty Cinema, Bombay (now Mumbai), India, 1947–50 >

Petit Casino de Vichy, Vichy, France, 1929 >>

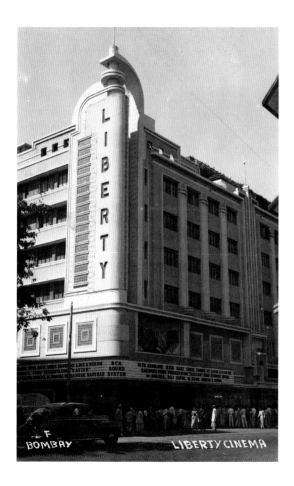

BOMBAY

LIBERTY CINEMA

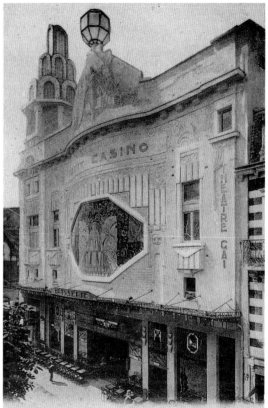

481. - Petit Casino de Vichy - Rue Maréchal-Foch
Les plus célèbres vedettes Théâtre Gai La meilleure troupe comique

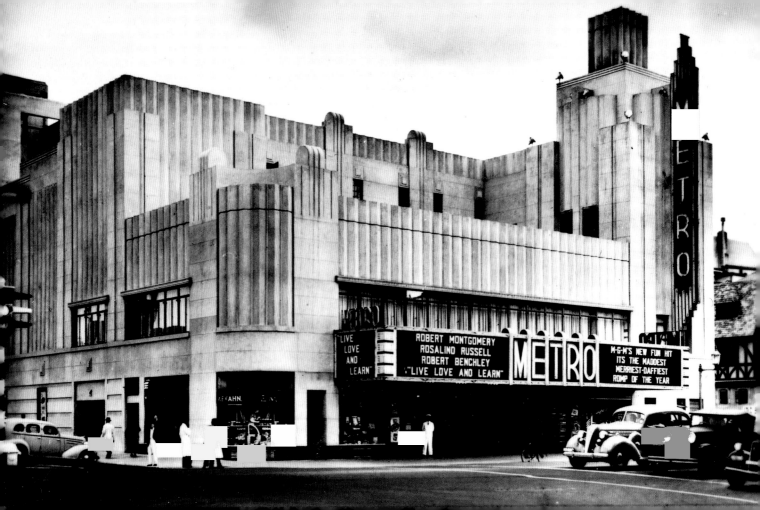

157

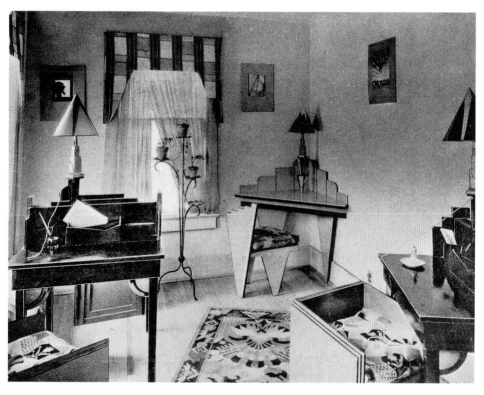

Modernistic Room, Napanoch Country Club, Napanoch, New York, USA, 1925

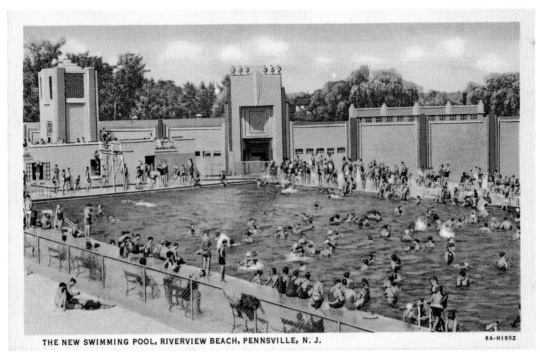

THE NEW SWIMMING POOL, RIVERVIEW BEACH, PENNSVILLE, N. J.

6A-H1952

New Swimming Pool, Riverview Beach, Pennsville, New Jersey, USA, 1936 (postcard: 1936)

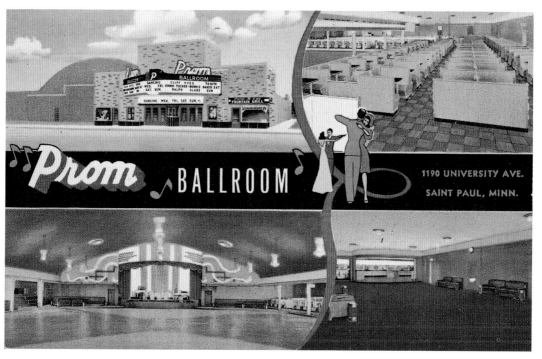

Prom Ballroom, St Paul, Minnesota, USA, 1941 (postcard: 1941)

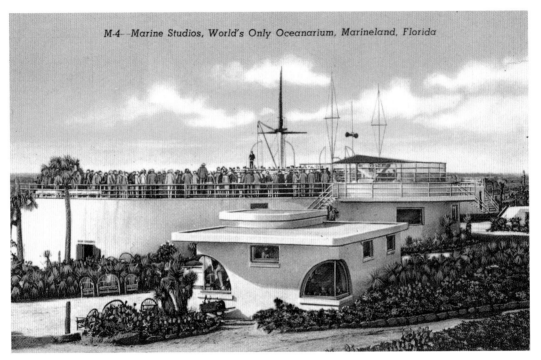

Marine Studios, Marineland, Florida, USA, 1938 (postcard: 1946)

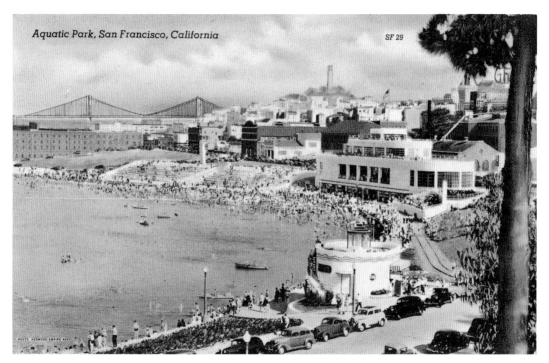

Aquatic Park, San Francisco, California

SF 29

Aquatic Park, San Francisco, California, USA (postcard: 1939)

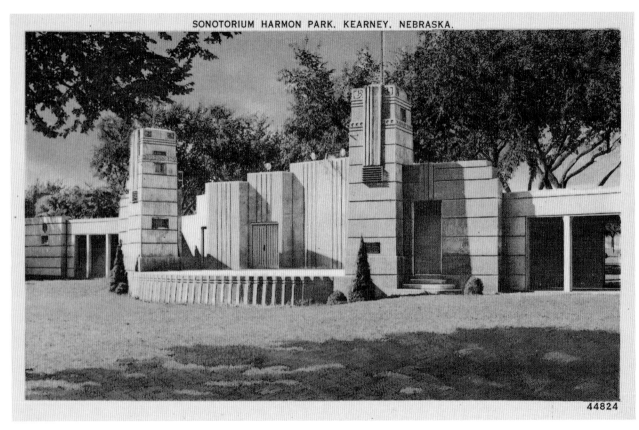

SONOTORIUM HARMON PARK, KEARNEY, NEBRASKA.

44824

Sonotorium Harmon Park, Kearney, Nebraska, USA, 1938

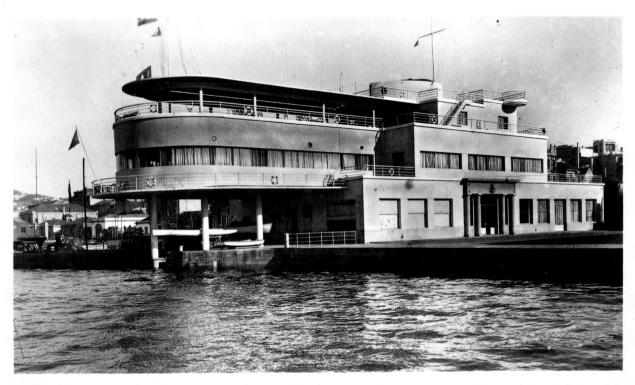

163

104 - Vigo Real Club Náutico Ed. Arribas

Sailing Club, Vigo, Spain, 1944

Palazzo del Cinema, Lido, Venice, Italy, 1937

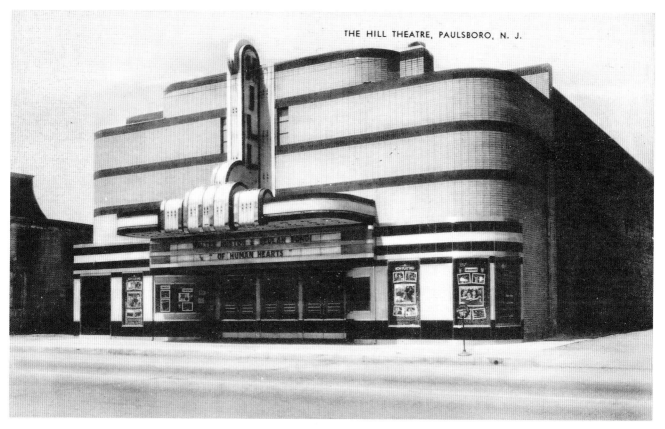

THE HILL THEATRE, PAULSBORO, N. J.

Hill Theatre, Paulsboro, New Jersey, USA, 1938

168

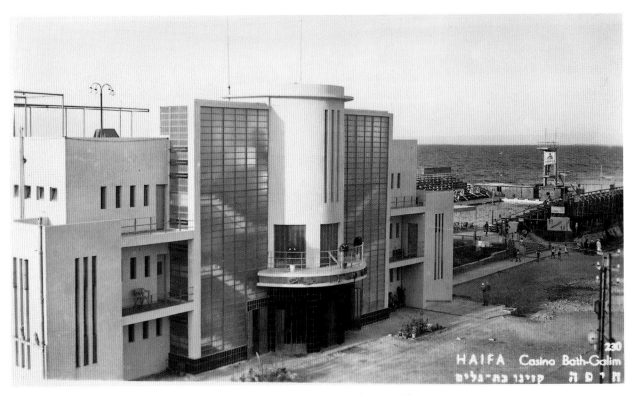

HAIFA Casino Bath-Galim
חיפה קזינו בת-גלים

Casino Bath-Galim, Haifa, Palestine (now Israel), 1934

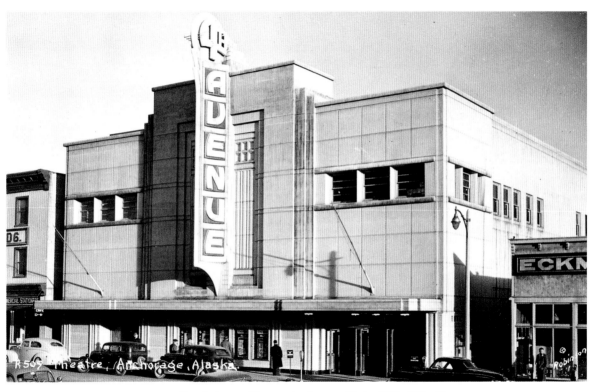

Fourth Avenue Theatre, Anchorage, Alaska, USA, 1941–47

170

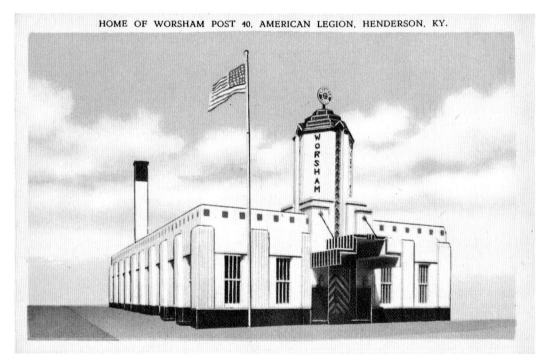

Home of Worsham Post 40, American Legion, Henderson, Kentucky, USA

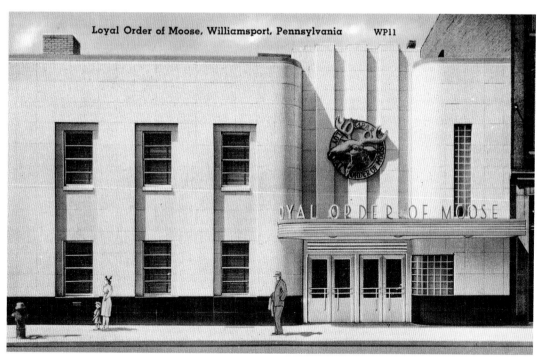

Loyal Order of Moose, Williamsport, Pennsylvania, USA, 1940

Open-air Festival, Szeged, Hungary

172

Nihon-Gekijo Theatre, Tokyo, Japan, 1933 >

プロローグ
レビュー
街の灯
景三
日本劇

チャップリンの
街の灯
日本劇塲

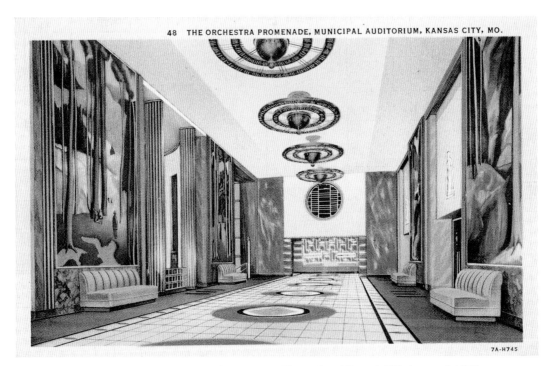

48 THE ORCHESTRA PROMENADE, MUNICIPAL AUDITORIUM, KANSAS CITY, MO.

7A-H745

Orchestra Promenade, Municipal Auditorium, Kansas City, Missouri, USA (postcard: 1937)

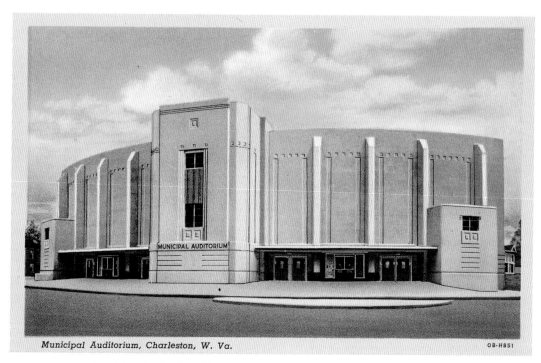

Municipal Auditorium, Charleston, W. Va.

OB-H851

Municipal Auditorium, Charleston, West Virginia, USA, 1939 (postcard: 1940)

176

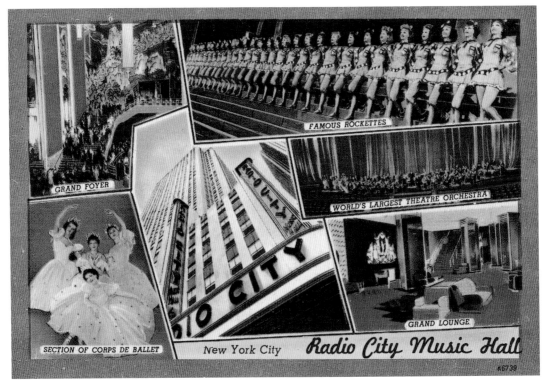

Radio City Music Hall, New York City, USA, 1932

PLACES OF BUSINESS AND INDUSTRY

From low-rise Streamline Moderne factories to lavish Paris-influenced storefronts to setback skyscrapers gleaming inside and out, Art Deco buildings connected to, at times even glorifying, business, industry, retail, manufacturing and the like make up one of the largest and most fascinating subsets of postcards – and the one featuring the most iconic and beloved buildings.

Pictured here are 'cathedrals of commerce' such as Rockefeller Center and the Chrysler and Empire State Buildings in New York City (the subjects of perhaps thousands of different cards since their Art Deco-era beginnings), Chicago's Palmolive Building and the Bank of Commerce in Toronto, as well as a wide range of retail establishments, including a shoe salon in Baltimore, a dry cleaners in Oklahoma City, a pharmacy in New Brunswick, Canada, and an Indian trading post in Albuquerque, New Mexico. A collection of stylishly modern Woolworth's retail stores, many of them corner buildings sharing distinctive shapes and decorative elements, popped up all over the USA and Canada and adorned linen postcards.

Structures that were the headquarters for newspapers, artificial-flower makers, radio and television broadcasters – such as NBC's building in Hollywood and the BBC's Broadcasting House in London – and oil and power companies were designed in the Art Deco style and at least semi-immortalized on postcards, and many a bank and insurance company as well.

There was even a postcard – one of my favourites – produced by an American engine manufacturer that depicted a stylish Machine Age display room, with a floor decorated with a cog motif (see p. 189). And an architectural classic is Frank Lloyd Wright's streamlined S. C. Johnson & Son complex in Racine, Wisconsin.

179

180

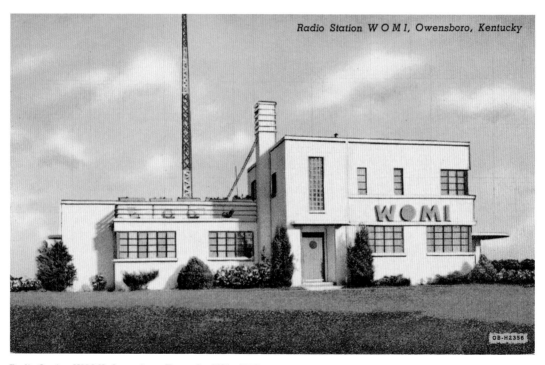

Radio Station WOMI, Owensboro, Kentucky, USA, 1937

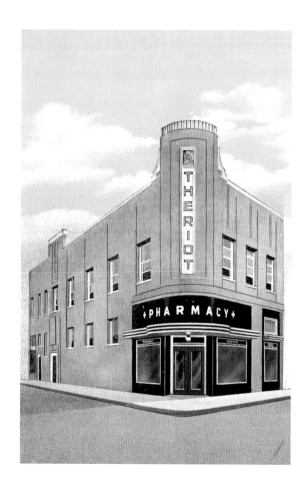

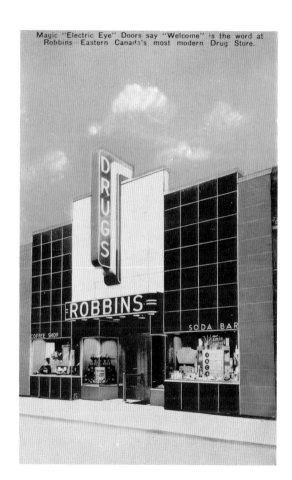

Magic "Electric Eye" Doors say "Welcome" is the word at Robbins—Eastern Canada's most modern Drug Store.

182

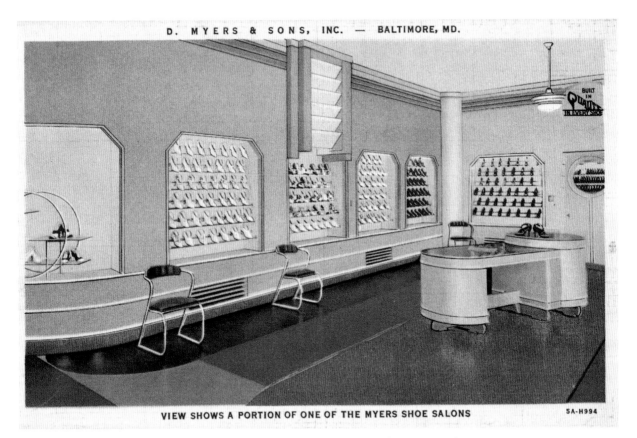

Myers Shoe Salon, Baltimore, Maryland, USA (postcard: 1935)

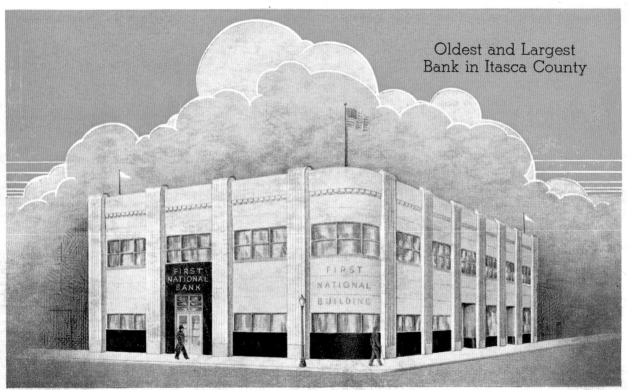

Oldest and Largest
Bank in Itasca County

THE FIRST NATIONAL BANK GRAND RAPIDS, MINNESOTA

First National Bank, Grand Rapids, Minnesota, USA

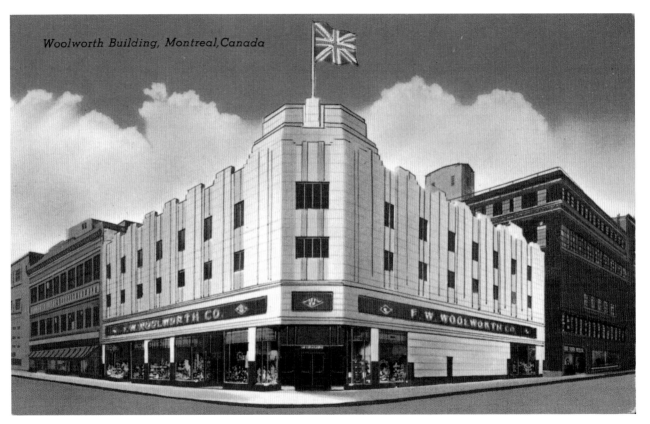

Woolworth Building, Montreal, Quebec, Canada, 1937–38

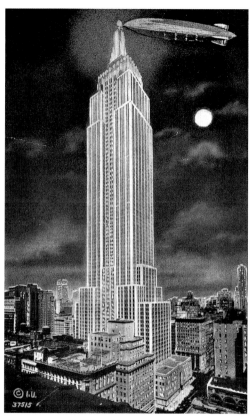

Empire State Building, New York City, USA, 1930–31

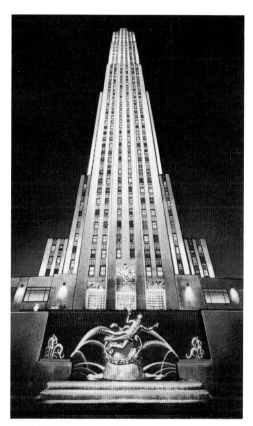

RCA Building, Rockefeller Center, New York City,
USA (postcard: 1935)

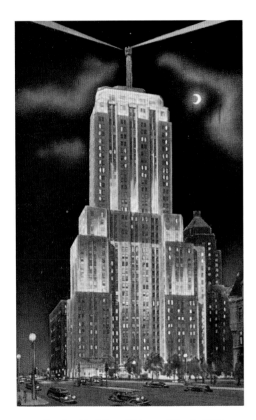

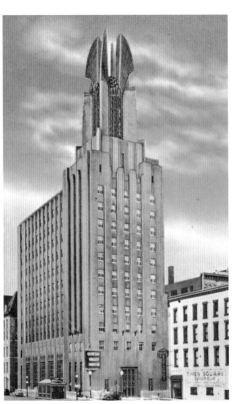

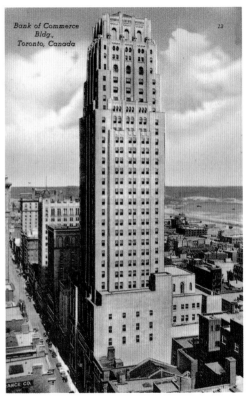

Palmolive Building, Chicago, Illinois, USA, 1929–30

Genesee Valley Trust Co., Rochester, New York, USA, 1929–30

Bank of Commerce Building, Toronto, Ontario, Canada, 1931

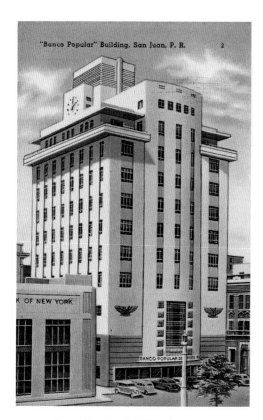

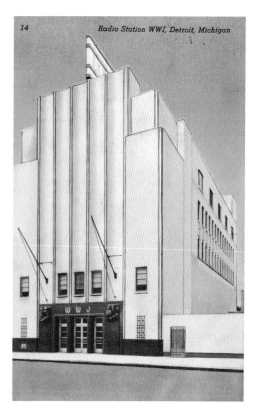

Banco Popular Building, San Juan,
Puerto Rico, 1939

Radio Station WWJ, Detroit, Michigan, USA

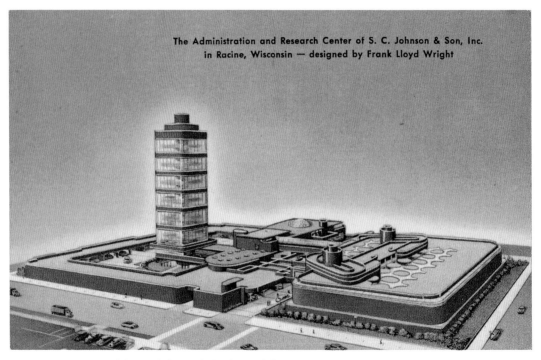

Administration and Research Center, S. C. Johnson & Son, Inc., Racine, Wisconsin, USA, 1936–39, 1944–50
(postcard: 1952)

190

Syracuse Lighting Company Office Building, Syracuse, New York, USA, 1932 (postcard: 1932)

D-15 Dallas Power & Light Company Building, Night Scene,

Dallas, Texas

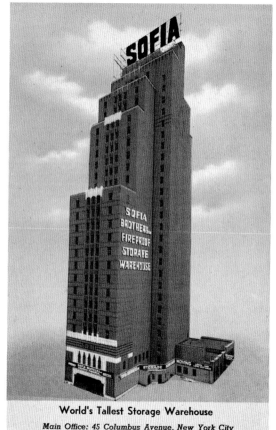

World's Tallest Storage Warehouse
Main Office: 45 Columbus Avenue, New York City

Hamburg. *Chile-Haus*

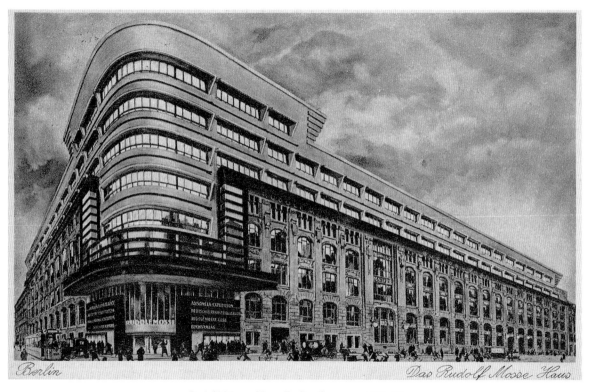

Rudolf-Mosse-Haus, Berlin, Germany, 1921–23

194

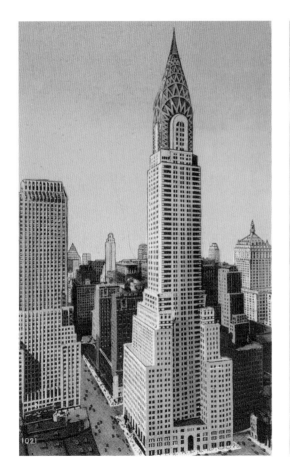

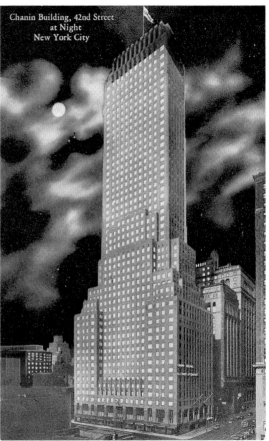

Chanin Building, 42nd Street
at Night
New York City

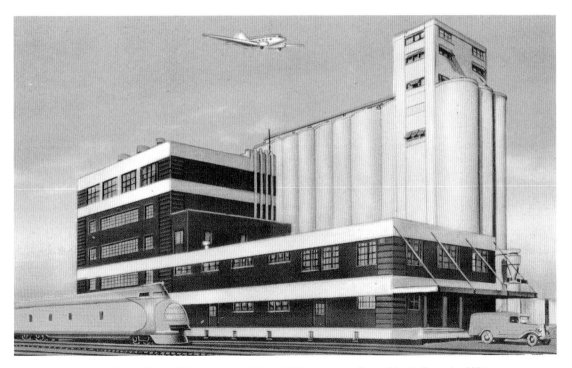

Grand Island Plant, Nebraska Consolidated Mills Company, Grand Island, Nebraska, USA

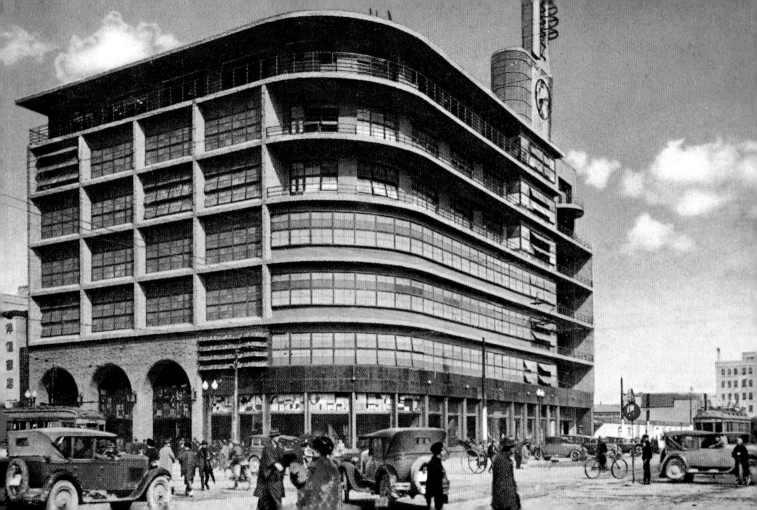

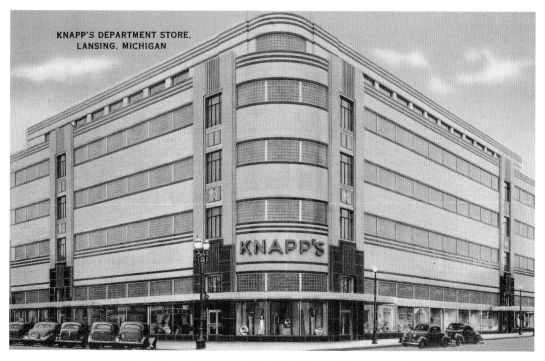

KNAPP'S DEPARTMENT STORE,
LANSING, MICHIGAN

KNAPP'S

Knapp's Department Store, Lansing, Michigan, USA 1938

197

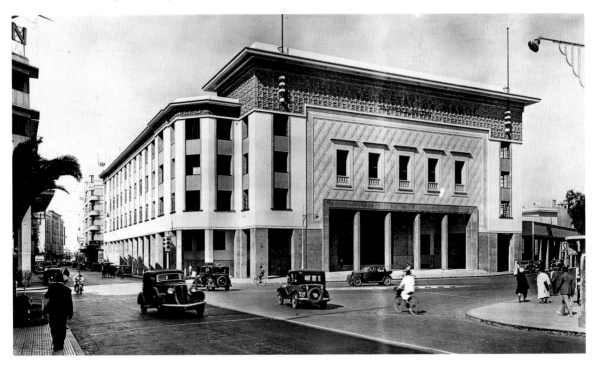

Daily Express Building, London, England, 1930–32 >
Broadcasting House, London, England, 1930–32 >>

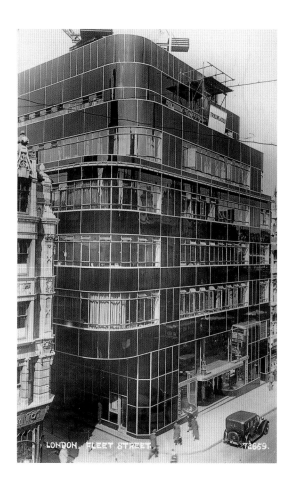

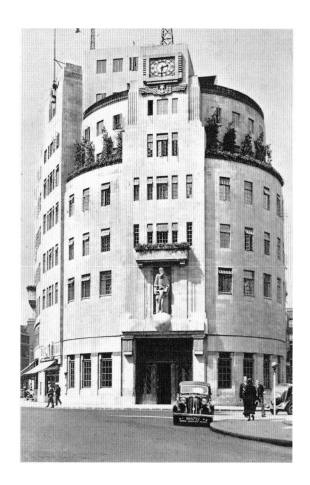

199

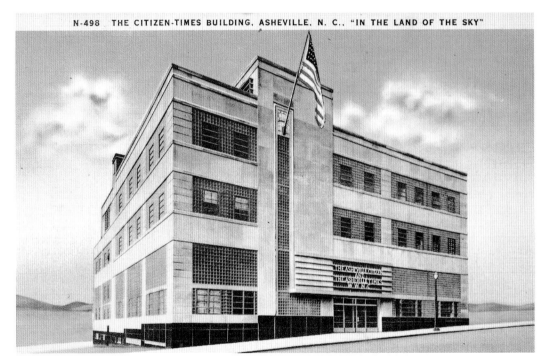

Citizen-Times Building, Asheville, North Carolina, USA

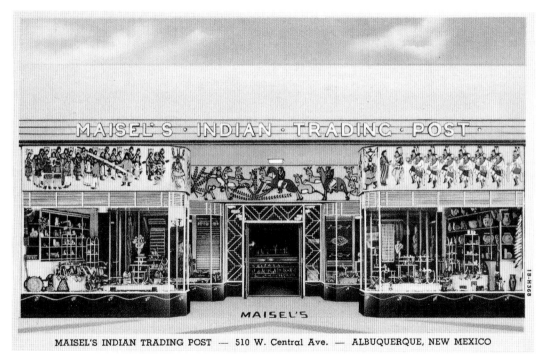

Maisel's Indian Trading Post, Albuquerque, New Mexico, USA, 1939 (postcard: 1941)

202

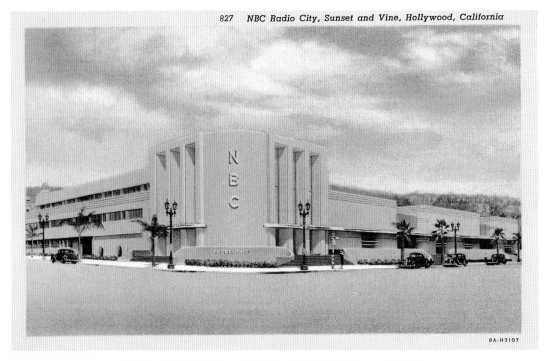

NBC Radio City, Hollywood, California, USA, 1938 (postcard: 1938)

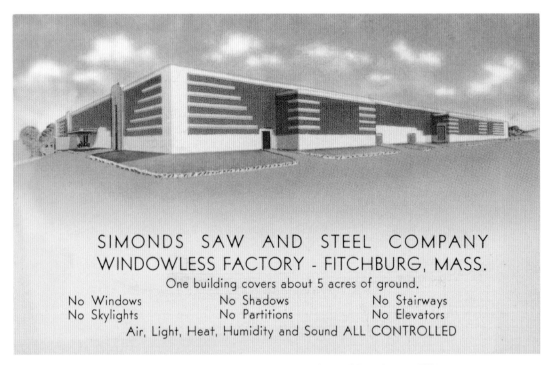

Simonds Saw and Steel Company Factory, Fitchburg, Massachusetts, USA

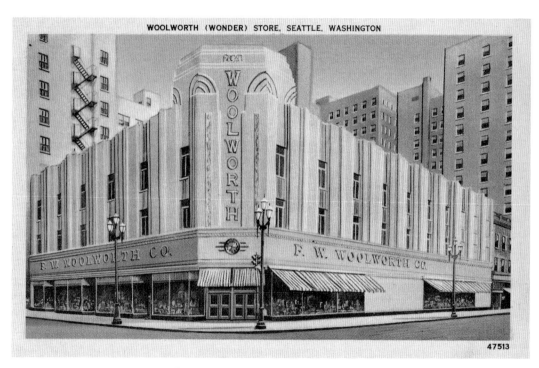

WOOLWORTH (WONDER) STORE, SEATTLE, WASHINGTON

47513

Woolworth Store, Seattle, Washington, USA, 1940

Dear	I Do Lots of	Business Is	
FRIEND	WORKING	PERFECT	
MAMA	NIGHT CLUBS	IMPROVING	
HUSBAND	DANCING	IN THE BAG	
PAPA	THINKING OF YOU	SLOW	
SWEETHEART	MAKING WHOOPEE	KEEPING ME BUSY	
WIFE	SLEEPING	I Wish You Would	
Do You Feel OKeh?	RIDING	WRITE OFTENER	
I Am	DRINKING	SEND MORE MONEY	
SWELL	SHOWS	COME HERE	
LUCKY	SWIMMING	STAY AT HOME	
RUSHED	READING	LOVE ME	
HAPPY	SUNNYING	WRITE A P. CARD	
BEWILDERED	MOVIE GOING	WAIT FOR ME	
STEPPING HIGH	SIGHT-SEEING	SEND YOUR PHOTO	
EXCITED	EATING	I Miss	
GETTING FAT	GOLFING	YOU	
The Place Here Is	I Need	MY LIQUOR	
HOT	YOU	MY HONEY	
COLD	LOVING	THE GANG	
RAINY	GLASSES	I Will Be Seeing You	
DRY	CASH		
MAGNIFICENT	KISSES	Yours	
WONDERFUL	REST	FOREVER	
A DREAM	SYMPATHY	WITH LOVE	7A-H171

BUSY PERSON'S CORRESPONDENCE CARD—TIME IS MONEY—CHECK ITEMS DESIRED

© C. T. & CO., CHICAGO

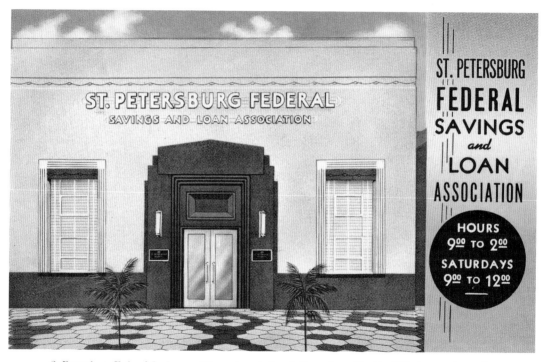

St Petersburg Federal Savings and Loan Association, St Petersburg, Florida, USA (postcard: 1948)

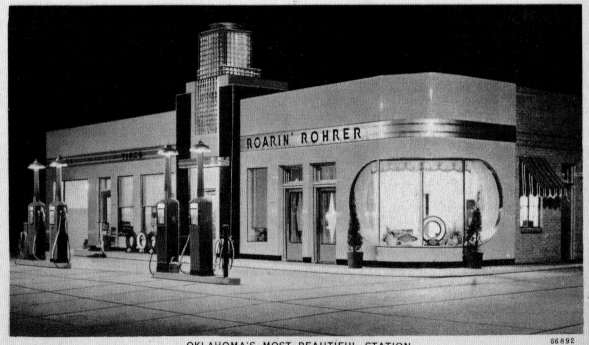

OKLAHOMA'S MOST BEAUTIFUL STATION
ON U. S. 270, McALESTER, OKLA.
STREAM LINED SERVICE

66892

TRANSPORT AND TRAVEL

The many and varied spaces and places, as well as vehicles and vessels, connected with travel and transport in the Art Deco era occupy this section, which includes some of the most exuberant and exciting postcards in the book. Not only are there cards featuring famous structures – also popular tourist attractions – such as the Hoover Dam (and the dramatic ribbon of highway surmounting part of it), but also on view is an international array of airport terminals, bus depots and train stations. Then there are the trains themselves, some of which sport shimmering skins on the outside and stylish spaces within.

Many a luxurious travel-related interior (these often reserved for the adventurous wealthy) was designed in the Art Deco or Streamline Moderne style, and some views of these spaces are extremely rare and sought-after today. There were 'floating palaces' such as the Gallic *Ile de France* and *Normandie* and the British *Queen Mary*, the last of which moored at an equally stylish (internally and externally) terminal in Southampton. The staterooms of some Japanese ferries were furnished in the Art Deco style and depicted on striking postcards. Though aircraft did not provide as much space as that of a seagoing vessel, the mode of transportation brought about the creation of some memorable streamlined interiors, notably those of Germany's ill-fated dirigible *Hindenburg*.

Not surprisingly, very well represented in this section are Streamline Moderne structures and transport, with 'streamline' being the key selling point. There are trains known as 'streamliners'; a sleek motor ferry that bills itself as 'the world's first streamlined vessel'; and a gas station in Oklahoma offering its patrons 'stream lined service'. The ultimate in streamlining was a bullet-shaped vehicle on wheels, a shiny racer posing on the Bonneville Salts of Utah that could be the forebear of a rocketship.

209

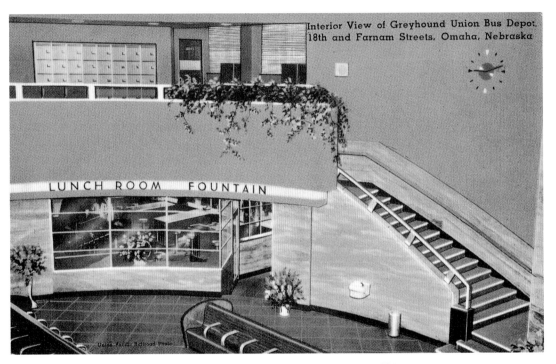

Greyhound Union Bus Depot, Omaha, Nebraska, USA

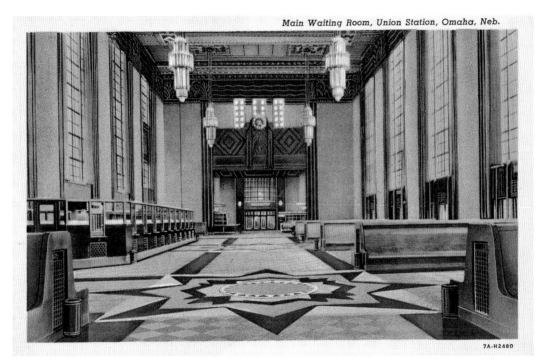

7A-H2480

Main Waiting Room, Union Station, Omaha, Nebraska, USA (postcard: 1937)

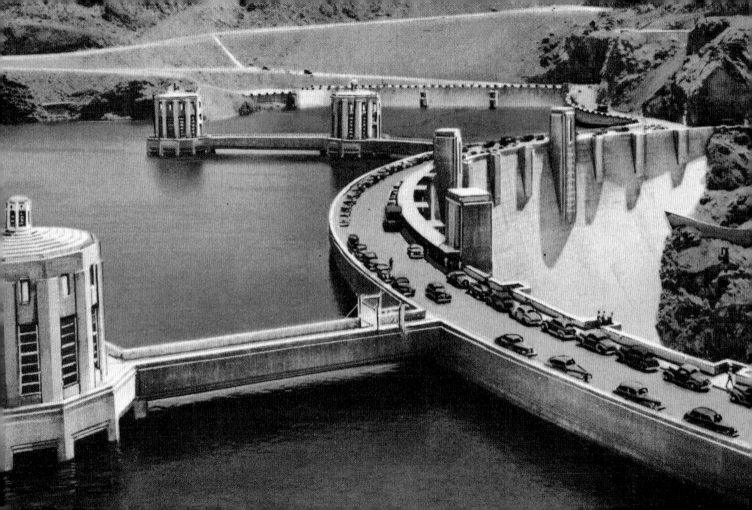

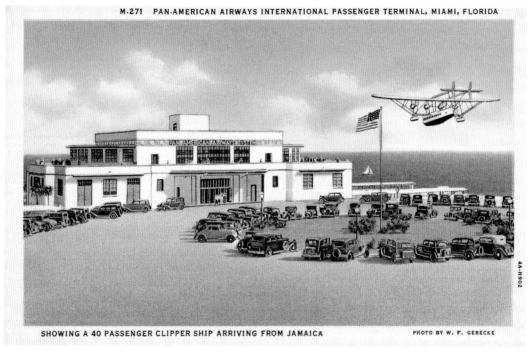

< Transcontinental highway across Boulder Dam (now Hoover Dam), Nevada–Arizona Border, USA, 1931–36 (postcard: 1941)

M-271 PAN-AMERICAN AIRWAYS INTERNATIONAL PASSENGER TERMINAL, MIAMI, FLORIDA

SHOWING A 40 PASSENGER CLIPPER SHIP ARRIVING FROM JAMAICA PHOTO BY W. F. GERECKE

Pan-American Airways International Passenger Terminal, Miami, Florida, USA (postcard: 1934)

214

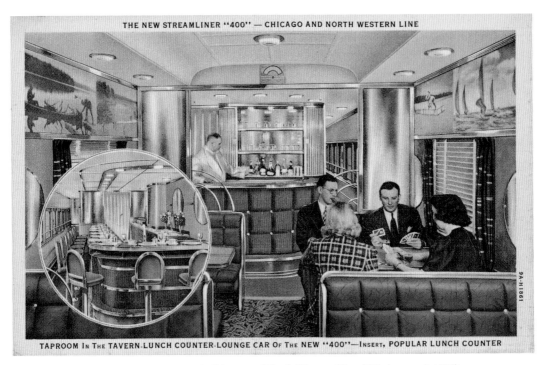

The new streamliner '400', Chicago and North Western Line, USA (postcard: 1939)

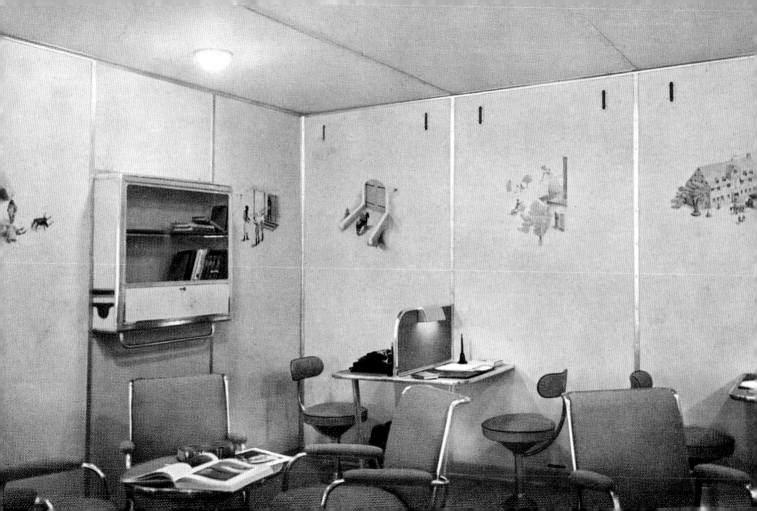

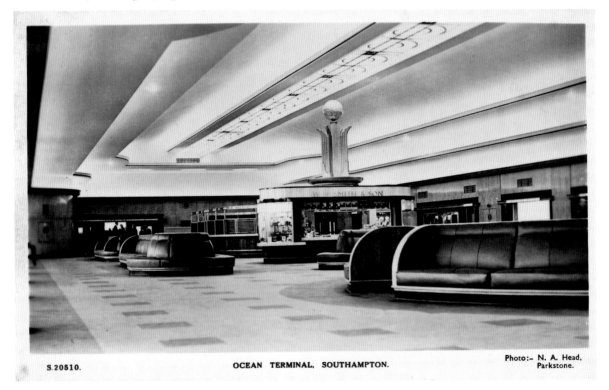

S.20510. OCEAN TERMINAL, SOUTHAMPTON. Photo:- N. A. Head, Parkstone.

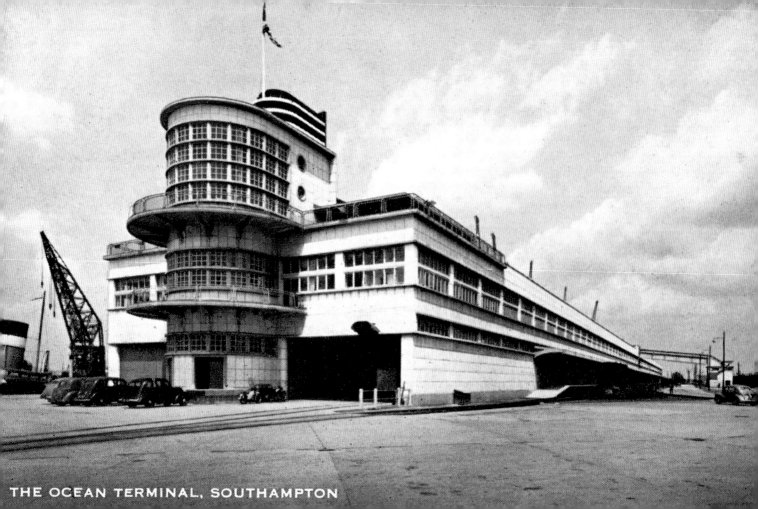

THE OCEAN TERMINAL, SOUTHAMPTON

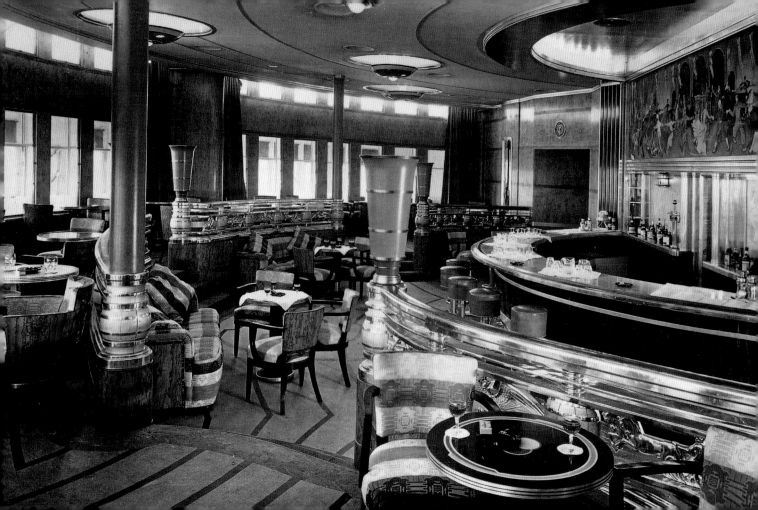

< Cabin Observation Lounge and Cocktail Bar of the ocean liner *Queen Mary*, 1936

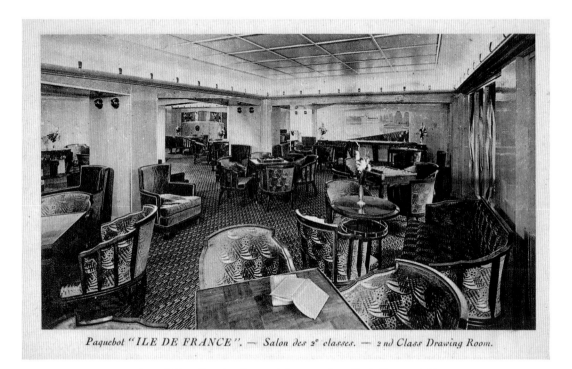

Paquebot "ILE DE FRANCE". — Salon des 2ᵉ classes. — 2 nd Class Drawing Room.

Second Class Drawing Room of the ocean liner *Ile de France*, 1927

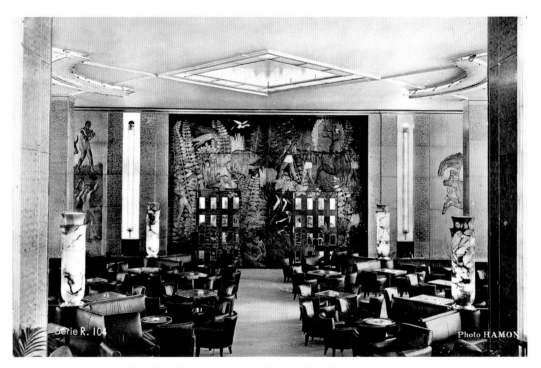

First Class Smoking Room of the ocean liner *Normandie*, 1935

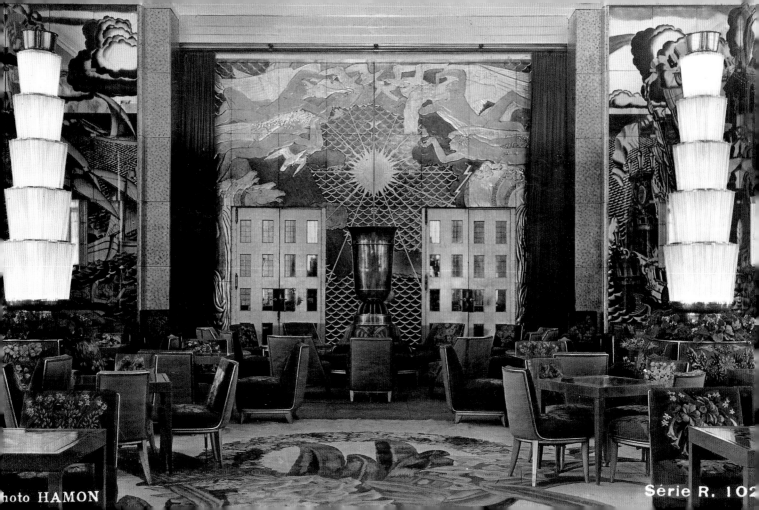

222

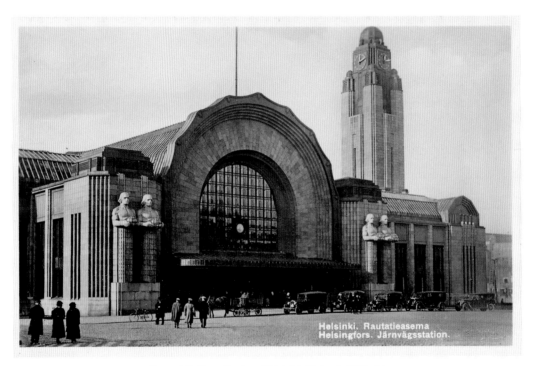

Central Railway Station, Helsinki, Finland, 1904–14

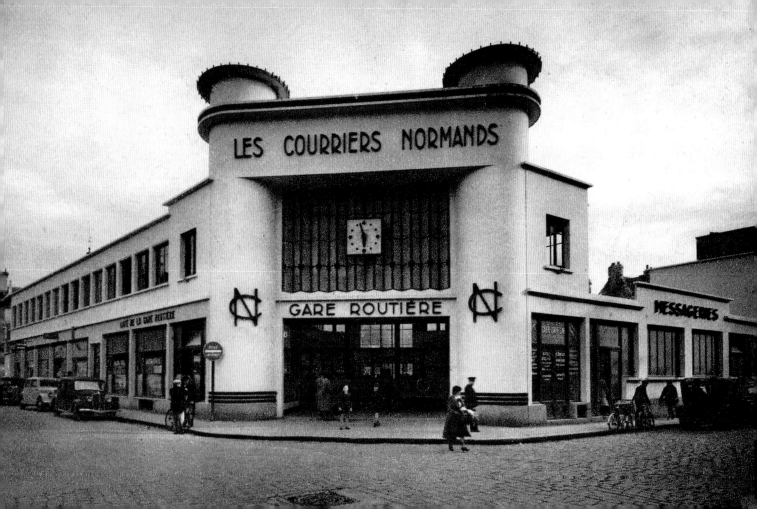

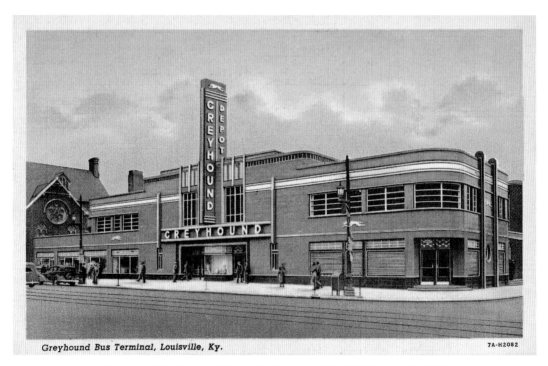

Greyhound Bus Terminal, Louisville, Ky.

7A-H2082

Greyhound Bus Terminal, Louisville, Kentucky, USA, 1937 (postcard: 1937)

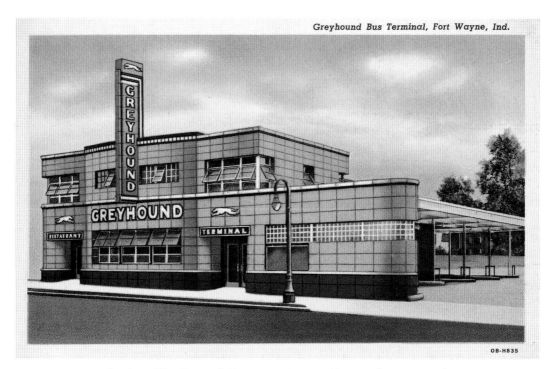

Greyhound Bus Terminal, Fort Wayne, Indiana, USA, 1938 (postcard: 1940)

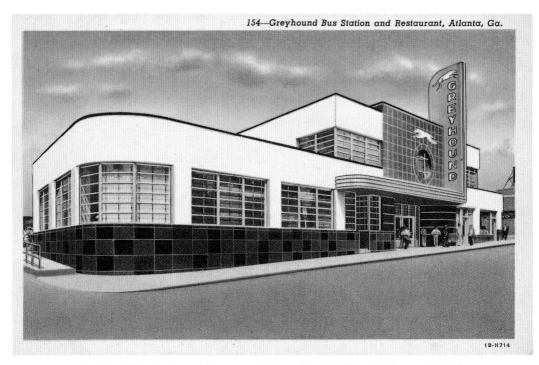

154—Greyhound Bus Station and Restaurant, Atlanta, Ga.

1B-H714

Greyhound Bus Station and Restaurant, Atlanta, Georgia, USA, 1940 (postcard: 1941)

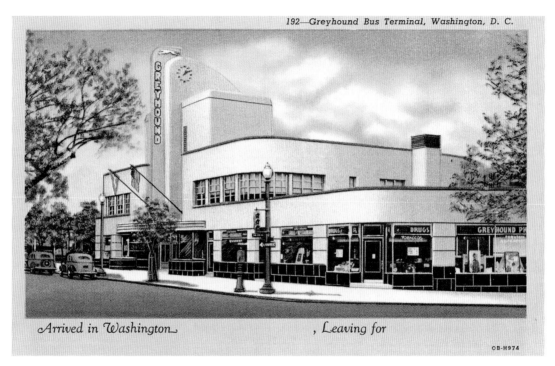

Greyhound Bus Terminal, Washington, D. C., USA, 1940 (postcard: 1940)

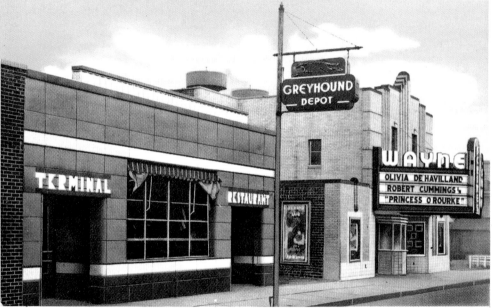

Greyhound Bus Depot and Wayne Theater, Wooster, Ohio, USA (postcard: 1944)

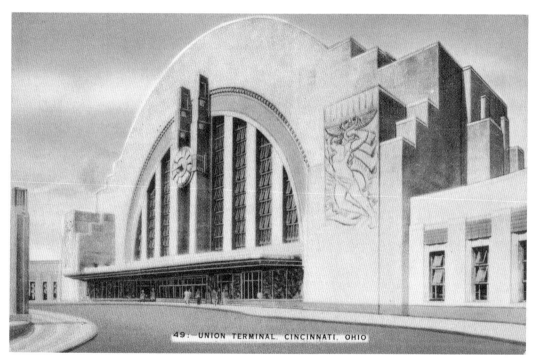

49: UNION TERMINAL, CINCINNATI, OHIO

Union Terminal, Cincinnati, Ohio, USA, 1929–33

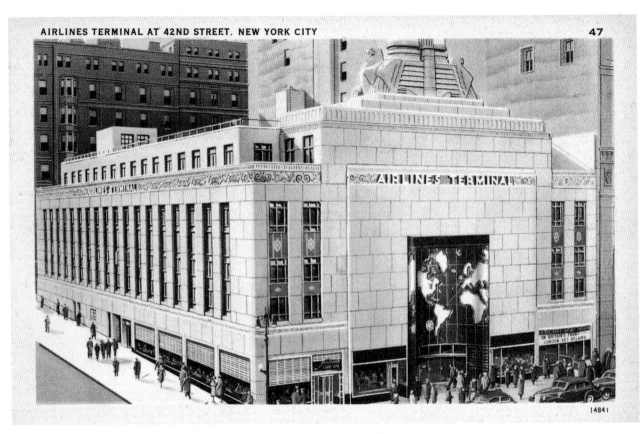

250

Airlines Terminal, New York City, USA, 1939–40

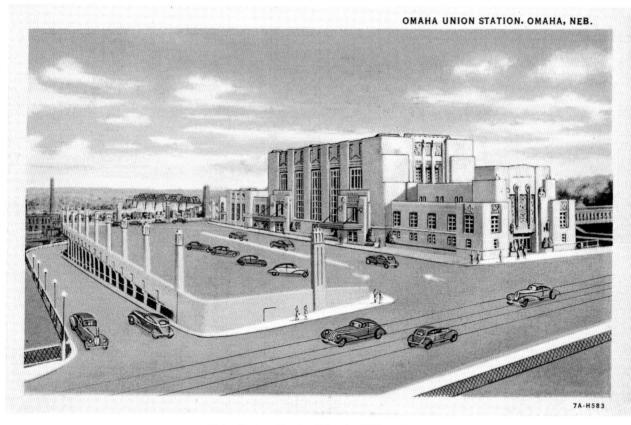

7A-H583

Union Station, Omaha, Nebraska, USA, 1929–31

232

The Car of Tomorrow, as shown at the Crosley Building at the New York World's Fair, USA, 1939

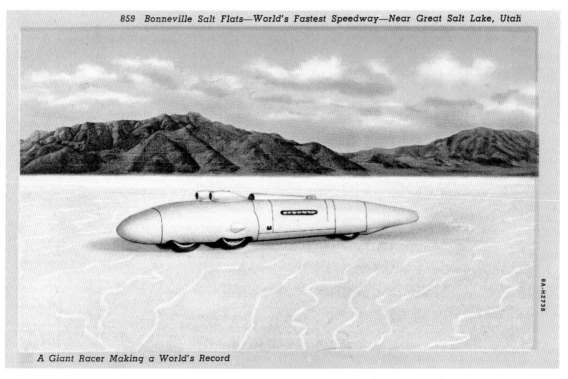

A 'giant racer' on the Bonneville Salt Flats, Utah, USA (postcard: 1938)

234

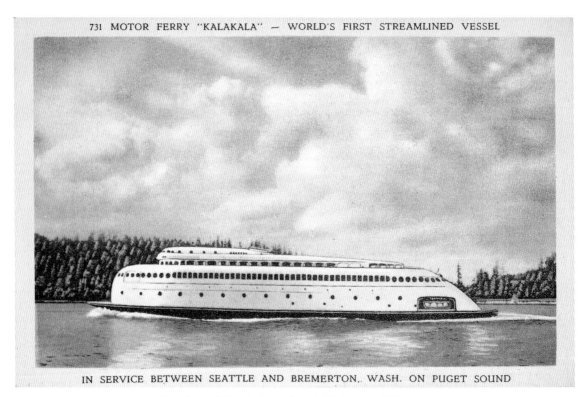

731 MOTOR FERRY "KALAKALA" — WORLD'S FIRST STREAMLINED VESSEL

IN SERVICE BETWEEN SEATTLE AND BREMERTON. WASH. ON PUGET SOUND

Motor Ferry *Kalakala*, Puget Sound, Washington, USA, 1935

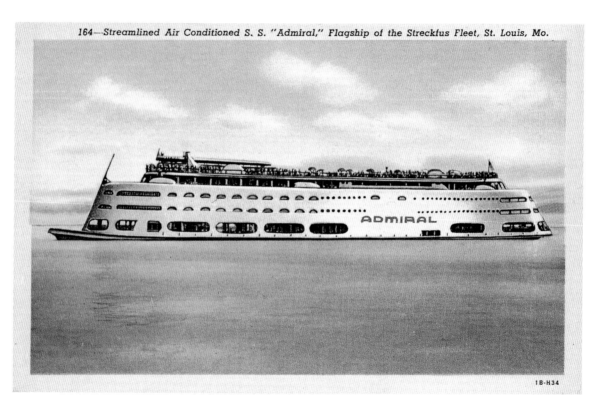

164—Streamlined Air Conditioned S. S. "Admiral," Flagship of the Streckfus Fleet, St. Louis, Mo.

1B-H34

S.S. *Admiral*, St Louis, Missouri, USA, 1940 (postcard: 1941)

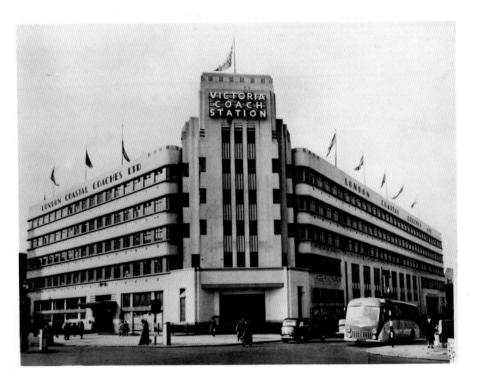

Victoria Coach Station, London, 1932

VICTORIA
COACH
STATION
BUCKINGHAM
PALACE ROAD,
LONDON, S.W.1

Dublin Airport Terminal Building, Republic of Ireland, 1941 >

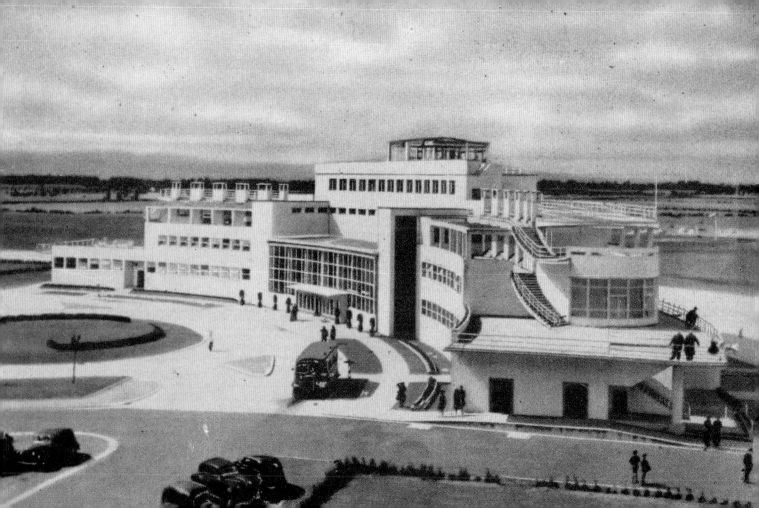

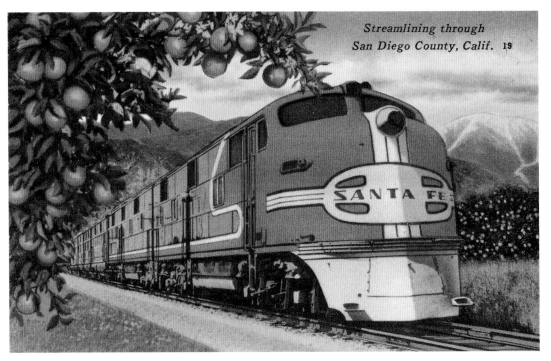

Streamlining through San Diego County, California, USA

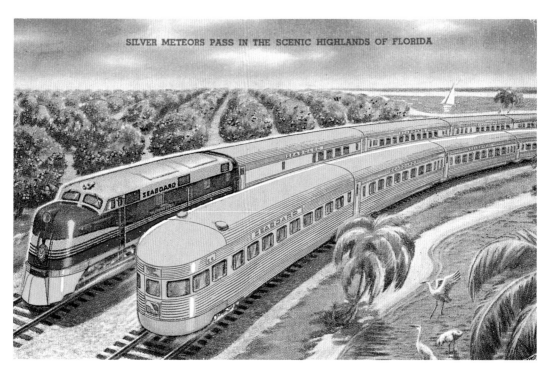

Silver Meteors pass in the scenic highlands of Florida, USA

The new passenger depot of the Union Pacific in Las Vegas, Nevada, is the world's first streamlined, completely air-conditioned railroad passenger station. Typically modernistic western in motif, the structure has been described by architects as one of the most beautiful in design and superlatively complete in appointments, in the United States.

DESERT SOUVENIR SUPPLY, BOULDER CITY, NEVADA

"C.T.ART-COLORTONE" REG. U.S. PAT. OFF.

POST CARD

240

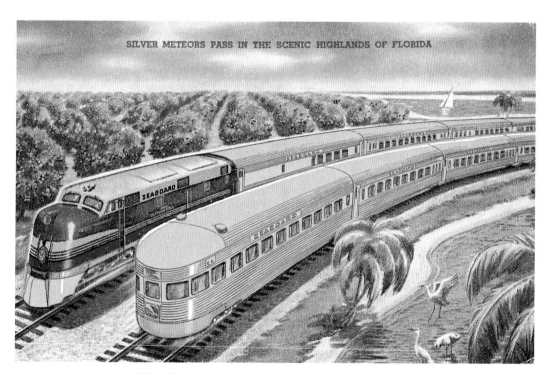

Silver Meteors pass in the scenic highlands of Florida, USA

239

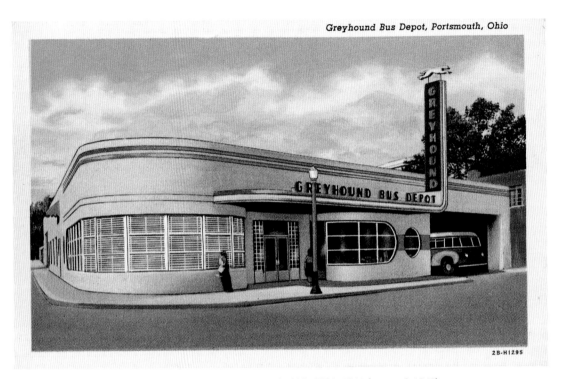

2B-H1295

240

Greyhound Bus Depot, Portsmouth, Ohio, USA, 1941 (postcard: 1942)

CENTENAIRE DE L'INDÉPENDANCE DE LA BELGIQUE

EXPOSITION INTERNATIONALE DE LIÉGE 1930

SOUS LE HAUT PATRONAGE DE LA FAMILLE ROYALE ET DU GOUVERNEMENT

GRANDE INDUSTRIE - SCIENCES & APPLICATIONS - ART WALLON ANCIEN
AGRICULTURE — CONGRÈS — MUSIQUE — SPORTS ET TOURISME — ATTRACTIONS

CORRESPONDANCE

ADRESSE

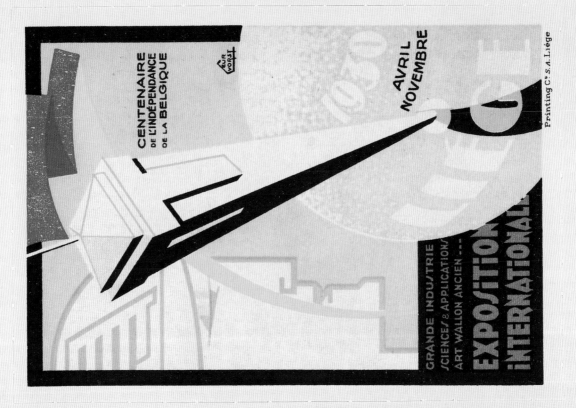

International Exposition for the Centenary of Belgian Independence, Liège, Belgium, 1930

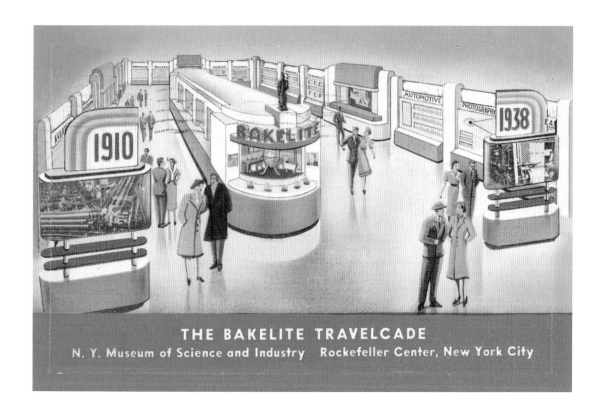

The Bakelite Travelcade, New York City, USA, 1938

THE BAKELITE TRAVELCADE

A panoramic view of the most complete exposition of plastics ever presented to the American public, featured at the New York Museum of Science and Industry during the entire month of March, 1938. Interesting, colorful, animated exhibits emphasize the part that plastics play in industry, in the home, in the daily life of everyone.

The Museum also features 2,000 other exhibits showing the latest developments in scientific and industrial fields.

DESIGNED AND PRODUCED BY HARRY H. BAUMANN, 216 W. 18TH STREET, NEW YORK

POST CARD

64148

VILLAGE RESTAURANT
 Your visit to Atlantic City, famous playground of America, will be more pleasant by dining at this famous restaurant for excellent food and waffles.

"TICHNOR QUALITY VIEWS" REG. U. S. PAT. OFF. MADE ONLY BY TICHNOR BROS., INC., BOSTON, MASS.

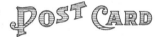

PLACE
ONE CENT
STAMP
HERE

MADE IN U. S. A.

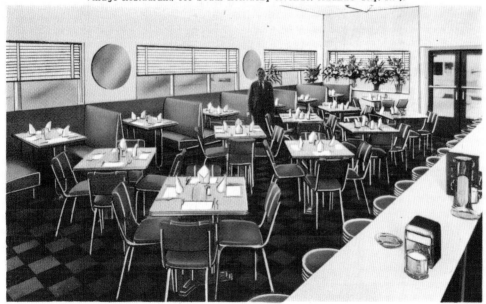

Village Restaurant, 168 South Kentucky Avenue, Atlantic City, N. J.

77703

Village Restaurant, Atlantic City, New Jersey, USA

Hotel Dixie, New York City, USA, 1930

HOTEL DIXIE

43rd Street — West of Broadway
In The Heart of Times Square - New York, N.Y.
700 attractive outside rooms, each with private
bath and radio.

For Your Enjoyment

NEW PLANTATION BAR AND LOUNGE

for choice beverages in delightful surroundings

Continuous Entertainment 7 P. M. to Closing
No Cover - No Minimum - No Cabaret Tax

For RESERVATIONS at any CARTER HOTEL - INQUIRE at FRONT DESK

In Boston
HOTEL AVERY
HOTEL ESSEX

In New Haven
HOTEL GARDE

In New York
HOTEL DIXIE
HOTEL GOVERNOR
CLINTON
HOTEL GEORGE
WASHINGTON

A "COLOURPICTURE" PUBLICATION, BOSTON 15, MASS., U.S.A.

K 5307

PLACE
STAMP
HERE

POST CARD

POST CARD

PLACE
ONE CENT
STAMP
HERE

MID-CONTINENT NEWS CO., OKLAHOMA CITY, OKLA.

GENUINE CURTEICH-CHICAGO "C.T. ART-COLORTONE" POST CARD (REG. U.S. PAT. OFF.)

257

and tableware were made of Lalique glass; the walls, and the furniture by Charles Bernel, were veneered in sycamore with silver touches.

17 'Pomone' Pavilion of the Bon Marché, Exposition des Arts Décoratifs, Paris, France, 1925. The notable designer Paul Follot was artistic director of the Bon Marché department store in Paris with its in-house artists' atelier, Pomone. The pavilion, designed by Louis-Hippolyte Boileau, sparkled with glass insets and windows with Art Deco motifs.

18 'Pavillon de l'Esprit Nouveau', Exposition des Arts

Décoratifs, Paris, France, 1925. The pavilion by the Swiss architect Le Corbusier and his cousin Pierre Jeanneret was the pure, stripped-down antithesis of the (much more popular) showcases of designers such as Lalique. This audaciously simple box, accommodating a live tree, caused a scandal, but its impact on future architecture proved far greater than that of Art Deco.

19 Palace of the Belgian Provinces, International Exposition commemorating the Centenary of the Independence of Belgium, Liège, 1930. Looking like a jewel box with its handsome leaded-glass windows, this pavilion by Legros showcased the regional activities and products of the nine provinces. *Benard S.A., Liège*

20 General Motors, Chrysler and Nash Buildings, A Century of Progress Exposition, Chicago, USA, 1933. The fair marked the centennial of the city. Here an unknown

artist depicts 'Transportation Row', with the green Travel Building and car makers' pavilions. When the fair was extended to 1934, the Travel Building was painted white. *American Colortype*

21 Ford Motor Co. Exhibit, A Century of Progress Exposition, Chicago, USA, 1934. The ten-storey-high main structure – its form like a stack of giant gears, its steel framework sheathed in Indiana limestone – was designed by Albert Kahn. It was later moved to Ford's at Dearborn, Michigan, where it was destroyed by fire in 1962. *American Colortype, 1934*

22 Court of Electrical Group, A Century of Progress Exposition, Chicago, USA, 1933. Allegorical figures of Light and Energy flank a 'waterfall' (created with the then new neon light) symbolizing hydroelectric power. Raymond Hood, architect of New York's Rockefeller Center, designed

the pavilion. *Kaufmann & Fabry photograph; American Colortype*

23 North Midway Luncheonette, A Century of Progress Exposition, Chicago, USA, 1933. The design of this restaurant is very striking and forward-looking, by no means a common feature of the eateries at the fair. *Reuben H. Donnelley Corporation*

24 *left* Three Fluted Towers, A Century of Progress Exposition, Chicago, USA, 1933–34. A trio of pylons symbolizing the branches of the US Government – legislative, executive and judicial – soar over and envelop the gold dome of the Federal Building. Arthur Brown, Jr, of San Francisco and Edward H. Bennett of Chicago were the architects. *Curt Teich*

24 *right* The Tower of Empire, Empire Exhibition, Glasgow, Scotland, 1938. The image is garishly hand-tinted – hardly necessary for the fair's strikingly dramatic steel

Rizal Avenue, Manila, Philippines (the Ideal Cinema was built in 1933)

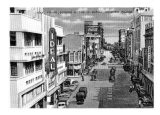

NOTES ON THE PICTURES

Numbers refer to the page on which the card appears

1 A card for Western View Farm, New Milford, Connecticut, USA. From the man at the desk in New York City (Empire State and Chrysler Buildings in the background) the road snakes its way to the Farm, a retreat with studio space for artists. The card is by Bertram Hartman; a message on the back is dated 1932.

2 Conlon Baking Company, Charleston, West Virginia, USA. This Streamline Moderne factory of 1938 in ceramic, glass, and stainless steel was designed by McCormick Co. of New York and Pittsburgh. It does not survive. *Curt Teich, 1938*

3 Electrical Products Building, New York World's Fair, USA, 1939. One of the fair's most striking pavilions, where its vertical pylon in French blue contrasted with the many white pavilions (see p. 37). The architects were Walker & Gillette. Above the entrance is a mural by Martha Axley showing the uses of electricity in modern life. *Curt Teich, 1939*

4 First Class Observation Deck, *Kogane Maru*. The image, seemingly floating on a star-spangled sea-sky of deep blue, is a rare and magical one. The hemispherical space has a bold geometric design on the floor and compact *moderne* tables, chairs, and sofas. The liner of 1936 was part of the fleet of the O.S.K. (Osaka Shosen Kaisha) Line; it was sold in 1942 and scrapped in 1971.

5 Villa Isola, Bandoeng (Bandung), Java, Indonesia. This magnificent concrete and steel stepped structure was designed by the Dutch architect C. P. Wolff Schoemaker and finished in 1933 for the Dutch media magnate D. W. Berretty, who died in a plane crash the following year. It became part of a hotel, then was occupied by the Japanese army in the war. Repaired and altered (with another storey), the villa became part of a teachers' training college and is now known as Bumi Siliwangi.

WORLD FAIRS AND EXPOSITIONS

12 Men's Apparel Quality Guild Exhibit Building, New York World's Fair, USA, 1939. This rather simplified image is appealing for the strikingly modern structure of the pavilion. Note the high vertical slab contrasting with the low building: such pylons were a leitmotif of the fair (see pp. 3, 31, 36–37). *Grinnell Litho Co.*

14 Galeries Lafayette Pavilion, Exposition des Arts Décoratifs, Paris, France, 1925. The stepped pavilion was made and installed by the Maîtrise, the applied arts atelier of the Paris department store. In its design the Maîtrise's artistic director, Maurice Dufrène, worked with the architects Jean Hiriart, Georges Tribout and Georges Beau. This image is one of the most beautiful from the fair; its designer is unknown.

15 Grands Magasins du Louvre Pavilion, Exposition des Arts Décoratifs, Paris, France, 1925. This richly decorated polygonal building was designed by Albert Laprade, with the collaboration of the ironworker Edgar Brandt and the sculptor Albert Binquet.

16 Dining Room of the René Lalique Pavilion, Exposition des Arts Décoratifs, Paris, France, 1925. The ceiling light

257

and tableware were made of Lalique glass; the walls, and the furniture by Charles Bernel, were veneered in sycamore with silver touches.

17 'Pomone' Pavilion of the Bon Marché, Exposition des Arts Décoratifs, Paris, France, 1925. The notable designer Paul Follot was artistic director of the Bon Marché department store in Paris with its in-house artists' atelier, Pomone. The pavilion, designed by Louis-Hippolyte Boileau, sparkled with glass insets and windows with Art Deco motifs.

18 'Pavillon de l'Esprit Nouveau', Exposition des Arts

..

Rizal Avenue, Manila, Philippines (the Ideal Cinema was built in 1933)

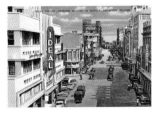

Décoratifs, Paris, France, 1925. The pavilion by the Swiss architect Le Corbusier and his cousin Pierre Jeanneret was the pure, stripped-down antithesis of the (much more popular) showcases of designers such as Lalique. This audaciously simple box, accommodating a live tree, caused a scandal, but its impact on future architecture proved far greater than that of Art Deco.

19 Palace of the Belgian Provinces, International Exposition commemorating the Centenary of the Independence of Belgium, Liège, 1930. Looking like a jewel box with its handsome leaded-glass windows, this pavilion by Legros showcased the regional activities and products of the nine provinces. *Benard S.A., Liège*

20 General Motors, Chrysler and Nash Buildings, A Century of Progress Exposition, Chicago, USA, 1933. The fair marked the centennial of the city. Here an unknown

artist depicts 'Transportation Row', with the green Travel Building and car makers' pavilions. When the fair was extended to 1934, the Travel Building was painted white. *American Colortype*

21 Ford Motor Co. Exhibit, A Century of Progress Exposition, Chicago, USA, 1934. The ten-storey-high main structure – its form like a stack of giant gears, its steel framework sheathed in Indiana limestone – was designed by Albert Kahn. It was later moved to Ford's at Dearborn, Michigan, where it was destroyed by fire in 1962. *American Colortype, 1934*

22 Court of Electrical Group, A Century of Progress Exposition, Chicago, USA, 1933. Allegorical figures of Light and Energy flank a 'waterfall' (created with the then new neon light) symbolizing hydroelectric power. Raymond Hood, architect of New York's Rockefeller Center, designed

the pavilion. *Kaufmann & Fabry photograph; American Colortype*

23 North Midway Luncheonette, A Century of Progress Exposition, Chicago, USA, 1933. The design of this restaurant is very striking and forward-looking, by no means a common feature of the eateries at the fair. *Reuben H. Donnelley Corporation*

24 *left* Three Fluted Towers, A Century of Progress Exposition, Chicago, USA, 1933–34. A trio of pylons symbolizing the branches of the US Government – legislative, executive and judicial – soar over and envelop the gold dome of the Federal Building. Arthur Brown, Jr, of San Francisco and Edward H. Bennett of Chicago were the architects. *Curt Teich*

24 *right* The Tower of Empire, Empire Exhibition, Glasgow, Scotland, 1938. The image is garishly hand-tinted – hardly necessary for the fair's strikingly dramatic steel

centrepiece, also called Tait's Tower after its designer, Thomas Smith Tait. It was to stay up once the fair ended, but in 1939 it was demolished lest it be a landmark for German bombers. *Valentine & Sons*

25 Pavilion of Inventions, International Fair of Samples, Rio de Janeiro, Brazil, 1934. The trade fair had many Art Deco-style buildings; the architect of this striking Nautical Moderne style pavilion is unknown.

26 Taiwan Exposition, Taipei, Taiwan, 1935. The fair was held 'In Commemoration of the First 40 Years of Colonial Rule' by Japan. The Sugar Production Hall (left) and Movie Theatre (right) show the influence of the 1925 Paris and 1933 Chicago expositions.

27 Grand Yokohama Exhibition, Japan, 1935. The fair was held to commemorate the reconstruction of the city after the great earthquake of 1923. Quake rubble as landfill became Yamashita Park, on which it was held.

28 Centenary Palace, International Exposition, Brussels, Belgium, 1935. Designed by Joseph van Neck, the official architect of the fair commemorating the centennial of the creation of Belgium, the imposing structure has stepped sides in the Art Deco style, and its centre is topped by four bronze figures. It was used again for Expo '58, and functions today for trade fairs. *A. Dohmen photograph*

29 West Flanders Pavilion, International Exposition, Brussels, Belgium, 1935. With text in French and Dutch, Belgium's two languages, this card depicts the Nautical Moderne pavilion that featured the beaches, historic towns and scenic spots of West Flanders. Its architect is unknown. *Création B. et Nr. – Imp. Helios S.A. Brux.*

30 Palace of Tourism, International Exposition, Liège, Belgium, 1939. This fair celebrated both Liège and the inauguration of the Albert Canal linking the city to Antwerp. It closed two months early, due to the onset of World War II. Ironically, the building in the background is the German Pavilion, by the architect Emil Fahrenkamp.

31 Chrysler Motors Building, New York World's Fair, USA, 1939. The US car maker's bold red pavilion by James Gamble Rogers displayed Chrysler's wares in the wings, while the centre showed 'man's progress from his first slow journeys on foot to his future voyages in rocket ships', culminating in the simulated flight of a rocket from New York to London. The frame shows the famous Trylon and Perisphere. *Miller Art Co.*

32 Marchant Calculating Machine Company Exhibit, New York World's Fair, USA, 1939. A reproduction of what may have been a watercolour, signed 'Butler '39', the card shows modish visitors with a swanky showcase for 'Silent Speed' adding machines. The firm was later bought by Smith Corona. *Curt Teich*

33 Sealtest Building, New York World's Fair, USA, 1939. DeWitt Clinton Pond designed this futuristic pavilion. Sealtest eventually became part of Kraft Foods. *Grinnell Litho Co.*

34 Maison Coty Building, New York World's Fair, USA, 1939. The pavilion, generally attributed to Donald Deskey (best known for his interiors of Radio City: see p. 176), resembled a giant powder box, adorned at the top with Coty's Airspun powder-puff motif, still used today. *Manhattan Post Card Publishing Co.*

35 Canadian Building, New York World's Fair, USA, 1939. The style of this *moderne* structure by F. W. Williams, made almost wholly of Canadian materials, was, the back of this officially licensed card proclaimed, 'typical of

such a young and virile country'. *Tichnor Brothers*

36 The Giant Underwood Master, New York World's Fair, USA, 1940. The letterhead of the company is emerging from the machine on a vast sheet of paper. To fairgoers the mammoth Master was a bold symbol of modernity. *Colourpicture, Cambridge, Mass.*

37 Electrical Products Building, New York World's Fair, USA, 1939. This pavilion (see also p. 3) was full of radical new gadgets powered by electricity. The card's bold colours are quite close to the true hues of the pavilion, generally considered the most dramatic Modernist structure by the architects Walker & Gillette. *Grinnell Litho Co.*

PUBLIC STRUCTURES

38 Post and Telegraph Office, Pola (now Pula), Croatia. Croatia was an Italian province from 1918 to World War II when this was built; its

architect and date are not known. With a stylish clock, curvilinear windowless main section and three-finned side projection, the structure still exists, with a tomato-red spiral staircase inside. *Ed. Ris G. Rude – Pola/Stab. Gratico Cesare Cappello – Milano*

40 State Capitol, Salem, Oregon, USA. This handsome structure of 1936–39, designed by Francis Keally of Trowbridge and Livingston in New York, is a striking example of a style that has been called 'PWA Moderne' (it was funded in part by the Public Works Administration). Sheathed in Vermont marble, it is topped by a lantern-like cupola atop which stands Ulric Ellerhusen's gilt-bronze statue of the archetypal Oregon Pioneer. *Photo by Wesley Andrews/Curt Teich, 1939*

41 Oklahoma County Court House, Oklahoma City, Oklahoma, USA. The 1937 ziggurat-shaped limestone building was designed by

the prominent city firm Layton & Forsyth. It was restored in the 1990s. Oil-well borders give this card a *moderne* local touch. *Colourpicture, postmarked 1950*

42 Ector County Court House, Odessa, Texas, USA. Completed in 1938 to the design of Elmer Withers of Fort Worth, this combines a shape verging on the Bauhaus style with *moderne* decorative elements in the form of figurative reliefs and asymmetrical grillework. Sadly the building was remodelled in 1964 and the façade masked by a screen. *Colourpicture*

43 *left* City Hall, Los Angeles, California, USA. This concrete giant of 1928 was designed by John Parkinson, with John C. Austin and Albert C. Martin, Sr. It blends classicizing elements (the tower was supposedly inspired by Mausolus's tomb at Halicarnassus) with *moderne* features, and recalls its slightly older neighbour, the Los Angeles Public Library (p. 47). *Longshaw Card Co.*

43 *right* Federal Building, Omaha, Nebraska, USA. A massive stepped box faced in limestone, granite, and brick, this structure in a style sometimes called Stripped Classical was designed by Kimball, Steele & Sandham with George B. Prinz; financed in part by the New Deal, it was built in 1933–34. *Curt Teich, 1950*

44 An 'important building', Heizyo, Tyosen (Pyongyang, North Korea). One of the Art Deco-style buildings that arose during the Japanese occupation of the Korean peninsula, influenced by the 1925 Paris Exposition, this structure of 1935–37, with banners displaying Japanese sun discs, is now Pyongyang Public Hall. *Hinode-Shoko. Seoul, Korea*

45 Post Office, Kharkov, Ukraine. The architect of this striking glass and steel Constructivist structure of 1928–29 was Arkady Mordvinov. It still stands in Railway Station Square, minus working clocks on its tower and

with different signage. The card, printed on flimsy paper, states on the back in Russian and English that it was part of a 'Series of the magazine 'USSR IN CONSTRUCTION', 1931.

46 Public Library, Pine Bluff, Arkansas, USA. Geometric motifs and a sunburst-like leaded-glass window design over the entrance are among the decorative touches identifying this as a product of the Art Deco era. The 1931 cream-coloured brick structure still stands at the corner of Fifth Avenue and Chestnut Street, no longer in use as a library. *Curt Teich, 1935*

47 Public Library, Los Angeles, California, USA. This tiled-pyramid-topped 1926 giant was one of the last projects of the noted architect Bertram Grosvenor Goodhue. Rich in Egyptian and Mediterranean Revival detail, rendered with a *moderne* touch, it was sympathetically restored and enlarged in 1988–93. *Longshaw Card Co.*

48 Einsteinturm, Potsdam, Germany. Erich Mendelsohn's unique stucco-covered brick structure, built in 1919–21 and first used as an observatory in 1924, is an icon of Expressionist architecture, but it also evokes later Streamline Moderne buildings. The architect said its inspiration came out of 'the mystique around Einstein's universe'. It was extensively restored in 1999. *Kunstverlag I. Wollstein, Berlin*

49 De La Warr Pavilion, Bexhill-on-Sea, England. An icon of Modernist architecture, commissioned by the 9th Earl De La Warr in 1935 from émigré architects Serge Chermayeff and Erich Mendelsohn, the steel and concrete Pavilion was 'pioneering in structure as it was in spirit', designed to 'provide accessible culture and leisure for the people of Bexhill and beyond': so its modern website explains, and it is now admirably restored. *Shoesmith & Etheridge Ltd., Hastings, postmarked 1949*

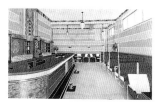

Cocktail Lounge, Hotel Marinette, Marinette, Wisconsin, USA

..

50 Jewel Box, Forest Park, St Louis, Missouri, USA. A New Deal project funded by the Public Works Administration, this stepped-form greenhouse of 1936 was designed by City Engineer, William C. E. Becker. On the National Register of Historic Places it is cited for being an 'Art Deco building' that is 'an outstanding example of greenhouse design'. It reopened in 2002 after major restoration. *Colourpicture*

51 Planetarium, Griffith Park, Los Angeles, California, USA. The massive complex on Mount Hollywood opened in 1935, its principal architect, John C. Austin, having worked

from preliminary sketches by Russell W. Porter. The building featured in the 1955 film *Rebel Without a Cause*, starring James Dean; its Art Deco exterior was retained during renovation and expansion in 2002–6. *Curt Teich, 1938*

52 'Brick Glass' School Building, Hibbing, Minnesota, USA. The Park School, designed in 1935 by J. C. Taylor, was also called the 'little glass schoolhouse' and was strikingly *moderne* in appearance and construction. Glass bricks were used for the windows. *David Milavetz News Co., Virginia, Minn.*

53 Bailey Junior High School, Jackson, Mississippi, USA. This 1938 building by N. W. Overstreet made *Life* magazine's cover for its 'forward look and revolutionary technique of formed-in-place concrete'. Now Bailey Magnet High School, it was voted a state landmark in 2008. *Curt Teich, 1941*

54 Administration Building, Creighton University, Omaha, Nebraska, USA. A stately Art Deco structure of 1929–30 with stepped form, central tower, and ornamental relief panels along the roofline and on the tower, this survives as Creighton Hall on the campus of the large Jesuit institution. *Curt Teich, 1937*

55 Montreal University, Montreal, Quebec, Canada. Ernest Cormier, who designed many Art Deco buildings in Montreal, helped create a mini-city of sorts here. Most of the structures date to the 1920s, though the project was not finished until the 1940s. The *moderne* central tower (now the Roger Gaudry Building), initially controversial, is now considered one of Cormier's finest accomplishments.

56 Museum Building at Ocmulgee National Monument, Macon, Georgia, USA. The whitewashed curvilinear building, dotted with glass bricks and punctuated by rust-red horizontal bands with a Pueblo Deco-like pattern, contains a record of life in the region, from the ancient indigenous peoples up to the present day. *Curt Teich, 1943*

57 State Trade School, New Britain, Connecticut, USA. The Art Deco entrance to this rather plain brick structure, a vocational school training youngsters for the state's thriving industries, features stylized *moderne* lettering and decorative panels around the door. *Curt Teich, 1944*

58 High School, Benalla, Victoria, Australia. The darker, off-centre tower with its three soaring vertical elements is what makes this simple school building remarkable. The high school later merged with Benalla Technical School to become Benalla College. The date, architect, and present condition of this building are unknown. *'Valentine's Post Card'*

59 Nicanor Reyes Memorial Hall, Far Eastern University, Manila, Philippines. The founder of the university, Nicanor Reyes, Sr, desired a modern campus. After viewing Manila's Ideal Cinema (see p. 258) he commissioned from its designer, the Filipino architect Pablo Antonio (who had studied architecture in London), a series of buildings, built in 1938–50. Note the *moderne* lettering here. *Curt Teich, 1947*

60 St Joseph's Hospital, Alton, Illinois, USA. The card tells us that 'This beautiful ultra-modern hospital was opened Oct. 7th, 1937 and is conducted by the Sisters of Charity of St. Vincent de Paul'. The handsome box with glass brick side sections, brick striping, and a stepped pediment over the entrance is today part of St Anthony's Health Center; many of its Art Deco features survive. *Curt Teich, 1938*

61 The New St Michael Hospital, Texarkana, Arkansas, USA. This multi-stepped and streamlined building may have been built in the early 1940s; its architect is unknown. It was formerly run by the Texas-based Sisters of Charity of the Incarnate Word, but is now part of the Area Health Education Center Southwest. *Curt Teich, 1947*

62 Hall of Waters, Excelsior Springs, Missouri, USA. Taking the waters was a popular US pastime and recommended curative. The caption explains that this is 'the beautiful dispensary in the Hall of Waters where various mineral waters are served'. The fashionable tiled interior features Art Deco geometric and Mayan elements and lighting. The building now functions as city offices. *Tichnor Brothers*

63 Indian Sanatorium, Albuquerque, New Mexico, USA. Constructed in 1934 to the design of Hans Stamm by the Indian Service, this was, the card explains, 'for Indian patients, composed principally

of Southwestern Indians. Pueblo and Navajo Indians are treated for Tuberculosis at no charge. Non-Indians are not admitted.' Today it is Albuquerque Indian Hospital. *Curt Teich, 1938*

64 'Joie et Santé', Oostduinkerke, Belgium. The simple yet elegant *moderne* holiday home whose name means 'Joy and Health' was designed in 1934 by Maurice Ladrière for the Ligues Ouvrières Féminines Chrétiennes and Ligue des Travailleurs Chrétiens du Pays Wallon (Christian Women's Labour Leagues and League of Christian [Male] Workers of the Walloon Country). Run until around 1990, it has been torn down. *Ern. Thill, Bruxelles/NELS*

65 Beach Patrol Hospital at Steel Pier, Atlantic City, New Jersey, USA. This presumably first-aid/emergency hospital facility in the Nautical Moderne style at the famous resort resembles a beached boat, with

its porthole windows, streamlined curves fore and aft, and even a large funnel over the entrance. *Tichnor Brothers*

66 Shrine of the Little Flower, Royal Oak, Michigan, USA. Honouring the 'Little Flower', the French saint Thérèse of Lisieux, this elaborate granite and limestone complex of 1931–36 was designed by Henry J. McGill of Hamlin & McGill, and largely funded by the radio 'sermons' of its controversial right-wing pastor, Father Charles E. Coughlin.

67 Annie Pfeiffer Chapel, Florida Southern College, Lakeland, Florida, USA. The chapel of 1938–41 was the first of twelve buildings on the campus by Frank Lloyd Wright. Its decorative concrete and coquina (a local coral-like stone) blocks were cast on site; its geometric and decorative components, such as the pyramidal and square motifs, echo aspects of Art Deco structures, especially those of the Southwest. *Curt Teich, 1941*

68 Eglise du Sacré-Coeur, Casablanca, Morocco. The Church of the Sacred Heart (1930–52) was designed by the French architect Paul Tournon, who was known for his reinforced-concrete and religious structures, of which this is both. Its form is Gothic but its decoration is Art Deco. Today it is deconsecrated and used for cultural events. *Photo Flandrin, Casablanca*

69 Latter-Day Saints Temple, Idaho Falls, Idaho, USA. An imposing structure of reinforced concrete with cast stone, this was the first Latter-Day Saints temple with a central spire – a ziggurat-like tower supposedly inspired by a vision of an ancient Nephite temple seen by John Fetzer, Sr, one of the architects to whose design it was built in 1940–45. *Photo L. W. Bacon, Idaho Falls/ printed by Gravcraft Card Co., Danville, Va.*

70 *left* Grundtvig Church, Copenhagen, Denmark. This Lutheran church was designed

by P. V. Jensen-Klint and built in 1920–38 (after Klint's death in 1930 his son, Kaare Klint, took over the project). The façade with its dramatic stepped sections and minimalist ornament may appear Art Deco, but in fact it refers to earlier Danish architecture, notably the stepped-gable churches of Zeeland. *Carl A. Thejll's Kunsforlag*

70 *centre* Holy Trinity Church, Bloomington, Illinois, USA. The first purpose-built church of the Roman Catholic parish burned down in 1932, and in 1934 the new Art Deco style church was dedicated. Details include chevron motifs on the façade and tower and stylized wave patterns embellishing grillework over the front doors. *Curt Teich, 1934*

70 *right* Boston Avenue Methodist Church, Tulsa, Oklahoma, USA. The soaring church was created in 1929 by the architect Bruce Goff, of Rush, Endicott and Rush, and the art teacher Adah Robinson.

Her stylized sculptures symbolizing praying hands rise from the tower's top and from the walls. One of the finest US examples of Art Deco ecclesiastical architecture, it was named a National Historic Landmark in 1999. *Colourpicture*

71 Latter-Day Saints Seminary, Ogden, Utah, USA. This unassuming glass brick and porthole-windowed structure is where young Mormons were taught the Gospel of Jesus. The card's back tells us that it is 'located in the fashionable district beneath the shadow of beautiful Mt. Ben Lomand [*sic*]'. It seems that a new larger seminary now occupies the site. *E. C. Kropp*

72 *left* 'Tower in Memory of Loyal Souls Who Went on Their Last Journey during War', Dairen, China. A massive stepped pyramid, this structure was erected by the Japanese, who had acquired what is now Dalian (in present-day

Liaoning Province) after the 1904–5 Russo–Japanese War. The memorial was torn down after World War II.

72 *right* Monument to the Financial Independence of the Republic, Ciudad Trujillo (now Santo Domingo), Dominican Republic. The dictator Rafael Trujillo had this monument erected in the 1930s when the national debt was paid off. The capital was called after him from 1930 until 1961, when he was assassinated. The massive structure still stands on the waterfront, it seems, but is now painted all white. *Curt Teich(?), 1948*

73 *left* Wright Memorial, Kill Devil Hills, North Carolina, USA. The wing-shaped granite monument commemorates the pioneering flights by the brothers Orville and Wilbur Wright in 1903 near the hill on which it stands. By Rodgers and Poor, it was dedicated in 1932. *Miller Art Co.*

73 *right* Coit Memorial Tower, Telegraph Hill, San Francisco, California, USA. A bequest of the wealthy socialite Lillie Hitchcock Coit funded this 1931 monument to city firefighters, a reinforced-concrete tower designed by Arthur Brown, Jr, and Henry Howard. *Scenic View Card Co., San Francisco, Cal., Nature Tone Views*

74 The Rocks, Fort Christiana (Christina) Park, Wilmington, Delaware, USA. The black granite monument marks the spot where Swedish colonists landed in 1638. Created in 1938 by the Swede Carl Milles, then sculptor in residence at the Cranbrook Academy of Art, it is topped with a stylized model of the *Kalmar Nyckel*, one of the colonists' ships, and carved with images of the colony. (The location, Fort Christina, is misspelled on the card.) *Curt Teich, 1938*

75 *left* World War Memorial, New Britain, Connecticut, USA. Located in Walnut Hill

Park, this monument of 1928–32 honouring the fallen of World War I is in the form of a slightly tapered dodecagonal column, surmounted by a huge stylized eagle. The architect was Harold Van Buren Magonigle. *American Art Post Card Co., Boston, Mass.*

75 *right* Tower of Legends (Singing Tower), Sioux City, Iowa, USA. The bold Constructivist 60-carillon bell tower and Streamline Moderne lower structure are made of reinforced concrete, glass bricks and alumite (anodized aluminium). The monument was used for Sunday concerts in Memorial Park Cemetery, incorporated in 1936, and includes glass-fronted niches, presumably for urns. *E. C. Kropp*

76 Town Hall, Zelo Buon Persico, Italy. The 'Casa del Popolo' is a Streamline Moderne delight in this real photo card, made even more appealing by the jaunty car posing in front of it. After the Second World War it was

stripped of its Fascist-era elements and given pitched roofs; only the porthole windows remain. *Foto-Stampa N. Marangoni, Milano*

77 Post Office, Bar-le-Duc, France. The Art Deco-style space in the 1925 'Hôtel des Postes' by Guillaume Tronchet was stunning to behold, with stepped, chevron and Cubist decorative motifs as well as architectonic and transportation images. *Editions Artistiques 'OR' Ch. Brunel – Reims, postmarked 1933*

PLACES TO STAY OR LIVE

78 Hotel St George, Brooklyn, New York, USA. Once the world's largest hotel, across the river from Manhattan (note the Brooklyn Bridge), the hotel was built between 1885 and 1929, culminating in the Art Deco-period 30-storey tower with 1,000 rooms by the architect Emery Roth. Occupying a whole city block above the Clark Street subway station, the building is now a multi-use complex.

80 *left* Delano Hotel, Miami Beach, Florida, USA. The winged forms atop the hotel at 1685 Collins Avenue bring to mind the aerodynamic shapes on New York's Empire State Building. The *moderne* creation of 1947 by Robert Swartburg is still awe-inspiring, painted white, with a surreal interior of 1995 by French designer Philippe Starck. *Colourpicture*

80 *right* Alto Tourist Court, New Orleans, Louisiana, USA. Tourist courts were proto-motels that sprouted up in the 1930s–50s when cars became the preferred method of travel and more highways were

...

Imperial Suite 'Huzi' of the Japanese ship *Argentina Maru*, 1938

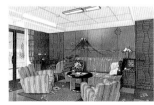

constructed. With its porthole windows, streamlined curves, and red and white palette, the Alto was a Southern variant on the Nautical Moderne theme. *'Bursheen Finished' MWM*

81 Coral Court, St Louis, Missouri, USA. This legendary Streamline Moderne motel was designed by Adolph L. Struebig and Harold Tyrer and built in 1941–48. The complex consisted of bungalows of honey-coloured glazed ceramic bricks, glass brick walls and brown tile trim. When it was torn down one unit was saved, and in 2000 it was at the Museum of Transportation in St Louis. *Tichnor Brothers*

82 Hotel Normandie, San Juan, Puerto Rico. The Streamline Moderne hotel was designed by Raúl Reichard for the Puerto Rican engineer Félix Benitez, who built it in 1942 for his French wife, a dancer known as La Môme Moineau. The couple had met aboard the liner *Normandie* (see pp. 220–21), which

inspired the nautical-themed haven. As of late 2010 it was closed, but it remains a star piece of Art Deco architecture. *Tichnor Brothers*

83 Veroes Building Apartments, Hotel Anauco, Caracas, Venezuela. Somewhat dreamily isolated on this card, the building is really on the busy Avenida Urdaneta. It was designed in the early 1940s by the architect–engineer Gustavo Wallis Legórburu, who had worked with Albert Kahn in Detroit. Today the building is no longer residential. *Colourpicture*

84 Midland Hotel, Morecambe, England. Spirally twisted piers stand at the entrance to this sweeping white comma whose curve echoes the beach beyond it. The hotel, of 1933, was designed by Oliver Hill to be 'a building of international quality in the modern style'. It is rich with marine references, including two seahorses on the central feature. After years of neglect it was carefully restored

and reopened in 2008. *Matthews, Bradford*

85 Wrest Point Hotel, Hobart, Tasmania, Australia. The Wrest Point Riviera was developed by the entrepreneur Arthur Drysdale from 1936, and he and his architects, Colin Philp and David Hartley Wilson, sought to create an outstanding hotel reflecting 'the atmosphere of an ocean liner berthed in the Derwent'. Happily it survives. *Terry Turle Photo, postmarked 1958*

86 Winterhaven Hotel, Miami Beach, Florida, USA. The self-styled 'ultra modern' hotel, designed by Albert Anis in 1939, looks imposingly tall on this vertical card. Located at 1400 Ocean Drive, it was distinguished by its raised central feature with concertina sections and its corner overhangs. It was completely restored in 2000, but the vertical sign at the top no longer exists. *Curt Teich, 1945*

87 *left* Hotel New Yorker, Miami Beach, Florida, USA. A streamlined beachfront beauty of 1939 by Henry Hohauser (see also p. 105). Despite preservationists' efforts to save what many deemed the architect's finest creation, in 1981 it was torn down, prompting the city to enact laws to protect listed properties. The New Yorker's façade lives on as the Miami Design Preservation League's logo. *Curt Teich*

87 *right* The Raleigh, Miami Beach, Florida, USA. L. Murray Dixon, a prolific Miami Beach hotel designer in the Art Deco era, created this asymmetrical beachfront high-rise in 1940. At 1775 Collins Avenue, it curves from top to bottom on its corner to 18th Street. It received a major facelift in the early 2000s courtesy hip hotelier-owner André Balazs, who kept its Art Deco exterior but infused the building with 21st-century luxuries. *Colourpicture*

88 Planeta Palace Hotel, Atlántida, Uruguay. In 1935 the Italian Natalio Michelizzi visited the Atlántida region, on Uruguay's Gold Coast east of Montevideo; there he soon bought land, and commissioned Pérez Butler y Pagano to build this futurist Nautical Moderne hotel. The massive stepped structure was long a luxurious international tourist destination. The card was posted from Uruguay to Germany in 1937.

89 Colonia Fara, Chiavari, Italy. This summer colony on the Ligurian coast was commissioned by the National Fascist Party, built in 1935–36, and opened in 1938; the streamlined Italian Rationalist structure was designed by Camillo Nardi Greco and Lorenzo Castello. Abandoned for some time, it was bought in 2010 by a group whose goal is to transform the complex into a luxury resort and health spa.

90 Florida Court, Asheville, North Carolina, USA. 'Asheville's most distinctive motor court' had a grand stairway leading to a curved entrance with a fluted hat-like top, and was painted pale green. It appears painted pink on a 1961 chrome post card, and was demolished some time after that. *Tichnor Brothers*

91 'One of the Beautiful Residences', Dyersburg, Tennessee, USA. With its glass brick walls and cantilevered overhang, this streamlined Tropical Moderne house would not be out of place in Miami Beach. Its architect and address are unknown. *Curt Teich, 1942*

92 Hotel Waterloo, Wellington, New Zealand. The podium-style Art Deco hotel at 28 Waterloo Quay was built in 1937 for New Zealand Breweries, and hosted Queen Elizabeth's retinue on her 1953 Coronation Tour. Since 1991 it has been a backpackers' hostel, externally virtually unchanged. The cars date the card to the late 1950s. *Scenic New Zealand, N. S. Seaward's Studio, Broad Bay, Dunedin*

93 *left* Kavanagh Building, Buenos Aires, Argentina. Using up most of her inheritance, Corina Kavanagh commissioned local architects Gregorio Sánchez, Ernesto Lagos and Luis Maria de la Torre to build her a Manhattan-style 105-apartment building at 1065 Florida Street in 1934–36; she herself occupied the 14th floor. The austere Art Deco/Modernist reinforced-concrete structure still stands tall. The card was sent by the timpanist Karl Glassman, on tour with the NBC Symphony Orchestra, in 1940.

93 *right* Apartment Buildings, Villeurbanne, France. A hand-tinted card shows two 19-storey stepped towers flanking the avenue Henri Barbusse in the Lyon suburb of which they have become the symbol. The first skyscrapers to be built in France, they were designed by Môrice Leroux and built in 1927–34; they have since been renovated. *Les Éditions J. Cellard, Bron*

94 Streamline Hotel, Daytona Beach, Florida, USA. This 1940s hotel at 140 South Atlantic Avenue was an early fireproofed structure; its architect is unknown. In the Ebony Bar here on 21 February 1948 the National Association for Stock Car Auto Racing (NASCAR) was founded; it is still headquartered in the city. The Streamline Moderne building no longer has its Deco signage, but it is still a hotel. *E. C. Kropp*

95 Hotel Florence, Missoula, Montana, USA. Built in 1941 by G. A. Pehrson and Alloway & George, the Streamline Moderne hotel at 111 North Higgins Avenue appealed to motorists with its interior parking garage. In the early 1990s it was restored and adapted for re-use by the local firm of A&E Architects, who added a one-storey extension of sympathetic design. *Robbins-Tillquist Co., Spokane, Washington*

96 The Parlour, Cumberland Hotel, London, England. The huge luxury hotel at Marble Arch, designed by F. J. Wills in 1933, still functions, but this sparkling space with its stylish light fixtures, geometric patterned rugs and streamlined, stepped motifs on frosted-glass wall partitions is no more. Oliver P. Bernard, designer of the spectacular Strand Palace Hotel entrance (p. 97), also worked on the Cumberland. *Kingsway/Real Photo Series*

97 Strand Palace Hotel foyer, London, England. The 1909 hotel was refurbished in 1930 by Oliver P. Bernard, also a designer of theatre and opera sets. The new foyer featured walls sheathed with pale pink marble, geometric motifs, and elements constructed of such new materials as translucent moulded glass and chromed steel. In 1969 the foyer was removed and subsequently acquired by the Victoria & Albert Museum, which in 2003 partly reconstructed

it for the exhibition *Art Deco 1910–1939. Bridge House/Real Photo Series*

98 Lobby, Prince of Wales Hotel, Waterton Lakes National Park, Alberta, Canada. Depicted is a painterly twilight scene in this 1926–27 resort hotel, which boasts *moderne* touches inside a structure akin to a massive Alpine chalet. It was named in anticipation of the Prince of Wales's visit to Canada in 1927; he did not stay there, but Prohibition-era Americans were attracted to stay, and drink. *Curt Teich, 1937*

99 Lobby, Hotel Elliott, Des Moines, Iowa, USA. This Midwestern hotel dated back at least to the first decade of the 1900s, but its lobby underwent some modernization: note the geometric-patterned carpeting under the seating, pastel stripes along the walls, the lighting, and the decorative motif behind the desk at the rear. *Curt Teich, 1937*

100 Marine Drive, Bombay (now Mumbai), India. A ribbon of streamlined residential buildings curves round the coast of India's financial hub and most populous city. Semi-tropical Mumbai has been called a worthy counterpart of Art Deco-rich Miami Beach, with the relatively intact collection of seafront buildings in Marine Drive the equivalent of South Beach's Ocean Drive.

101 Park Hotel, Shanghai, China. The 1934 structure of Chinese black granite, brown brick, and ceramic tile in Nanjing Road was designed by the Hungarian architect Ladislav Hudec. With its 22 storeys, until 1952 it was not only Shanghai's but Asia's tallest building. The Art Deco lobby was restored by the American architect Christopher Choa in 2001.

102 Hotel Ibo Lele, Port-au-Prince, Haiti. Located in Pétionville, a wealthy hillside suburb that was to suffer greatly in the 2010 earthquake, the hotel was the family villa of its designer, Robert Baussan, who had studied in Paris under Le Corbusier before returning to Haiti in the 1940s. It has an earlier tropical *moderne* look to it, with its colourful wall-paintings and streamlined wicker furniture.

103 The Surrey, Miami Beach, Florida, USA. The sprawling U-shaped hotel in the Indian Creek area offered patrons – according to this card – a private beach, swimming pool, coffee shop, cocktail lounge, solarium and outdoor dancing. It also appears, painted white, on a 1955 Teich chrome, and was in operation as a hotel until at least 1967. The site it seems is now a parking lot. *Colourpicture*

104 Imperial Hotel, Tokyo, Japan. Frank Lloyd Wright looked to Japanese and Western architecture in the design of the expansive hotel of 1923 – built mostly in concrete and *oya* stone, an easily carved rock – marked by decoration including Cubistic figures, pyramids, stepped sections and spheres. It survived the great earth-quake later the same year, as it did wartime bombs, but it was torn down in 1968 to make way for a high-rise hotel. The façade and pool seen on this card were saved and are on view at the Meiji Mura Museum near Nagoya.

105 Taft Hotel, Miami Beach, Florida, USA. Designed in 1936 by Henry Hohauser (see also p. 87), the hotel at 1040 Washington Avenue is rich in Art Deco ornament, from stylized organic forms to Zigzag Moderne motifs. It and two nearby Art Deco hotels now form the Wyndham Garden Hotel. *Colourpicture*

106 Cavalier Hotel, Miami Beach, Florida, USA. Roy F. France designed the hotel, which boasted among other things 'Individual Roof Solariums', in 1936. Its strong rectilinearity, broken up by panels of stylized organic ornament, makes it more like a French Art Deco creation. On the beach at 1320 Ocean Drive, it was renovated in 2008–9. *Curt Teich, 1937*

107 Beresford Hotel, Glasgow, Scotland. The reinforced-concrete structure at 460 Sauchiehall Street, the city's first tall building, was designed by William Beresford Inglis of Weddell & Inglis for visitors to the 1938 Empire Exhibition (see p. 24). After serving various purposes for decades, in 2003 it was sold and converted into a mixed-use residence whose exterior more closely echoes that of the original, which sported mustard, black, and red faïence details. The artist of this card is unknown.

PLACES TO EAT AND DRINK

108 Frecker's Malted Milk Shop, Columbus, Ohio, USA. The card tells us there were three Frecker's establishments, but not the city where they were located – Columbus, Ohio.

Despite their name, all served breakfast, lunch, and dinner. This branch, at 67 East State Street, had a minimalist façade: from the porthole window the white 'eyebrow' extends to the right, with lights below and 'RESTAURANT' in stylish capitals above. *Curt Teich, 1937*

110 Lobby and Foyer, Chez Paree Theater Restaurant, Chicago, Illinois, USA. What a Chicago columnist called 'the most glamorous night club in history', at 610 Fairbanks Court, is seen here probably in the 1930s (the founding co-owner Mike Fritzel is cited as 'Host' on the back). The pale pinks and blues, elegant grays, Greek key pattern around the doors, and veneered furniture give the room a sophisticated look evocative of Paris between the wars. *E. C. Kropp*

111 Lobby and Foyer, Chez Paree Theater Restaurant, Chicago, Illinois, USA. This shows the same interior as in the previous view, a decade or two later. It is now a more Hollywood Moderne theatrical space, with burlesque-style mermaids on the walls. The banquette seating is the same, but the tables now look more Streamline Moderne than French. *E. C. Kropp*

112 Cocktail Lounge, Hotel Schroeder, Milwaukee, Wisconsin, USA. The 1928 hotel – built in Art Deco style by Chicago's Holabird & Roche – featured this 'Dazzling and Luxurious Cocktail Lounge' with an '82-foot Serpentine Bar In a Quarter-Million-Dollar Empire Setting' and female nudes on two panels above the bar. The hotel is now known as the Hilton Milwaukee City Center. *Curt Teich, 1940*

113 Joseph Urban Room, Congress Hotel and Annex, Chicago, Illinois, USA. This space was named after its designer, the Viennese-born architect Joseph Urban. The hotel (now the Congress Plaza) was built in 1893 to lodge World Fair visitors. Urban transformed its Elizabethan Room into a 'supper room' that in the mid-1930s aired Benny Goodman's radio show. *E. C. Kropp*

114 Ye Eat Shoppe, New York City, USA. The restaurant in 8th Avenue between 45th and 46th Streets, popular with the show-business community, had Art Deco lighting fixtures and theatrical-themed murals as a setting for its tables and counter. This illustration is signed and noted 'Drawn from life' by Edward C. Caswell. The time is the 1940s, and all the women are wearing hats. *Lumitone Photoprint*

115 Terrace Garden, Morrison Hotel, Chicago, Illinois, USA. Modishly coiffed and dressed flappers and their beaux are enjoying the dine-and-dance venue described as 'Chicago's Wonder Restaurant'. The world's tallest hotel when it was built in 1925, the Morrison, designed by Marshall and Fox, was demolished forty years later to make way for what is now Chase Tower. *Western P. & L. Co., Racine, Wisc.*

116 Barrett's Bar and Cocktail Lounge, Wisconsin Dells, Wisconsin, USA. Barrett's must have been a standout in this resort town, not only because of its striking façade – seen in the small inset – but also because of its dazzling interior, as Streamline Moderne as they come. Somewhat in contrast to its showy looks, the venue is described on the back of the card as 'a quiet place to meet your friends'. *E. C. Kropp*

117 Cocktail Lounge, Melody Lane Restaurant, Los Angeles, California, USA. This restaurant at 744 South Hill Street was a blend of traditional and *moderne* – the former in the square wooden stools and patterned floor, the latter in the streamlined mirrors, horizontal white elements and cylindrical metal lamps over the bar, and subtle pastel palette. The card is probably from the 1930s. *E. C. Kropp*

269

118 Mayfair Hotel, Kings Cross, Sydney, Australia. Sidney Ward was the architect of many hotels – really pubs offering accommodation – for New South Wales's major brewery, Tooth and Co., including this handsome structure of 1937. Except for its sober cladding, the central-turreted, curvilinear building could have been on the oceanside in Miami Beach. It no longer exists.

119 *left* Court Café, Albuquerque, New Mexico, USA. The plain storefront of 111 North Fourth Street was elegantly transformed in Pueblo Deco style by tilework, a neon sign, and ziggurat motifs. Inside, murals depicted local history. A 'handwritten' note printed on the card reads: 'P.S. I certainly had a wonderful dinner here'. *Curt Teich*

119 *right* Kents Restaurant, Atlantic City, New Jersey, USA. The exaggeratedly tall storefront of this Kents (no apostrophe) Restaurant,

installed in 1927 at 1214 Atlantic Avenue – one of three Kents in Atlantic City – featured Art Deco motifs: stylized floral bas-reliefs, zigzag and wave elements, and a sunburst window frame. The restaurants are long gone, with a park now in their place. *Curt Teich*

120 Tai Shan Restaurant, San Antonio, Texas, USA. A San Antonio eatery with a distinctive tower feature was 'The South's finest Chinese-American Restaurant – where fine food reaches celestial heights'. The curvilinear glass-brick structure at 2611 Broadway still exists, without its monumental sign, as the Fiesta San Antonio Commission Building. *Colourpicture*

121 M.A.C. Cocktail Room, Milwaukee, Wisconsin, USA. This Art Deco cocktail bar in the Milwaukee Athletic Club M.A.C. – at Broadway and Mason Street was called the Snake Pit. In this card of *c.* 1935 note the room's

geometric floor design, curvaceous bar with metallic trim, wall paintings of *moderne* dancers, and etched-glass bar panels awash with stylized waves, clouds, sunrays, and female nudes. The bar closed many years ago.

122 Whitey's Wonder Bar and Café, East Grand Forks, Minnesota, USA. Edwin 'Whitey' Larson opened a lunchroom in 1925 and changed its name to Whitey's Wonder Bar in 1930. It boasted the USA's first stainless steel horseshoe bar (by the local architect Samuel DeRemer), celebrated in this card with its bright colours and geometric details. The interior is now part of Whitey's Steaks & Seafood at 121 Demers Avenue. *Curt Teich, 1935*

123 Tops in Taps, Rockford, Illinois, USA. A handsome card that has a great *moderne* look, with its inset drawing of the lacquer-red façade of this air-conditioned bar, which featured entertainment, 'across

from City Hall'. *J. A. Fagan, Madison, Wisc.*

124 Paul's Luncheonette, Troy, New York, USA. The booths of what called itself 'The Restaurant Unusual', at 295 River Street, were surrounded by a cheery wall design with a bold stepped Art Deco pattern. It is long gone. *Curt Teich, 1944*

125 Vogel's Restaurant, Whiting, Indiana, USA. With its stepped, streamlined overdoor sign, curved entryway windows, and glass-brick components, this plain box of a building in Indianapolis Boulevard assumed a Streamline Moderne look. In business since 1922, the restaurant, continuously run by Vogel family members, was demolished in 2006. *Curt Teich, 1945*

126 Latin Quarter Night Club, Miami Beach, Florida, USA. This exclusive 'smart night club' in man-made Palm Island, a sublime Streamline

Deco structure under the mottled pastel sky, with its graceful symmetry and subdued colour touches, featured the likes of Jack Benny, Martin and Lewis, and Frank Sinatra as well as Latin music. Closed by 1968, it was later torn down. *Colourpicture*

127 Richard's Drive In, Denver, Colorado, USA. This Streamline Moderne eatery stood at 2615 South Broadway. Note the cars pulled up to the 'drive in'. The pastel glow from the curved corners of glass blocks and the white light coming down from the curved overhang give this nocturnal view an otherworldly look. Among the items on offer were 'Good and Bad Liquor', 'Thick Steaks', and 'Denver's Best Hamburger'. *Curt Teich, 1948*

128 The Rendezvous, New Hotel Jefferson, St Louis, Missouri, USA. In a hotel built for the 1904 World Fair, this stylish spot sports an Art Deco bar, smart tables, and stageside ornamental metalwork. (Sadly,

a 1940s card shows the bar's glass front replaced by tufted fabric.) *Curt Teich, 1934*

129 New Henry Bar and Rathskeller, Hotel Henry, Pittsburgh, Pennsylvania, USA. The geometric designs and streamlined elements, and a striking colour scheme, distinguish this interior. The floor's circular pattern with four arms is echoed in the mirror on the wall. 'One of Pittsburgh's Newest and Smartest Rendezvous' was an feature in the forty-year-old hotel. *Curt Teich, 1936*

130 Earl Abel's, San Antonio, Texas, USA. Silent-film organist Abel, made jobless by the talkies, opened this eatery on Highway 81 in 1933 and went on to own six more. (The present one in San Antonio is on a different site and under different management.) This striking nocturnal view shows off the red-neon-lit central tower and *moderne* sign above three glowing neon rings. *'Bursheen Finished' MWM*

131 Horn & Hardart Automat, New York City, USA. 'Automat' cafeterias, with glass-doored niches offering sandwiches, pies and the like, and elaborate machines dispensing hot drinks, all in return for coins, were started by Joseph Horn and Frank Hardart in Philadelphia in 1902; eventually New York City had forty, including this one at West 57th Street and 6th Avenue. Playwright Neil Simon called them 'the Maxim's of the disenfranchised'. A *New York Times* article of 1991, chronicling the closure of the last one, lamented 'the golden age of Automats, whose Art Deco décor was as luscious as the lemon meringue'. *Lumitone Photoprint*

132 The White Drum, Orange, Massachusetts, USA. Resembling its name, but also immediately identifiable as a diner-like Streamline Moderne eatery, the White Drum, on Western Massachusetts's Mohawk Trail (Route 2), still stands, but now it serves Asian

food. This is a somewhat unusual duotone card without a surface. *Curt Teich, 1937*

133 Hightstown Diner, Hightstown, New Jersey, USA. One of dozens of train-inspired, prefabricated eateries of stainless steel, chrome and glass dotting US roadways from the 1930s through the 1950s (and sometimes later), this Streamline Moderne jewel was opened in the early 1940s by Nick and Mary Mastoris. It no longer exists; a present-day Mercer Street Hightstown Diner bears no relation to it. *Curt Teich, 1949*

134 Airway Diner, San Diego, California, USA. This diner was made up of two railway cars, 'part of an actual train that operated between San Diego and Old Mexico years ago', on US 101 across what is now San Diego International. It opened in 1935; in 1942 the fountain, drive-in, canteen and patio seen at the top were added. *'Bursheen Finished' MWM*

135 Saratoga Café and Cocktail Lounge, Phoenix, Arizona, USA. Porthole windows, a black-tiled façade, and a window with a geometric pattern above a shiny metal door are exterior details that help date this Southwestern eatery and bar to the Art Deco period. It was in business as early as 1925, but is long gone. *Colourpicture*

136 Techau Cocktail Lounge, San Francisco, California, USA. 'San Francisco's most beautiful refreshment salon' was at Powell and Geary, home of the old Techau Tavern. With its Streamline Moderne bar, leather booths, wood panelling, and floor-to-nearly-ceiling *moderne* décor, it was one of the poshest cocktail bars in town. The spot is today occupied by the Gold Dust Lounge. *Curt Teich, 1941*

137 Bon Ton Restaurant, Keene, New Hampshire, USA. The typeface used for the name in the middle of this richly detailed card of the 1930s and on the restaurant's façade is as stylish and modern as something by a noted European artist-designer such as A. M. Cassandre or Eric Gill. The Bon Ton is no longer, but traces of its interior survive in 45-47 Main Street, occupied since 2007 by Fritz's, The Place to Eat. *Colourpicture*

138 Lauer Sisters' Restaurant, Chicago, Illinois, USA. Located at 63rd and Normal in the Windy City's South Side, this was a popular eatery with two separate dining areas, the one pictured here more informal and diner-like, with its counter at the right, under a robin's-egg-blue ceiling. *Curt Teich, 1934*

139 Cocktail Lounge, Grand Hotel, Mackinac Island, Michigan, USA. The blue, yellow and black colouring of this card gives the room a curious unreal air. The 'world's largest summer hotel', built in 1887, was designated a National Historic Landmark in 1989. *Curt Teich, 1935*

140 Hotel Jordan Tap Room, Glendive, Montana, USA. One of the most colourful and dreamy images of a bygone cocktail lounge, this striking linen presents a pure fantasy of geometry, colour coordination and streamlining, with a fillip at each side in the form of a beribboned star in a bright yellow border. *Curt Teich, 1940*

141 The Gazelle Restaurant, Cleveland, Ohio, USA. The restaurant's namesake animal was a popular Art Deco subject, often elegantly depicted in a balletic leaping stance, as here in the main dining room and on the façade at 1132 Euclid, which gleamed with shiny metal and black sheathing (possibly Vitrolite). *Curt Teich, 1940*

142 Hoe Sai Gai Modern Room, Chicago, Illinois, USA. This Chinese restaurant in West Randolph Street – its name means 'prosperity' – was modernized at great cost in 1937. The fancy red columns, curvilinear partitions, and chrome and glass elements are thought to have been designed by L. Byron Fanselow. The building was torn down in the 1960s. *Curt Teich, 1939*

143 Cocktail Lounge and Bar, Hotel Jermyn, Scranton, Pennsylvania, USA. With its tubular metal furniture, stylish murals, modish lighting, and three-times-a-night floor show, this dazzling venue demonstrated that the Jermyn, originally built in 1895, was by the mid-1930s in step with contemporary Paris and New York design. *Curt Teich, 1935*

PLACES OF ENTERTAINMENT

144 Savoy Ballroom, New York City, USA. Owned by the Jewish Moe Gale and run by the African American Charles Buchanan, the 1926 venue was one of the first racially integrated public places in the USA. Before closing in 1958, the Savoy featured world-class floor shows, dancers and musicians, including Ella Fitzgerald,

Dizzy Gillespie, and Charlie Parker. *Colourpicture*

146 Roseland Dance Hall, New York City, USA. Touted as 'America's Foremost Ballroom', the Roseland in Manhattan was 'the eighth wonder of the age . . . with its extravagant and luxurious surrounding appointments . . . The best music in the world would not make a perfect Roseland without the . . . environment that we pictorially herewith present'. *E. C. Kropp*

147 West Flagler Kennel Club, Miami, Florida, USA. The entrance to this structure (architect unknown) is a gem of Streamline Moderne design, topped by a sign with stylish modern lettering and, at the sides, illuminated crown-type forms. The track opened in 1930. *Tichnor Brothers*

148 City Auditorium, Superior, Nebraska, USA. This small-town auditorium, funded in 1936 by the Public Works Administration, is a handsome

Art Deco structure with gentle curves, stepped elements, and pleasing massing. It closed in 1997; a project is planned to transform it into a performance space. *Curt Teich, 1947*

149 Downtown Bowl, San Francisco, California, USA. The 1940s–60s were the golden age of ten-pin bowling, at the start of which this 40-lane alley, with a façade like an Art Deco cinema marquee, opened. It was demolished in 1978. *Curt Teich, 1942*

150 Hollywood Bowl entrance, Hollywood, California, USA. This striking real photo card depicts a 1940 stepped fountain shell. Towering over the fountain is the granite *Muse of Music*, designed by George Stanley, who also created the Oscar® statuette. The band shell was rebuilt in 2003–4, retaining the original's distinctive concentric-ring interior. *Bob Plunkett*

151 Interior of the Theatre, New Casino, Catalina Island,

California, USA. Among the attractions in the Casino, opened in 1929, which had no gambling, was a large cinema. This shows the back wall of the vividly hued mural, featuring allegorical figures and local flora and fauna, painted by artists working under John Gabriel Beckman. Note, too, the Art Deco sculptural masks over the doors. *Curt Teich*

152 Music Hall, Municipal Auditorium, Kansas City, Missouri, USA. This Streamline Moderne Music Hall in the mid-1930s Art Deco landmark designed by Hoit, Price & Barnes and Gentry, Voskamp & Neville, as grand as an international opera house (see also p. 174), continues to be available for meetings, concerts, etc. *Curt Teich, 1937*

153 Waikiki Theater, Honolulu, Hawaii. A Tropical Moderne movie palace designed by C. W. Dickey in 1936, the Waikiki boasted a lush forecourt with garden and fountain, and an interior with

'clouds' projected on a deep-blue curved ceiling, striking murals and an imposing organ. The theatre was demolished in 2005. *Postmarked 1941*

154 Teatro Opera, Buenos Aires, Argentina. Here is a dramatic image of a 1936 theatre and cinema in Avenida Corrientes (not to be confused with the city's opera house, the Teatro Colón), designed by the Belgian–Argentine architect Albert Bourdon. The Opera presented films, tango concerts, and performers such as Louis Armstrong and Edith Piaf. It was rescued and remodelled in 1998 as a live-act theatre, a success that led to the passage of the National Theatre Law to aid distressed theatres.

155 *left* Liberty Cinema, Bombay (now Mumbai), India. Conceived in 1947 – the year of Indian Independence – by the British architect M. A. Riddley Abbott, it was completed after his death in altered form in 1950 by John Berchmans Fernandes and Waman

Moreshwar Namjoshi. It retains its striking façade with a corner fin bearing the cinema's name, and also public areas rich in marble and teak and fine ornamental metal grilles.

155 *right* Petit Casino de Vichy, Vichy, France. This entertainment venue of 1929, its façade rich in Art Deco ornament, was designed by Anthony Chanet and Jean Liogier. For many the building will always be connected to the wartime Vichy Government, when members of the French resistance were tortured here, but today it is thriving as the Centre Culturel Valéry Larbaud.

156 Metro Cinema, Durban, South Africa. The Scottish-born American theatre architect Thomas W. Lamb designed this multi-stepped cinema in Smith Street in 1957. Once Durban's principal MGM moviehouse, boasting a fine Wurlitzer organ, it is now closed. *Lynn Acutt, Durban, S. A.*

157 Modernistic Room, Napanoch Country Club, Napanoch, New York, USA. The Barrow Farms Inn in Ulster County became the Napanoch Country Club in 1925; its 'Modernistic Room' was doubtless one of the most stylish spaces outside of Manhattan. Note the stepped corner dressing table with triangle-themed chair and the lively patterned rug and cushion covers. *The Albertype Co.*

158 New Swimming Pool, Riverview Beach, Pennsville, New Jersey, USA. Set in an old picnic grove that became an amusement park, this Olympic-size swimming pool and Art Deco bathhouse opened in 1936. The back of the card boasted '60,000 gallons of purified water per hour. . . . Everything for the comfort of the patrons.' The funfair attractions and pool are long gone. *Curt Teich, 1936*

159 Prom Ballroom, St Paul, Minnesota, USA. A live-acts venue as well as a dance hall, this opened in 1941 with Glenn Miller and his orchestra. With its vast maple floor and geometric and zigzag designs surrounding the stage, over the years it hosted entertainers including Count Basie and Buddy Holly before being torn down in 1987. *Curt Teich, 1941*

160 Marine Studios, Marineland, Florida, USA. 'The world's only oceanarium' opened in 1938, many of its structures nautically inspired examples of Streamline Moderne, offering habitats for aquatic life and feature-film facilities. Clint Eastwood's 1955 film debut – in an uncredited role as a lab technician – was in a horror movie filmed at Marineland, *Revenge of the Creature*. Closed in 1999, it reopened in 2006 as an educational and research facility. *Curt Teich, 1946*

161 Aquatic Park, San Francisco, California, USA. William Mooser, Sr, and William Mooser, Jr, designed the ocean-liner-like Streamline Moderne Bathhouse. In 1951 it became the San Francisco Maritime Museum. *Colourpicture, 1939*

162 Sonotorium Harmon Park, Kearney, Nebraska, USA. This stepped Art Deco structure of 1938 was described as an open-air theatre with 'spreading concrete wings which house an electric sound system capable of being heard for any distance from a few feet up to a mile or two'. *Miller Art Co.*

163 Sailing Club, Vigo, Spain. The Real Club Náutico de Vigo is one of Spain's premier sailing clubs. It was designed in 1944 by Francisco Castro Represas in Nautical Moderne style, with the look of a ship at her berth. *Ed. Arribas, postmarked 1953*

164 Folies Bergère, Paris, France. The name alone evokes the racy Jazz Age in the City of Light, and performers such as Loïe Fuller, Charlie Chaplin and Josephine Baker

took to its stage. The façade was – and is – dominated by Georges Picot's mammoth 1920 bas-relief of an exuberant *moderne* dancer, and characterful Art Deco lettering. *Les Éditions Artistiques/A. Leconte, Paris*

165 Boardwalk at Night, Wildwood-by-the-Sea, New Jersey, USA. The absence of distracting signs on the façade of this presumably retail structure gives the card an evocative, mysterious look, the neon-lit building glowing bright against the night sky. The strollers reflect a time when people dressed up to take a summer evening promenade. *Curt Teich, 1946*

166 Palazzo del Cinema, Lido, Venice, Italy. This nautically inspired curvilinear-sided cinema of 1937 by Luigi Quagliata was long the centrepiece of the Venice Film Festival. In the early 1990s it was due to be replaced by a larger theatre, but the idea was quashed and it was

preserved, with newer and larger venues for the festival. *Stab. Grafico Cesare Capello, Milano/Cecami*

167 Hill Theatre, Paulsboro, New Jersey, USA. A subtly toned postcard shows the handsome movie palace in West Broad Street, designed in 1938 by William Harold Lee. The building is now Hill Studio & Scenic. *Mayrose Co., New York*

168 Casino Bath-Galim, Haifa, Palestine (now Israel). A hand-tinted card with Roman and Hebrew lettering, this depicts a striking Modernist casino – for gathering, not gambling – built in 1934 in Bath (or Bat) Galim, which means 'Daughter of the Waves' in Hebrew. Its designer was Alfred Goldberger, an immigrant from Vienna. Today only the bare bones of the structure remain. *Palphot, Hertsliya, Palestine*

169 Fourth Avenue Theatre, Anchorage, Alaska, USA. Construction of this Streamline

Moderne movie palace began in 1941 and ended after the Second World War in 1947. A characteristic design by the Glasgow-born architect B. Marcus Priteca, with soaring vertical signage, it is set to become a venue for the Anchorage Convention & Visitors Bureau.

170 Home of Worsham Post 40, American Legion, Henderson, Kentucky, USA. This mid-1930s structure was designed by Alves Clore for the local branch of the war veterans' organization. It is now painted Miami-style in pale shades of pink and blue. *Art Tone 'Glo-Var' Finished – Made Only By Beals, Des Moines, Iowa*

171 Loyal Order of Moose, Williamsport, Pennsylvania, USA. The striking lodge was built in 1940 and occupied by the Moose for some fifty years. New owners renovated it, exploiting its Art Deco characteristics, and turned it into a restaurant, 33 East. There is still a roundel over

the doorway, but the moose head has been covered up. *The Mebane Greeting Card Company, Wilkes-Barre, Pa.*

172 Open-air Festival, Szeged, Hungary. The card shows a scene from a production of Imre Madách's *The Tragedy of Man*, an 1861 dramatic poem featuring Adam, Eve and Lucifer, in the 1920s or '30s: the skyline behind the stage is a jumble of overlapping skyscrapers eminiscent of Fritz Lang's Expressionist film *Metropolis* of 1927. A note in Hungarian on the card's back says that the image was shot by Liebmann – possibly the Hungarian Jewish photographer Bela Liebmann – on a Leica camera, using Kodak film.

173 Nihon-Gekijo Theatre, Tokyo, Japan. Better known as the Nichigeki Theatre, the curved structure of 1933 by Jin Watanabe in part resembles a huge beached ocean liner, especially with its two rows of Nautical Moderne porthole windows. It was demolished

in 1983. *Made in Japan Shikaido Tokyo*

174 Orchestra Promenade, Municipal Auditorium, Kansas City, Missouri, USA. The public areas of this splendid civic building (see also p. 152) were – and largely still are – rich in ornate bronze grillework, marble panelling and floors and painted murals. The elaborate lighting included exquisite Art Deco chandeliers and smart illuminated signage. *Curt Teich, 1937*

175 Municipal Auditorium, Charleston, West Virginia, USA. With its winglike pilasters, horizontal banding, and sweeping curved form, the 1939 auditorium by Alphonso F. Wysong is a restrained, elegant concrete and steel monolith. It is included on the National Register of Historic Places, and the interior retains much of its original fittings. *Curt Teich, 1940*

176 Radio City Music Hall, New York City, USA. One

of the world's best-known performing arts venues, the 6,000-seat auditorium in the Rockefeller Center complex (see p. 185) has been a spectacular success from its opening in 1932. Principal designer Donald Deskey's Art Deco creations are only glimpsed here, but his overall vision was unparalleled, taking in furnishings, fittings, and aspects ranging from the classical grandeur of owner S. L. 'Roxy' Rothafel's wood-lined private office to the glittering *moderne* beauty of the Grand Foyer. *Colourpicture*

177 Odeon Cinema, Burnley, England. Characteristic of Britain's Odeon chain with its soaring vertical sign and cream tiles, this 1937 cinema was designed by Robert Bullivant and Harry Weedon. 'Odeon' means 'theatre' in Greek, but the name was also an acronym referring to the chain's founder and his achievement: 'Oscar Deutsch Entertains Our Nation'. The film advertised

was the hit of 1952. The cinema does not survive. *Lilywhite Ltd., Brighouse*

PLACES OF BUSINESS AND INDUSTRY

178 Calart Building, Providence, Rhode Island, USA. The 1939 factory of Calart – the California Artificial Flower Company – at 400 Reservoir Avenue was designed by Albert Harkness for the Italian immigrant Michele D'Agnillo, founder in 1922 of the firm that produced paper and fabric flowers. The 'up-to-date daylight factory' was 'surrounded by attractive gardens, pools, and shrubberies'. It is now offices. *Colourpicture*

180 Radio Station WOMI, Owensboro, Kentucky, USA. But for the huge broadcasting tower in its backyard, this boxy Art Deco structure could be a private dwelling. It was completed in 1937, and torn down in 1988. *Curt Teich, 1940*

181 *left* Theriot Pharmacy, Houma, Louisiana, USA. Over the vertical sign is a relief of a kneeling figure, while the black-sheathed storefront sports a curving fascia and modish overhang, making the building look more like a sleek neighbourhood cinema. It survives in much altered condition as the People's Drugstore. *Curt Teich, 1938*

181 *right* Robbins Drug Store, St John, New Brunswick, Canada. 'Eastern Canada's most modern Drug Store', with a vertical sign like that of a cinema and dark cladding, boasted 'Magic "Electric Eye" Doors'; sadly, it no longer survives. *Photogelatine Engraving Co., Ltd, Toronto*

182 Myers Shoe Salon, Baltimore, Maryland, USA. Myers was a purveyor of 'popular-priced women's novelty shoes'. This branch, with its *moderne* tubular metal furniture, stylish lighting and dramatic, vividly hued flooring, was located at Sherwood and

Curtain Avenue. On the back is written: 'Sample rooms designed and executed by E. Paul Behlers & Co., Baltimore, Md.' *Curt Teich, 1935*

183 First National Bank, Grand Rapids, Minnesota, USA. This postcard of a generic Streamline Moderne building, described as the 'Oldest and Largest Bank in Itasca County', stands out because of its atmospheric effects and artistic composition. No date, architect or artist's name is mentioned.

184 Woolworth Building, Montreal, Quebec, Canada. Many 1930s–50s Woolworth

Model Tobacco Factory, Richmond, Virginia, USA, 1938–40

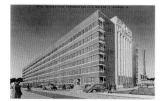

stores were notable for their Art Deco decoration (see also p. 205). This glazed terracotta structure of 1937–38, with a black granite base, stepped crenellated roof, and flagpole set before a central octagonal tower, was designed by Ian Thurston Archibald and Hugh Percival. It was torn down in 1986 to widen the street. *Colourpicture*

185 *left* Empire State Building, New York City, USA. This depiction of the 102-storey building at night, with the moon amid clouds and a dirigible moored to the mast, is a dramatic image of what is arguably the premier example of Art Deco architecture and a symbolic icon as Manhattan's tallest building (which it is again since the destruction of the World Trade Center). Designed by William Lamb of Shreve, Lamb & Harmon, it was built in only eighteen months at the depth of the Great Depression, in 1930–31. *Photograph by Irving Underhill*
185 *right* RCA Building,

Rockefeller Center, New York City, USA. The RCA – Radio Corporation of America – (now GE) Building of 1933 by Raymond Hood and others seems to soar into nighttime infinity, with Paul Manship's gilt-bronze *Prometheus* the centrepiece of the 1934 fountain at its base. Manship had the flanking sculptural groups removed in 1935, but they were reinstalled half a century later near their original location. *Photo Wendell McRae/Curt Teich, 1935*

186 *left* Palmolive Building, Chicago, Illinois, USA. This nocturnal view is low on detail but high on atmosphere, with the dreamy pastel lights and the 'Lindbergh Beacon . . . mounted atop a shining bronze column with its two billion candlepower beam visible to aviators for many miles'. The 1929–30 skyscraper, designed by Holabird & Root, is now Palmolive Building Landmark Residences. *A. C. [Chicago Aerial Survey] Co., postmarked 1948*

186 *centre* Genesee Valley Trust Co., Rochester, New York, USA. The signal tower's cast-aluminium *Wings of Progress* boldly punctuate a structure of 1929–30 whose dramatic effect, notably at night, was likened to 'an elegant René Lalique perfume bottle' by the architectural historian David Gebhard. Its designer, Ralph T. Walker of Voorhees, Gmelin & Walker, is said to have been inspired by four seashells on a beach. This is now the Times Square Building. *Metropolitan, Everett, Mass.*

186 *right* Bank of Commerce Building, Toronto, Ontario, Canada. The tallest building in the British Empire when it opened in 1931, the bank at 25 King Street was designed by York & Sawyer of New York with Darling & Pearson of Toronto. Its silhouette echoes that of its exact contemporary, the Empire State Building (p. 185). It is now the Canadian Imperial Bank of Commerce Building. *Colourpicture (Canadian-printed)*

187 *left* Banco Popular Building, San Juan, Puerto Rico. This Art Deco gem in the Calle de Tetuán was designed by Osvaldo Toro as the bank headquarters; when it opened in 1939 it was the Caribbean's tallest structure. *Moderne* reliefs on the façade include panels depicting heads of Greek deities and stylized eagles with outstretched wings. A clock face is set at the side of the gently setback upper levels. *Tichnor Brothers*

187 *right* Radio Station WWJ, Detroit, Michigan, USA. The striking stepped limestone structure at 600 West Lafayette Boulevard was designed by Albert Kahn's architectural firm in the mid-1930s, with black granite reliefs of musicians by the Swede Carl Milles. As the Roehrer-Gambling Building it still stands, with a later extension. *Colourpicture*

188 Administration and Research Center, S. C. Johnson & Son, Inc., Racine, Wisconsin, USA. Frank Lloyd Wright's corporate campus for these makers of cleaning products was built in two stages: the low-lying administration building in 1936–39 and the research tower in 1944–50. Wright said it was 'simply and sincerely an interpretation of modern business conditions designed to be as inspiring to live in and work in as any cathedral ever was to worship in'. *Curt Teich, 1952*

189 Fairbanks-Morse Display Room, Chicago, Illinois, USA. A rare interior view of an industrial display, this card has a strong Machine Age/Streamline Moderne look, rendered in a palette of cream, silver-grey, plum and black. A Fairbanks-Morse diesel engine stars at the centre, surrounded by a cut-away diesel engine and 'many types of pumps, motors, water systems and other products'. Note the grey and white cog-like floor design. *Curt Teich, 1952*

190 Syracuse Lighting Company Office Building, Syracuse, New York, USA. The structure of 1932 by Bley & Lyman of Buffalo and Melvin L. King of Syracuse was, the card tells us, 'one of the most beautifully lighted buildings in America. The colours are changed at frequent intervals and afford a marvelous spectacle.' At the corner of Erie Boulevard West and Franklin Street, it is now the Niagara Mohawk Power Building. *Curt Teich, 1932*

191 *left* Dallas Power & Light Company Building, Dallas, Texas, USA. A dramatic nighttime view adds somewhat unrealistic colours to the striking setback form of this brand-new Art Deco skyscraper, designed by local architects Otto H. Lang and Frank O. Witchell. It is today a residential high-rise known as DP&L Flats. *Curt Teich, 1939*

191 *right* Sofia Brothers Storage Warehouse, New York City, USA. Built in 1930 by Jardine, Hill & Murdock at 45 Columbus Avenue as a parking garage, clad in orange and black brick with cream and blue terracotta accents, this was converted into a warehouse in 1943. Declared an official city landmark in 1983, in 1985 it was transformed into luxury condominiums. *Colourpicture*

192 Chilehaus, Hamburg, Germany. The brick-faced reinforced-concrete office building of 1922–24 is the masterpiece of Fritz Höger. A fine example of North German Brick Expressionism, in its curving upper sections it also prefigured the next decade's Streamline Moderne buildings. Its famous pointed end resembling the prow of a ship is at the far right. *Verlag von C. Worzedialeck, Hamburg*

193 Rudolf-Mosse-Haus, Berlin, Germany. In 1921–23 Erich Mendelsohn with Richard Neutra and Paul Rudolf Henning added more storeys and a new entrance to the offices and printing press

of the newspaper publisher Mosse in Jerusalemer Strasse. The striking corner is thought by some to be the first Streamline Moderne structure; it certainly influenced such buildings in the 1930s. The reunification of Germany led to its restoration in the 1990s. *I. W. B. Serie Rembrandt*

194 *left* Chrysler Building, New York City, USA. The 77-storey building of 1930 by William Van Alen dwarfs its neighbour, the Chanin Building. To distinguish its glittering, exotic crown, with the curved zigzags of its windows, in the daylight, the printer has rendered it in a deep aqua hue. *Manhattan Post Card Publishing Co.*

194 *right* Chanin Building, New York City, USA. The developer Irwin S. Chanin had visited the 1925 Exposition in Paris, and his building of 1929 in East 42nd Street, designed by Sloan & Robertson, is one of the city's top Art Deco architectural showcases (and

one in which the author had the opportunity to work for several years, long ago). *Manhattan Post Card Publishing Co.*

195 Grand Island Plant, Nebraska Consolidated Mills Company, Grand Island, Nebraska, USA. Industry and transportation combine to create a striking image, as the massive stepped structure is set between the bright yellow streamlined railroad engine and boxy van at the bottom and the white plane overhead. The scene is reminiscent of Modernist paintings and photographs by Charles Sheeler. *Metrocraft / Miller Art Co.*

196 Shirokiya Department Store at Nippon Bashi, Tokyo, Japan. The streamlined building replacing a structure damaged by the 1923 earthquake was designed in 1931 by Kikuji Ishimoto, who had studied at the Bauhaus with Walter Gropius. It included an Art Deco clock

tower atop its flat roof and other geometric design elements.

197 Knapp's Department Store, Lansing, Michigan, USA. The huge Streamline Moderne retail store in Michigan's capital opened in 1938. Note the extensive use of glass blocks on the curved structure and the vertical elements leading to elaborate doorways. The cladding is yellow and blue 'Maul Macotta' – concrete blocks faced with metal and ceramic. Knapp's is to be renovated and converted for housing, retail and offices. *Tichnor Brothers*

198 State Bank of Morocco, Casablanca, Morocco. The bank was designed by Edmond Brion, an associate of Albert Laprade in the 1920s–30s development a new quarter of the city, combining aspects of Moroccan and French architecture and decoration. Thoroughly modern in construction, it includes repeated diamond and other

geometric motifs that have a Moorish character but also resemble patterns on *moderne* structures in Paris. It is now a branch of the Bank Al Maghrib.

199 *left* Daily Express Building, London, England. A superb Streamline Moderne structure of 1930–32 by Ellis & Clarke with Sir Owen Williams, its gleaming, subtly stepped form was a striking arrival in Fleet Street, then the centre of the English newspaper industry. The cladding is panels of black Vitrolite and clear glass, bound together and at the same time broken up by chromium bands. It remains a landmark today, occupied by Goldman Sachs. *Photochrom Co. Ltd, London and Tunbridge*

199 *right* Broadcasting House, London, England. The headquarters of the British Broadcasting Company (BBC) in Portland Place, a curving stone-clad mass, was designed

279

by George Val Myer and built in 1930–32. Sculptural elements include the overdoor group by Eric Gill seen here, of two characters from *The Tempest*: Prospero, the magician, and Ariel, the spirit of the air, representing the air waves. High above, under the rectangular-framed clock, stylized wings frame an hourglass, symbolizing the passage of time. *Raphael Tuck & Sons*

200 Citizen-Times Building, Asheville, North Carolina, USA. Designed by Anthony Lord with Lockwood Greene, the asymmetrical structure was constructed soon after the 1930 merging of the two daily papers in its name. It makes extensive use of glass blocks, 'adding to its lighting efficiency', notes the locally published card, 'and giving it a modernistic appearance'. Above the flagpole is a relief showing an Art Deco landscape of stylized mountains, clouds and sunburst. *Asheville Post Card Co.*

201 Maisel's Indian Trading Post, Albuquerque, New Mexico, USA. Maurice Maisel began selling Mexican and Southwestern curios in 1939, in this Pueblo Revival store by John Gaw Meem of Santa Fe. The exterior features cladding in coloured glass akin to Vitrolite, and murals designed by Olive Rush showing local Indians in ceremonial garb, painted by young Pueblo and Navajo artists. It is still trading, slightly altered, at 510 Central Avenue, SW; the murals are intact. *Curt Teich, 1941*

202 NBC Radio City, Hollywood, California, USA. The headquarters of the National Broadcasting Company's West Coast Radio City on the storied corner of Sunset and Vine opened in 1938 and was home to a bevy of radio (and from 1949, television) personalities and shows. The designer of the creamy Streamline Moderne confection was John C. Austin, architect of Los Angeles City Hall (see p. 43).

It was torn down in 1964. *Curt Teich, 1938*

203 Swiss Cleaners & Dyers, Oklahoma City, Oklahoma, USA. This striking interior reflects a sophisticated contemporary aesthetic. Note the cash register at the right, old-fashioned-looking alongside the *moderne* blue-hued and tubular metal furniture throughout. *Curt Teich, 1945*

204 Simonds Saw and Steel Company Factory, Fitchburg, Massachusetts, USA. The card gives an air of mystery and intrigue to the huge low-lying windowless factory with Art Deco decorative elements. We are told that Simonds 'employs the best workmen, provides the most modern working conditions, and produces the very highest quality Saws, Machine Knives and Files'. *Colourpicture*

205 Woolworth Store, Seattle, Washington, USA. The store at 301 Pike Street with its cream-

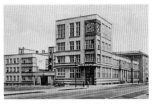

Post and Telegraph Office, Gdynia, Poland (postcard: 1925)

and salmon-hued terracotta façade was designed in 1940 by the company architect, Harold B. Hillman. The caption states that the 'completely air-conditioned' store had 'Terrazza [*sic*] floors' and 'columns of Gold Grain Tennessee marble'. The structure is now a discount clothing store. *C. J. Johnston Co., Seattle, Washington*

206 Empire State Building, New York City, USA. Next to the picture of the famous skyscraper (see p. 185), this 'Busy Person's Correspondence Card' includes three columns of ten sorts of messages waiting to be checked, with

potentially humorous results. *Curt Teich, 1937*

207 St Petersburg Federal Savings and Loan Association, St Petersburg, Florida, USA. This charming card advertising the opening hours depicts a subtly *moderne* single-storey, flat-roofed structure with a grand entrance with stepped overdoor and a geometric-patterned tile and palm-tree-adorned sidewalk in front. The building, at 556 Central Avenue, still stands, beautifully conserved by the present owner-occupant, architect Kevin J. Bessolo of the Bessolo Design Group. *Curt Teich, 1948*

TRANSPORT AND TRAVEL

208 Roarin' Rohrer gas station, McAlester, Oklahoma, USA. This Streamline Moderne petrol station was immortalized in a 1972 acrylic on canvas by the American Photorealist painter John Baeder (born 1938), whose primary subject matter is roadside America. Baeder, based in Nashville,

Tennessee, has said: 'I look at these early "linen" postcard paintings, and they still hold up . . . These images . . . mostly of small towns and corner drugstores and gas stations and other auto-related images . . . pushed me into painting more realistically.' *Tichnor Brothers*

210 Greyhound Union Bus Depot, Omaha, Nebraska, USA. Here unusually is an inside view of a Greyhound Bus station (see pp. 224–28), designed in the late 1940s–early 1950s by an unknown architect. The caption on the back reads 'Fully air-conditioned – even in the phone booths! – and with every feature for comfort and convenience, this ultra-modern terminal is one of the country's finest.' It has been torn down. *Tichnor Brothers*

211 Main Waiting Room, Union Station, Omaha, Nebraska, USA. Splendid designs cover floor, walls, and ceiling, and the lighting fixtures are stylishly *moderne*.

The card was posted in 1944 by a soldier who wrote on it: 'Hi Auntie & Uncle, Here I am in Kansas, suppose to get six weeks Tng [Training]. . . . Need plenty Infantry men. . . . So long. Ralph.' The building is today home to the Durham Museum. *Curt Teich, 1937*

212 Transcontinental highway across Boulder Dam (now Hoover Dam), Nevada–Arizona Border, USA. The structure of 1931–36, built in record time at the depth of the Depression, harnesses the power of the Colorado River. The English-born Los Angeles architect Gordon B. Kaufmann was called on to give the dam decoration worthy of its location and immense scale, with Art Deco elements outside and Native American and Southwestern motifs inside, which could be enjoyed on sight-seeing tours. *Curt Teich, 1941, postmarked 1946*

213 Pan-American Airways International Passenger Terminal, Miami, Florida,

USA. The Terminal, built by Delano and Aldrich, was described in 1934 as 'Conservatively Modernistic'. Rising suns and winged globes alternate in a decorative frieze near the top, with eagles at the corners. In 1954 it became Miami City Hall, and after a more recent restoration its interior, with Barnet Phillips murals of the history of flight, is also back to its original splendour. *Photo by W. F. Gerecke/Curt Teich, 1934*

214 The new streamliner '400', Chicago and North Western Line, USA. This card shows 'The most unusual car in America – a tap-room at one end, lounge at the other and in

...

Spa Building, Gdynia, Poland (postcard: 1925)

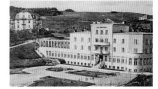

between an attractive Lunch Counter. . . . Speedometer over the bar. Radio and deep-cushioned chairs and sofas in the lounge. Photo-mural decorations.' All the '400' trains were gone by the mid-1960s. *Curt Teich, 1939*

215 Writing and Reading Room of the Zeppelin *Hindenburg*. The luxurious German airship, the biggest ever built, was launched in 1936. Its furnishings were designed by Fritz August Breuhaus. The 'Schreib- und Lesezimmer' had leather and tubular steel furniture and its walls were decorated with scenes from around the world painted by Otto Arpke. In 1937 the vessel burst into flames and crashed while trying to land in New Jersey. *Verlag Gebr. Metz, Tübingen*

216 Ocean Terminal, Southampton, England. The interior boasted sleek furniture in light and burl woods, stylish lighting, and even a writing room. The Streamline

Moderne terminal was not built until after the war, and opened in 1950. It was demolished in 1983. In 1974 I was lucky to have passed through here, having disembarked from the *France* on my way from New York to London, and the space made a huge impression on me. *N. A. Head, Parkstone*

217 Ocean Terminal, Southampton, England. Like so many land-based maritime structures, this shared some design characteristics with ocean-going vessels, notably the rounded central tower and semi-wraparound 'decks'.

218 Cabin Observation Lounge and Cocktail Bar of the ocean liner *Queen Mary*. The interior of the Cunard Line's 1936 ship, 'the world's largest and fastest liner', included this chrome-embellished Streamline Moderne bar. The transatlantic liner proved immensely popular. She retired in 1967, and became a tourist attraction, events venue and hotel docked

at Long Beach, California. In May 2011 she celebrated the 75th anniversary of her maiden voyage. *C. R. Hoffmann, Southampton*

219 Second Class Drawing Room of the ocean liner *Ile de France*. What is considered to be the first Art Deco ocean liner made her maiden voyage in 1927. This card shows elegant furniture as well as fabric and carpeting with Art Deco patterns. Used to transport British troops in World War II, the liner went back to the French Line in 1947 and sailed twelve more years before being broken up. The card was specially produced for the French Line.

220 First Class Smoking Room of the ocean liner *Normandie*. The largest, fastest, and most luxurious ship to sail the seas when her transatlantic crossings began in 1935, the French Line's *Normandie* featured the work of premier Paris designers. The Smoking Room had huge doors

decorated with ancient Egyptian-style deer hunters; the lacquered panels surrounding them, of *The Hunt*, were by Jean Dunand (on the reverse was his *Aurora*: see p. 221); four more Dunand wall panels, of which two are visible left and right, showed fishing, taming horses, wine harvesting and ancient Greek sports. It had club chairs, banquettes and small tables by Jean-Maurice Rothschild, who gave the space a further 'men's club' look (though women were allowed) by using a brown-toned palette. The *Normandie* entered service in 1935; she was being converted into a US Navy troopship when she caught fire and sank in New York harbour in 1942. Some elements had been removed, and survived. *Hamon hand-tinted real photo card*

221 First Class Grand Salon of the ocean liner *Normandie*. Seen here are Jean Dunand's *Aurora* in lacquer and metal leaf on plaster relief in the centre, and to the left and

right details of the reverse-painted-on-glass *History of Navigation* mural designed by Jean Dupas and made by the famed stained-glass workshop Maison Champigneulle of Metz. The furniture is by Ruhlmann, the lighting is by Lalique, and on the floor is a vast Aubusson carpet. Part of Dupas' mural now belongs to the Metropolitan Museum of Art, New York, and Dunand's relief is in the Carnegie Museum of Art, Pittsburgh, Pennsylvania.

222 Central Railway Station, Helsinki, Finland. Eliel Saarinen's granite and copper station dates from 1904–14. It is widely considered to have influenced Art Deco architects and designers in America, where Saarinen settled in 1923. The four massive stylized figures holding lamps flanking the entrance and the stepped, ornamented clock tower are among the features that can be related to later 1920s and 1930s structures, notably public buildings and monuments.

223 Bus Station, Caen, France. An old railway station that was taken over by Les Courriers Normands, primarily a bus line, this late 1930s structure features rounded corners, contemporary lettering and other Streamline Moderne – not Parisian Art Deco – elements. A newer building now stands on the site. *Edit. d'Art Belfrance*

224 Greyhound Bus Terminal, Louisville, Kentucky, USA. This 1937 terminal was the first of several dozen Greyhound stations designed by W. S. Arrasmith over two decades (see also pp. 225–27). It featured many elements that were to be characteristic: curved sides, cinema-type vertical sign with canine logo, and 'Greyhound Blue' enamelled steel panels. *Curt Teich, 1937, postmarked 1949*

225 Greyhound Bus Terminal, Fort Wayne, Indiana, USA. Built in 1938 to a design by W. S. Arrasmith, the terminal featured a tall sign pylon, a

flow of glass bricks and distinctive 'Greyhound Blue' enamelled steel panels. It was demolished in the 1980s. *Curt Teich, 1940*

226 Greyhound Bus Station and Restaurant, Atlanta, Georgia, USA. This handsome Streamline Moderne station by W. S. Arrasmith opened in 1940. It had a porthole-like window over the entrance, a vertical sign – forming the right side of a reverse 'L' with the cantilevered metal overhang – and two images of the company's canine mascot. *Curt Teich, 1941*

227 Greyhound Bus Terminal, Washington, D. C., USA. This W. S. Arrasmith design was built on a prime corner not far from the White House in 1940; perhaps in keeping with its setting, it was faced in limestone and glazed black terracotta. A Cinderella story, the terminal was restored and reopened in 1991 as part of the new 1100 New York Avenue office tower. *Curt Teich, 1940*

228 Greyhound Bus Depot and Wayne Theater, Wooster, Ohio, USA. The coach terminal (with restaurant) is next to the 1939 Wayne Theatre, a Streamline Moderne building designed by Peter M. Hulsken and part of the Schine Theatres chain. Showing on the big screen was the 1943 romantic comedy *Princess O'Rourke*, with Olivia De Havilland and Robert Cummings. *Curt Teich, 1944*

229 Union Terminal, Cincinnati, Ohio, USA. Designed by Roland Anthony Wank and Paul Philippe Cret for Fellheimer & Wagner, the terminal of 1929–33 had remarkable Art Deco ornament inside and out. The relief seen here is one of two, symbolizing Commerce and Transportation, by Maxfield Keck. After threats of demolition in the 1980s the station was saved and became the Cincinnati Museum Center at Union Terminal. *Kraemer Art Co., Cincinnati, Ohio*

283

230 Airlines Terminal, New York City, USA. This low-rise, high-style limestone box for the new means of transport was designed by John B. Peterkin and built in 1939–40. The *moderne* eagles atop were saved in 1981 when the building was demolished, and survive in Richmond, Virginia, on the entrance to the old Best Products headquarters. *Colourpicture*

231 Union Station, Omaha, Nebraska, USA. The 1929–31 Union Pacific station, designed by Gilbert Stanley Underwood, is often called America's first Art Deco railroad terminal. The structure is clad in

Sugg Clinic, Ada, Oklahoma, USA, 1947 (postcard: 1950)

cream glazed terracotta and incorporates Native American and stylized Art Deco floral, shell, zigzag and other motifs. It is now the Durham Museum. *Curt Teich, 1937*

232 The Car of Tomorrow, as shown at the Crosley Building, New York World's Fair, USA, 1939. This jaunty compact car got 50 miles to the gallon, and sold in appliance and department stores for $325–350. It was made, with an interruption during the war, until 1952. *Litho U.S.A./© NYCWF*

233 A 'giant racer' on the Bonneville Salt Flats, Utah, USA. The six-wheeled racer is on a track where land-speed records were broken from the 1930s. Sir Malcolm Campbell set his final land record here in 1935, as the first person to drive an automobile over 300 miles (483 km) per hour. *Curt Teich, 1938*

234 Motor Ferry *Kalakala*, Puget Sound, Washington,

USA. 'The world's first streamlined vessel', the *Kalakala* – said to mean 'flying bird' in Chinook – served Seattle and Bremerton from 1935 to 1967, when she briefly became a floating crab-processing plant in Alaska. After a long period of neglect, by late 2010 repairs and restoration were underway, and there is hope for the sleek vessel to be plying Washington's waters once again as an Art Deco summer tourist attraction. *C. P. Johnston Co., Seattle, Wash.*

235 S.S. *Admiral*, St Louis, Missouri, USA. A 1907 side-wheeled steamboat was transformed in 1940 into this steel-sheathed excursion steamboat on the Mississippi. The back of this card commended its 'sleek, streamlined design and absence of all exterior decorative frills'. In the 1970s it was permanently berthed as a St Louis nightclub, and its future is uncertain. *Curt Teich, 1941*

236 Victoria Coach Station, London, England. This massive Art Deco bus terminal, designed by Wallis, Gilbert and Partners in 1932, remains a functional and attractive transport hub. Major renovations have been undertaken inside and out, including the addition of an upper storey, but essentially the character of the behemoth in Buckingham Palace Road (which is not listed) has not been compromised.

237 Dublin Airport Terminal Building, Republic of Ireland. The terminal, whose sleek white lines echo the curves of an ocean liner, was designed by Desmond FitzGerald and opened in 1941. Early on, what is now known as the Old Central Terminal Building accommodated 100,000 passengers yearly.

238 Streamlining through San Diego County, California, USA. An Atchison, Topeka and Santa Fe streamliner makes its way through orange groves on this

linen. Rolling stock for a new, streamlined train between Los Angeles and San Diego was ordered from the Budd Company of Michigan in 1936, and in 1938 the Santa Fe company inaugurated the San Diegan route. *Published by Hopkins News Agency, San Diego, Calif., postmarked 1956*

237 Silver Meteor trains pass in the scenic highlands of Florida, USA. The first streamliner travelled the New York–Miami route in 1939: the Silver Meteor, featuring fluted stainless-steel cars by Michigan's Budd Company, colourful diesel locomotives, and sleek, round-cornered observation cars at the rear, was hugely popular. The company, Seaboard, was probably responsible for the card, which has a metallic sheen that makes the train cars gleam.

240 Greyhound Bus Depot, Portsmouth, Ohio, USA. Designed by George D. Brown of Charleston, West Virginia,

this 1941 Streamline Moderne depot is unlike so many others of the time which featured the signature 'Greyhound Blue' colour (cf. pp. 224–26), but it does display the inverted 'L' canopy with greyhound atop. The glass brick and porthole-windowed structure was torn down in 2008. *Curt Teich, 1942*

POSTCARDS TO SEND

241 New Union Pacific Station, Las Vegas, Nevada, USA. A gleaming modern engine adds a stylish touch to this quintessential American Deco card. On the back the 1940 'Gateway to Boulder Dam' (the Hoover Dam: see p. 212), is described as 'the world's first streamlined, completely air-conditioned railroad passenger station'. It was demolished in 1970. *Curt Teich, 1940/© Boulder Dam Service Bureau*

243 Lower Dells Filling Station, Wisconsin Dells, Wisconsin, USA. The area has long been popular for its water

and gorges, supplemented by amusements, hotels and eateries. This Phillips 66 petrol station must have been a shining beacon, not just because of its glowing nighttime illumination and streamlined design: the card also touts 'superior service with courteous attendants always at your command'. *E. C. Kropp*

245 The Albion, Miami Beach, Florida, USA. Dating from 1939 and designed by Russian-born Igor B. Polevitzky with T. Triplett Russell, this hotel at 1650 James Avenue is rich with Nautical Moderne elements including portholes, curved corners, and a 'top deck'. On the back of the card the Albion calls itself 'The Hotel of Tomorrow' with 'a radio in every room'. It was remodelled in 2008, and today's Albion Hotel South Beach offers 'Art Deco-inspired guestrooms and suites'. *Curt Teich, 1939*

247 International Exposition commemorating the Centenary of the Independence of

Belgium, Liège, Belgium, 1930. This striking poster-like card was an advertisement for the Liège venue (see also p. 19), which displayed among other things heavy industry, science, and historic Walloon art (the Flemish venue was at Antwerp). The Art Deco signature of the artist, Ceurvorst, appears centre right. *Printing Co. S.A. Liège*

249 The Bakelite Travelcade, New York City, USA. The exhibition showcasing 'Modern Plastics for Modern Living' was a touring show organized by the Bakelite Corporation at several American venues, including, in 1938, the New York Museum of Science and Industry, then in the RCA Building. Bakelite, named after the chemist Leo Baekeland who developed it around 1907–9, has become identified with the Art Deco era. *Harry H. Baumann*

251 Village Restaurant, Atlantic City, New Jersey, USA. With its tubular-steel chairs,

chequerboard tiled floor, and row of blue stools hugging a bright yellow counter, this inviting, just-like-home Art Deco-period neat little eatery in the beach resort of Atlantic City is long gone. *Tichnor Brothers*

254 Hotel Dixie, New York City, USA. This hotel of 1930 by Emery Roth, in the theatre district, had Southern-inspired attractions such as the New Plantation Bar and Lounge, which offered 'Continuous Entertainment 7 P.M. to Closing'. At 43rd Street near Eighth Avenue, it became the Carter Hotel in 1976. *Colourpicture*

256 Skyscrapers, Oklahoma City, Oklahoma, USA. These three Art Deco skyscrapers in Park Avenue are the 18-storey Petroleum Building of 1927 (now Dowell Center) and two 33-storey edifices that were in a great race for the finish: both opened in 1931, with Ramsey Tower (now City Place) the winner by a whisker over the

beacon-topped First National Bank. All three still stand, testimony to the city's sagacity in preserving its heritage. *Curt Teich, 1932*

PAGES 258–284

258 Rizal Avenue, Manila, Philippines. The Art Deco Ideal Cinema was designed in 1933 by the Filipino architect Pablo Antonio, and inspired his choice as the architect of Manila's Far Eastern University (see p. 59); it was demolished in the late 1970s. *Metrocraft*

261 Cocktail Lounge, Hotel Marinette, Marinette, Wisconsin, USA. Red benches are lined up beside the curvaceous bar backed by ornate decoration. *E. C. Kropp*

265 Imperial Suite 'Huzi' of the Japanese ship *Argentina Maru*. Launched in 1938, the *Argentina Maru* was an Asian-meets-*moderne*-style passenger liner of the Osaka Shosen Kaisha (O.S.K.) Line. In 1942

the vessel was sold to the Imperial Japanese Navy and converted into an aircraft carrier, bombed in 1945. The card has on the reverse: 'Printed in Japan; O.S.K. Line Covers the Seven Seas'.

275 Church of the Cumberland Presbyterian Mission, Cali, Colombia. This unusual little structure, with its asymmetrical stepped roofline, door with sunburst motif and *moderne* signage, was erected in 1937. *Curt Teich, 1937*

277 Model Tobacco Factory, Richmond, Virginia, USA. The structure of 1938-40 by Schmidt, Garden and Erikson of Chicago on the Petersburg Pike (now Jefferson Davis Highway), with immense Art Deco lettering at the top, was, the card declares, 'considered by many to be the most beautiful manufacturing building in America'. In 2008 a developer announced plans (as yet unrealized) to turn it into a luxury residential building. *Colourpicture*

280, 281 Post and Telegraph Office, and Spa Building, Gdynia, Poland. Two images from a multiview card. The Post and Telegraph Office features a stylish (and numberless) clock on two façades and *moderne* lettering, while the Spa Building has stepped massing and curved structural components. *Fotograf L. Durczyklewicz, Gdynia, 1925*

284 Sugg Clinic, Ada, Oklahoma, USA. The clinic, with its glass-block windows, curved corners, brushed aluminium trim and tastefully coloured exterior, designed by H. S. Moore and Albert S. Ross, opened in 1947. It closed in 1980; at 100 East 13th Street, listed in the National Register of Historic Places, it is now in use for offices. *Curt Teich, 1950*

INDEX OF PLACES

287

00 964 1028

288